MW01008299

ALMOST
LOST
ARTS

ALMOST LOST ARTS

TRADITIONAL CRAFTS *and the* ARTISANS KEEPING THEM ALIVE

BY EMILY FREIDENRICH

With essays by NARAYAN KHANDEKAR *and* MARGARET SHEPHERD

CHRONICLE BOOKS
SAN FRANCISCO

To Jacob, Kate, & Oz! Love you guys so much. ♥ xo *Emily*

Text copyright © 2019 by Chronicle Books LLC.
Photography copyright © 2019 by the individual photographers.
Page 207 is a continuation of the copyright page.
Cover image by Adriana Zehbraukas/*The New York Times*/Redux

All rights reserved. No part of this book may be reproduced in
any form without written permission from the publisher.

Library of Congress Cataloging-in-Publication Data

Names: Freidenrich, Emily, author. | Khandekar, Narayan, 1964- | Shepherd, Margaret.
Title: Almost lost arts : traditional crafts and the artisans keeping them alive / by Emily
Freidenrich ; with essays by Narayan Khandekar and Margaret Shepherd.
Description: San Francisco, California : Chronicle Books LLC, 2019. |
Includes bibliographical references.
Identifiers: LCCN 2018039987 | ISBN 9781452170206 (alk. paper)
Subjects: LCSH: Handicraft. | Industrial arts. | Artisans.
Classification: LCC TT145 .F74 2019 | DDC 745.5—dc23 LC
record available at https://lccn.loc.gov/2018039987

Manufactured in China.

Design by Kayla Ferriera.

10 9 8 7 6 5 4 3 2 1

Chronicle books and gifts are available at special quantity discounts to
corporations, professional associations, literacy programs, and other
organizations. For details and discount information, please contact our premiums
department at corporatesales@chroniclebooks.com or at 1-800-759-0190.

Chronicle Books LLC
680 Second Street
San Francisco, California 94107
www.chroniclebooks.com

For Tyler

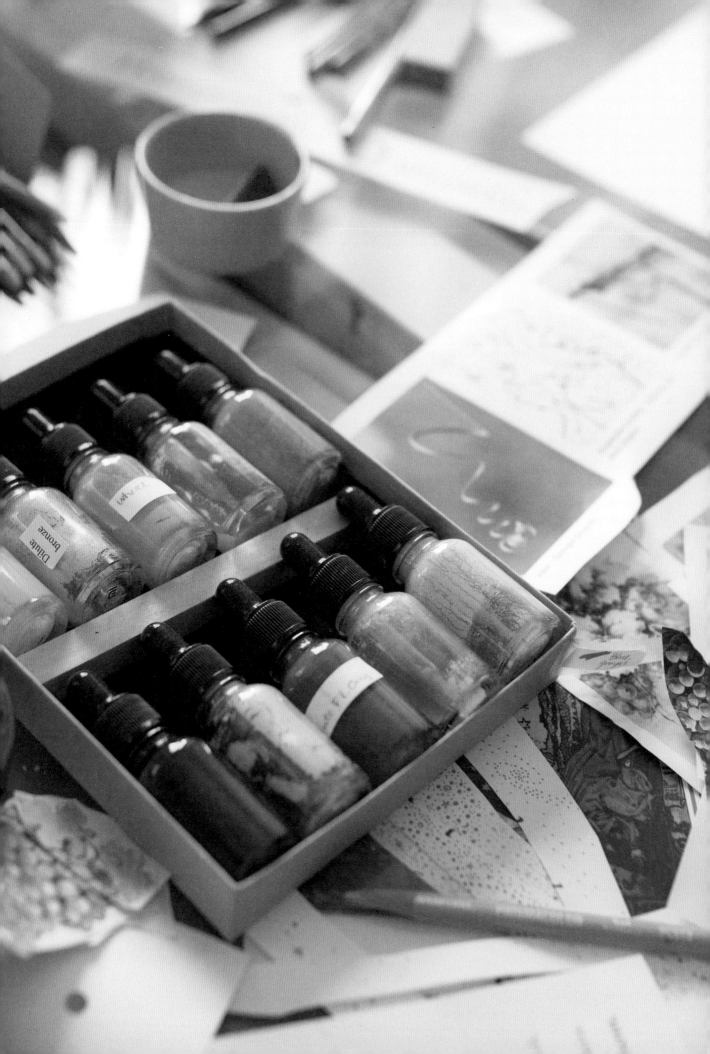

Contents

The Meaning of Making

"GETTING OUT THERE AND DOING THINGS WITH YOUR HANDS IS HONEST AND HUMAN."
Photographer Ray Bidegain is talking about what drives his work in alternative process
and wet plate photography, but his words largely reflect the feelings of the other artists,
artisans, and makers interviewed in this book. From traditional adobe-builders to an
antiquarian horologist, from sign painters to bronze casters, all of them work with their
hands. *Almost Lost Arts* celebrates these few skilled artists and devoted artisans dedicated
to creating something tangible, or useful, or beautiful, every day.

Whether they are continuing or reviving a craft that is decades or even centuries old,
every maker is inseparable from their process. And it is the presence of the human hand in
the end result—a ceramic bowl, or weaving, or photograph, or painting—that cannot be
replicated in a commercial setting. There is purity and honesty in the uncanny perfection
that comes with time and experience and skill and love, and equally so in the moments of
imperfection that remind us of the maker behind the object.

You may have sensed this. Maybe you once made something that felt as though it cap-
tured a part of you. Perhaps you've experienced awe while looking at the uncannily smooth
brush strokes of a painting, or admired the skill (earned from a lifetime of dedication) in
a piece of furniture. Art critic Walter Benjamin called this effect the *aura* of an original
work of art—an awareness in the onlooker of something living that feels almost physical;
a sense of the object's history, and of the emotion, skill, and human hand behind it.

In many cases, that history is deeply important. Several artisans in this book fol-
low traditional techniques to keep alive cultural heritage and celebrate national identity.
Indigenous Zapotec weaver Porfirio Gutiérrez and his family are among the few weavers
in their Oaxacan village who follow the ancient recipes for natural dyes (using native plant

materials) for their vibrant textiles and weavings. It's an art at the edge of disappearing, as synthetic dyes appeal to many weavers by saving time and offering a wider range of colors. But, according to Gutiérrez, they are often toxic and are costing his culture an ancestral tradition that goes back to pre-Columbian times.

Thousands of miles away in Tokyo, the Adachi Institute of Woodcut Printing is dedicated to maintaining the art of the *Ukiyo-e* print. Its atelier of talented carvers, printers, and publishers collaborate with artists around the world to produce these traditional prints. Meanwhile in Kyoto, lacquer artist Muneaki Shimode carefully repairs broken ceramic vessels with *urushi* lacquer and gold powder in the stunning *Kintsugi* technique. Both arts are important representations of Japanese aesthetics, cultural history, and philosophical ideals, but every year, fewer masters are certified in the practices.

Following tradition can also lead organically to innovation, experimentation, and growth. Korean potter Lee Eun Bum, who specializes in the ancient Goryeo celadon tradition, works under the motto of "mastering the old to create new." He explains: "I always contemplate on how I should approach a traditional technique into my work, how it can be efficient while being useful." Contemporary artist Daniel Arsham's innovations in casting processes continue to push the medium to new places, using unconventional media like volcanic ash to cast everyday objects like Chicago Bulls jackets and Pentax cameras.

But for many Old-World techniques displaced by technology over time, innovation comes not just by choice, but by necessity. Since knowledge was once passed from master to apprentice by demonstration and oral history, there are gaps in that knowledge today. When he began making globes as a hobby, Londoner Peter Bellerby spent two years learning his craft through experimentation and failure before he produced the two perfect globes he'd set out to make, and had developed a process he could be satisfied with (at least as a start). In Two Rivers, Wisconsin, Hamilton Wood Type & Printing Museum director Jim Moran describes printing machines and aspects of the wood moveable type process that were simply never recorded. The museum is dedicated to uncovering those secrets through the same patient acts of trial and error.

But these challenges are part of the magic and the meaning behind the making. And with time, these arts have been revived, or have managed to survive the threat of obsolescence. The craftspeople you'll meet in this book are just a small handful of the makers in our communities and cities all over the world who work every day to carry their cultural history into the future, who dedicate their lives to their work for love of artistry, and who keep alive knowledge that otherwise would be lost.

The Globemakers

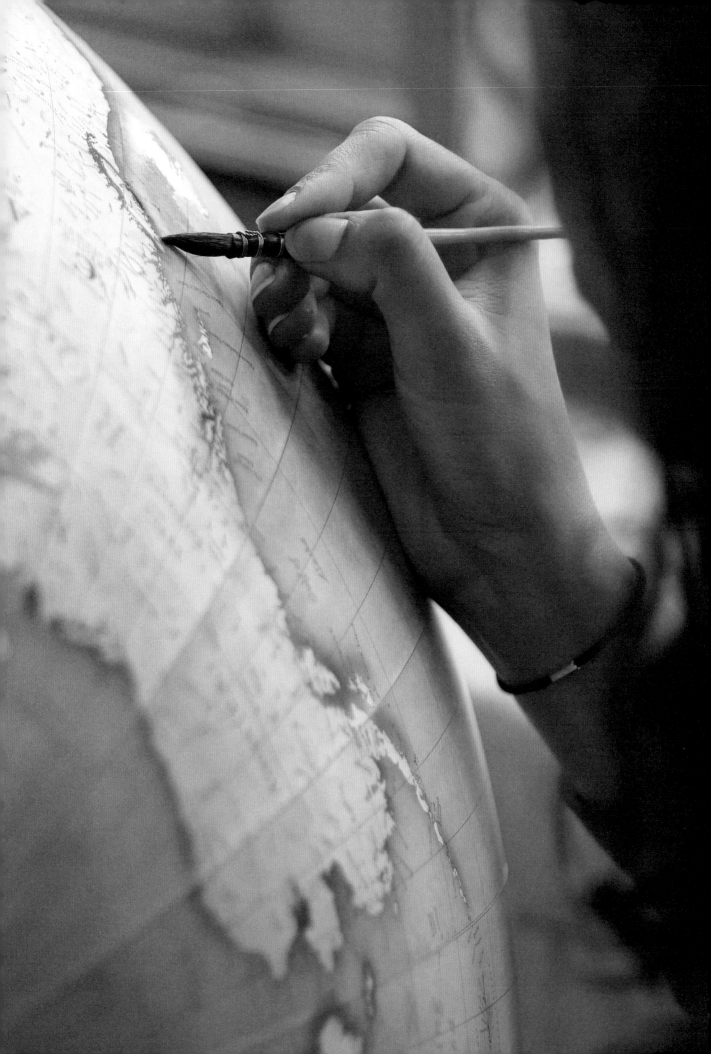

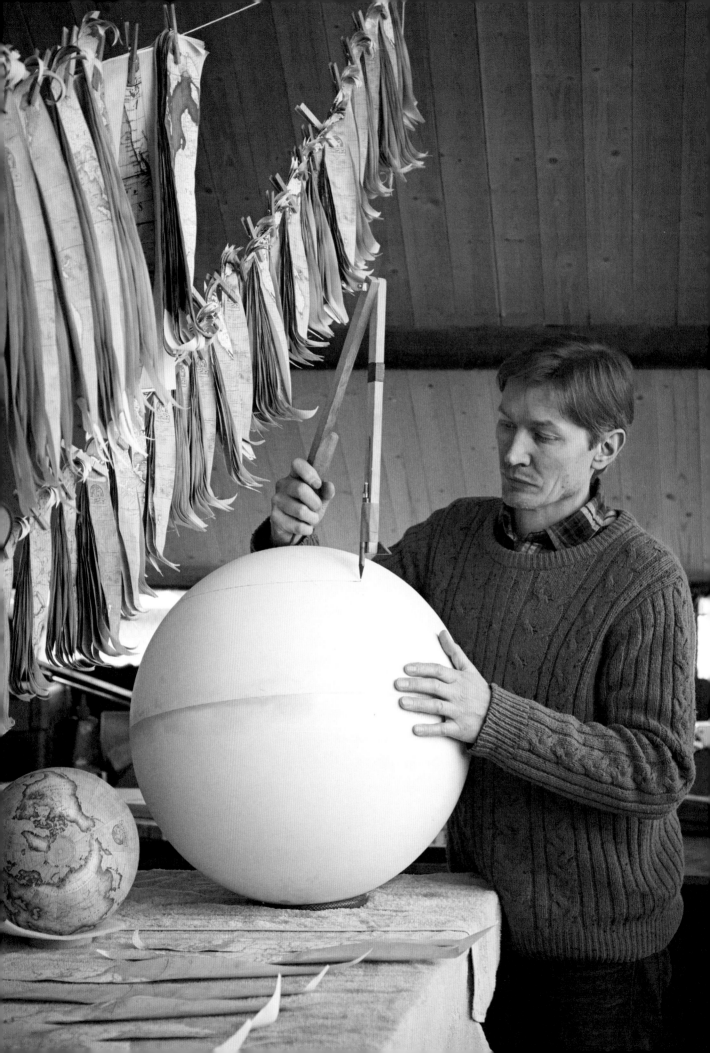

PETER BELLERBY,
BELLERBY & CO.
LONDON, ENGLAND

In a light-filled studio at the edge of Abney Park, strips of gently curling paper hang from clotheslines above tables strewn with paintbrushes, inkpots, rolls of paper, and drawing compasses. On every other available space sit perfect spheres of varying sizes. Many are tended to by an artisan, who is painstakingly painting, gluing, or sealing the plaster of Paris surfaces to bring each bespoke globe to life.

This is the workspace of Bellerby & Co., one of just two companies in the world devoted to the art of custom, handcrafted globes. The company was established in 2008, when Peter Bellerby went looking for a beautiful globe for his father's eightieth birthday but was frustrated by the lack of quality he found on the market. The Western globemaking tradition initially flourished during the European Renaissance and grew as a trade in the eighteenth century with the rise of globes as important technological and educational tools. But it was gradually replaced by factory-made versions and cheaper materials as the twentieth century dawned. The call for handmade globes has continued to diminish over time, and by 2008 the process was obsolete. The art and its techniques were seemingly lost to the past along with its artisans.

Always curious about how things work, and with a tendency to tackle repairs on his own instead of going to professionals, Bellerby jumped at the challenge of mastering something that "no one else on the planet" could help him learn. The former violin

"I never was formally schooled in the arts," says Bellerby. "Many of the greatest makers I know have simply been the type of people who are creative in their free time from a young age." Bellerby has always worked with his hands and was a violin maker and a house restorer before taking up his current profession. These two trades, he says, gave him an understanding of many of the tools and techniques used in globemaking.

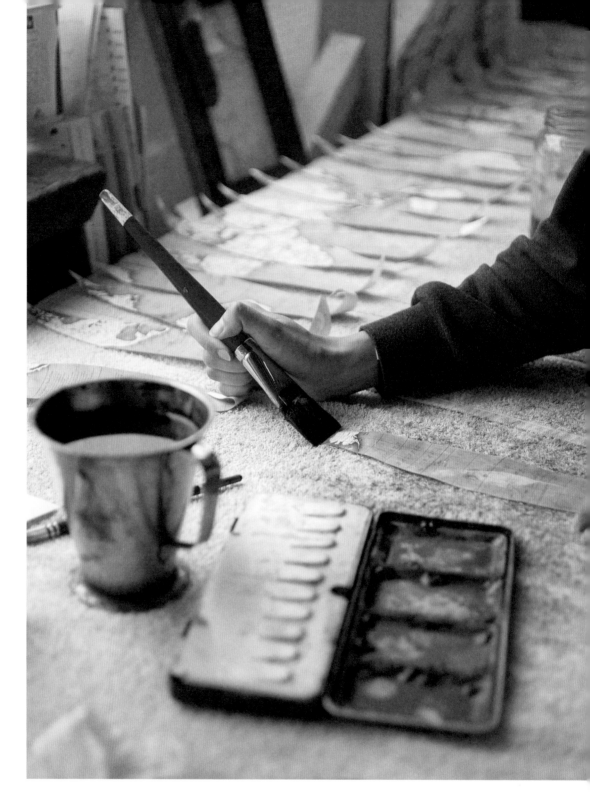

The printed map design is cut up by hand into the precise oval shapes called gores. The gores are then hand-painted with watercolors, which give a unique result for each globe. A globemaker takes the dried gores and wets them, and then delicately stretches and places them over the plaster body.

The Bellerby team includes four skilled globe-makers. Bellerby and his senior globemaker tackle some of the largest and most complicated projects, while the two others specialize in desktop-size globes. Apprentices sign on for a minimum of six months to learn the process, and the search for candidates up to the challenge of the slow and careful work is not easy.

maker spent the next two years piecing together the meticulous process of globemaking through extensive research, partnering with other fabricators and mapmakers—but mainly through trial and error. His goal was to produce just two perfect globes: one to keep, and one for his father. He never set out to turn his hobby into a business. But whether out of personal "stubbornness" or creative passion, the work soon "got out of hand."

Today, Bellerby and his globemakers work closely with their team of artists and artisans in considerate harmony (it's important, says Bellerby, that each artist be sympathetic to the next artist's work, since mistakes made at one phase can create more work down the line to repair the error). Woodworkers craft the globe base out of wood or metal. Cartographers plan the incredibly accurate maps of land and sea, or sometimes celestial bodies. An illustrator and several painters bring in color and dimension and integrate personal touches for the clients. And Bellerby's rarest find, a skilled engraver, hand-engraves the meridian—the metal band that encircles half or the entire globe—which is affixed to the globe on both poles and the base in the final stages.

"The key tools [in globemaking]," Bellerby says, "are hands, water, and glue. It is all traditional." Bellerby & Co. globes certainly evoke an Old-World aesthetic, both through their materials and process and by drawing inspiration from historic styles. But innovation is a key part of keeping the art alive. It would have been taking tradition too far even for Bellerby, for example, to adhere to the fifteenth century technique of etching the reverse image of a map into copper plates and then printing maps from those plates. Adobe Illustrator is used to plan maps today, but the cartographers can use it to reenact aspects

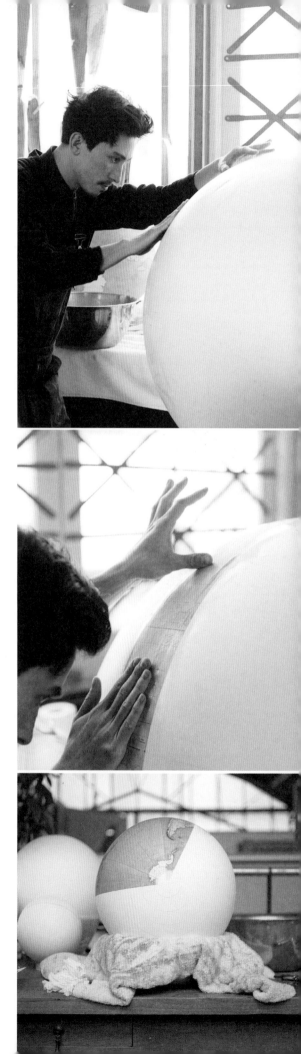

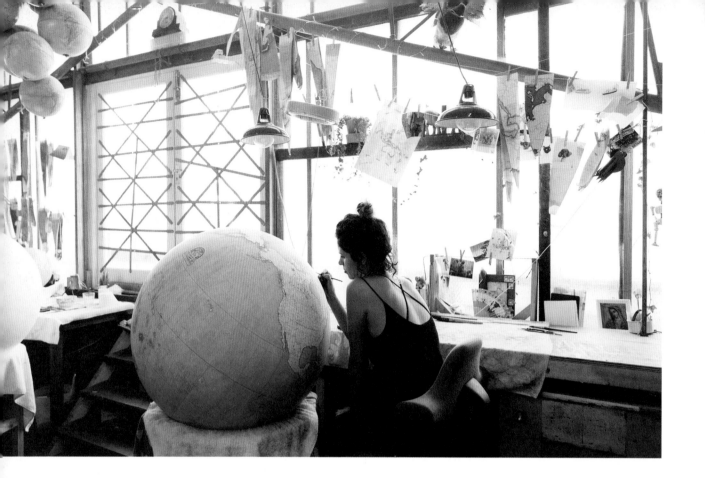

After the gores are applied, the illustrators and painters apply many more layers of watercolor and add details before the globe is sealed with either a gloss or matte finish.

The illustrator and painters of Bellerby & Co. are closely involved with planning the globe design with the client. Before they start on the actual globe, the artists have the chance to add design concepts to the cartographer's digital mock-up of the map, which is then sent for the client to review and approve. While some clients will prefer to keep their globe simple, based on something they saw online, many clients seize the opportunity to personalize the design with family history or reminders of their travels and adventures. The custom globes have even attracted Hollywood's attention: Two globes were commissioned by Martin Scorsese for his 2011 film *Hugo*.

of bespoke cartography. For example, they might mimic the irregularities of metal typesetting by adjusting the placement of individual letters for each word on the globe labels.

With every globe comes unique requirements, says Bellerby. "I am always learning new things myself, and we all still have challenges to overcome each day." That means that in the studio, no day is the same. Projects are varied, and the globes are all at different stages. While some are being molded, others are in drying or resting periods. In other areas of the studio, globes are in the goring phase—the application of soaked strips of paper map, called gores, to the globe's surface. Other globes are coming to life through painting, and near-complete globes just need to be sealed. Bellerby's artists and craftspeople understand the careful balance among all the pieces of the process, and they each plan their work to set up the next artist as well as possible. "As cheesy as it sounds," says Bellerby, "they need to put their heart into everything they do."

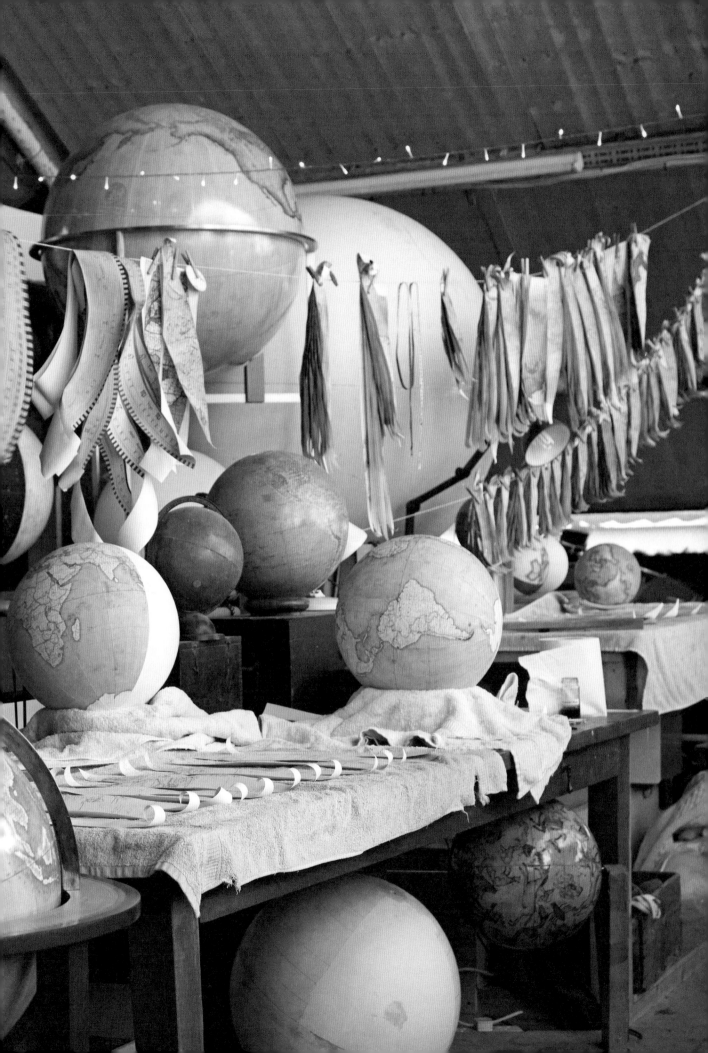

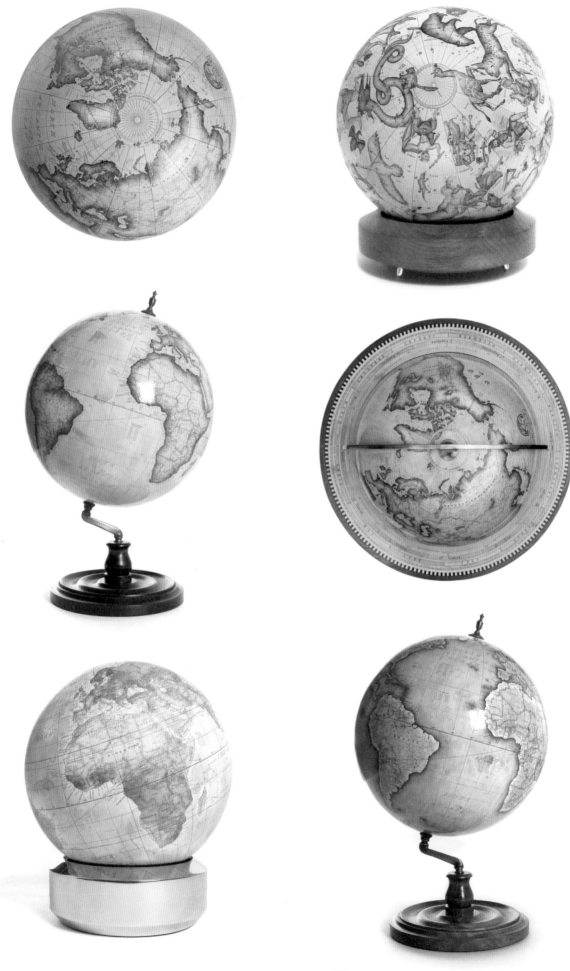

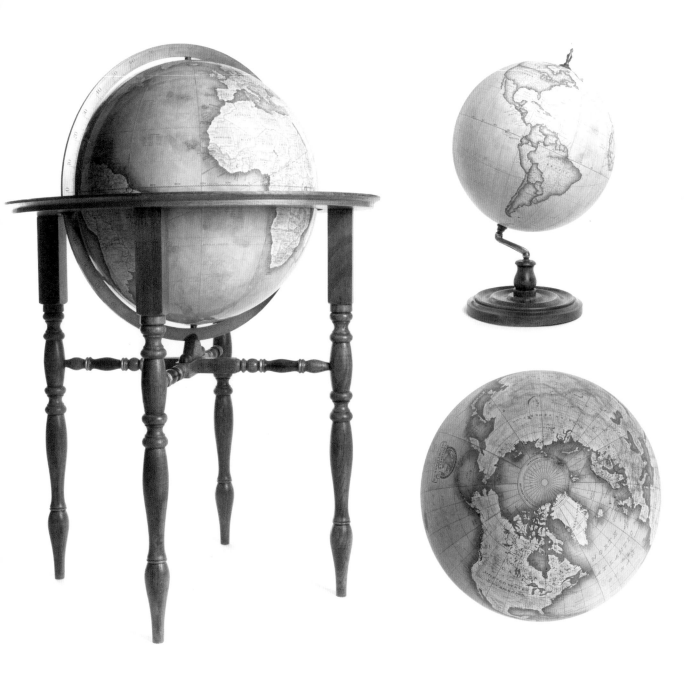

From when a client begins consulting to when they receive their custom globe can take anywhere from six months to a full year, depending on the complexity of the project.

In addition to the impeccable quality of Bellerby & Co. globes, it is this thoughtful effort put into every client's unique design that makes Bellerby confident their globes will last a century (or more). And, best of all, that their globes will become heirlooms for families to pass down for generations.

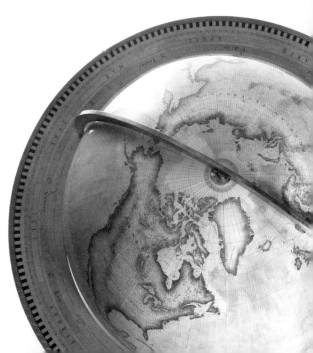

The Bookmender

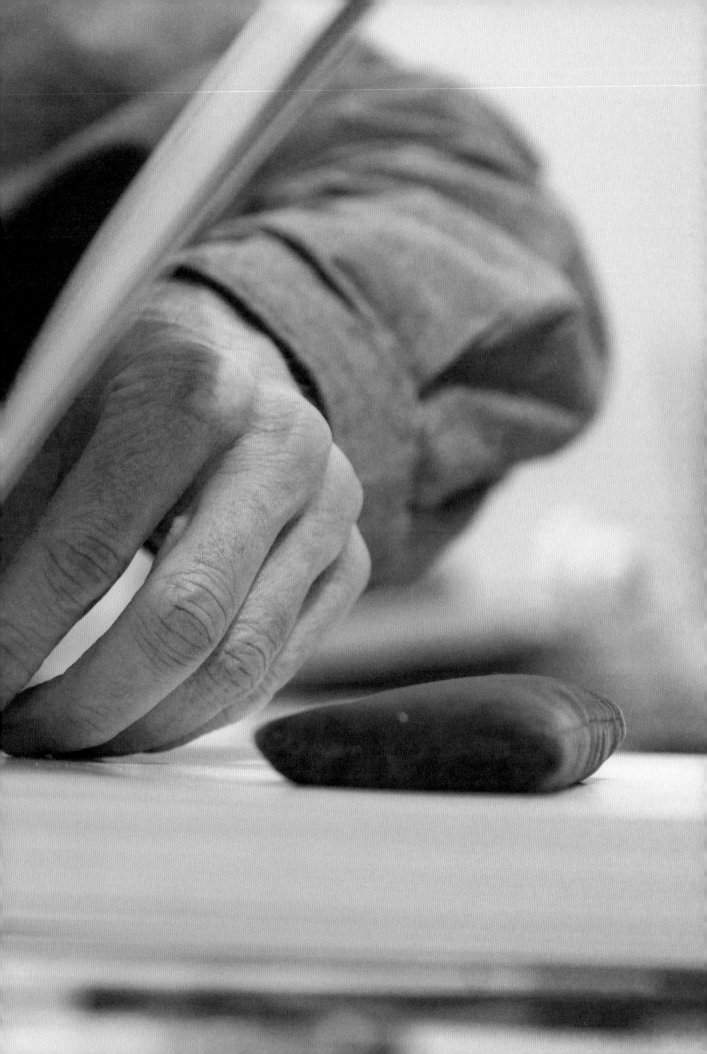

DONALD VASS,
KING COUNTY LIBRARY SYSTEMS
ISSAQUAH, WASHINGTON, USA

There are romantic booklovers and carnal booklovers. The former are tender and careful with books they handle and read, keeping them clean and pristine. Carnal lovers are the readers whose love translates to broken bindings, dog-eared corners, annotations, doodles, and underlining—behavior that would mortify their counterparts. "Here at King County Library Systems (KCLS), we're the romantic kind," says bookmender Donald Vass, who with great care and skill treats the cracked spines, restores the missing covers, mends the torn pages, and cures other ills that might befall printed matter.

The KCLS Service Center is about twenty minutes east of Seattle, in a quiet town at the base of evergreen-covered Tiger Mountain. The Service Center processes both the new and the circulating books from libraries all over the region, sorts them according to need, and also pulls any damaged titles for evaluation. Some are taken out of commission immediately (recycled or donated to charity), but others pass the tight criteria required to go to Vass's small team in the Mendery. Often these are old editions, rare titles, or formats that are more expensive to repurchase, like oversize art books.

In the small Mendery (or "book hospital"), books are in various stages of repair. Some are getting resewn, others are held securely beneath standing presses to ensure glue dries firmly and evenly. Some are squeezed in a finishing press, which holds the textblock (the folded edges of several sections of sewn pages, which form the spine) facing up for removing

In the Mendery at the KCLS Service Center, books need to be salvaged and resewn, reglued, or completely recased; covers need to be reaffixed; and tears must be mended. Every day, Vass moves between projects mostly by feel, checking progress frequently, and letting the books take the time they need. Patience and time are virtues in the meditative, slow process of bringing a book back to health and back into circulation.

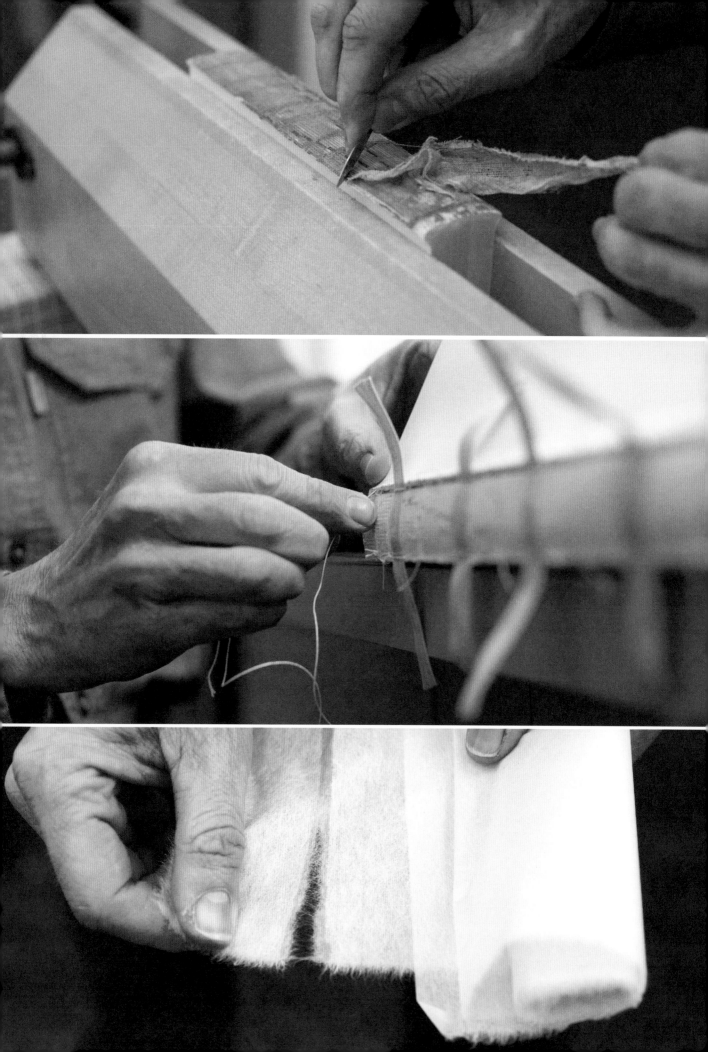

old glue and cloth or paper linings. In other corners, new book cases are drying—that is, the freshly cut book boards pasted to colored fabric, which will be reattached to the waiting textblock as the final step.

Vass will spend meticulous time assessing and planning the best mending methods for each book: The treatment that will be the least invasive and the most archival (not damaging to the books in the long-term), and that will yield the strongest repair. Frequent types of book patients include oversize hardcovers with heavy paper stock, like photography and art books. Vass explains that there is often inherent stress in the construction of large books, as their weight and size can act against too weak a binding. He'll often reinforce the spines with sewing tapes sewn on with a stronger thread and use a stitching pattern that creates a stronger attachment at the spine. A recently published photography book on animals of the world already needed fresh stitching at the spine, Vass's assistant said, because the weak attachment of the binding to the textblock was at odds with the size of the book. Their work would relieve that stress and give the book many more years of life.

Old leather-bound or cloth-covered tomes are also frequent visitors. Even though many tend to be for in-library use only, their fragile forms still need frequent TLC due to their age. Vass often uses Japanese paper to mimic the look of leather where it has decayed, or to mend a tear in a deckled-edge page. The fibrous texture of the Kozo paper can melt into the old page with little evidence. If more protection is still needed, he might craft a special archival case to enclose the whole book.

A surprisingly large number of language-learning books, Bibles, and children's books undergo the stress of frequent (and none-too-gentle) use by library patrons, and are all stacked in Vass's queue, ready to have their ills diagnosed. Vass estimates that an average of 80 to 100 repaired books are sent from the Mendery back to the shelves every month, ready for the next reader.

"There are book binderies all over the world, both small studios and commercial binderies," says Vass, who has been mending books for the KCLS for nearly thirty years. He explains how bigger academic libraries and other major institutions employ or go to specialized menders to preserve and maintain their important books or unique collections. Those larger institutions also have access to more cutting edge book repair and conservation technology, and with their larger teams, they can conserve on a greater scale. For example, conservators at the nearby University of Washington Libraries' preservation services can use technology like microscopy to treat and repair some ten thousand books

Vass can reinforce a spine using book linen sewing tapes, then attaching new cloth-covered boards to the original textblock. The salvaged spine can be strengthened by gluing a Japanese paper lining onto it with wheat paste. Other books will receive whole new cases, cover boards included, that will ensure longer life spans, and better withstand the stress of repeated opening and closing. In other cases, the sections need to be sewn together again, and stronger bands of linen are sewn across the spine to strengthen its hold to the textblock when it is affixed to a new or repaired case.

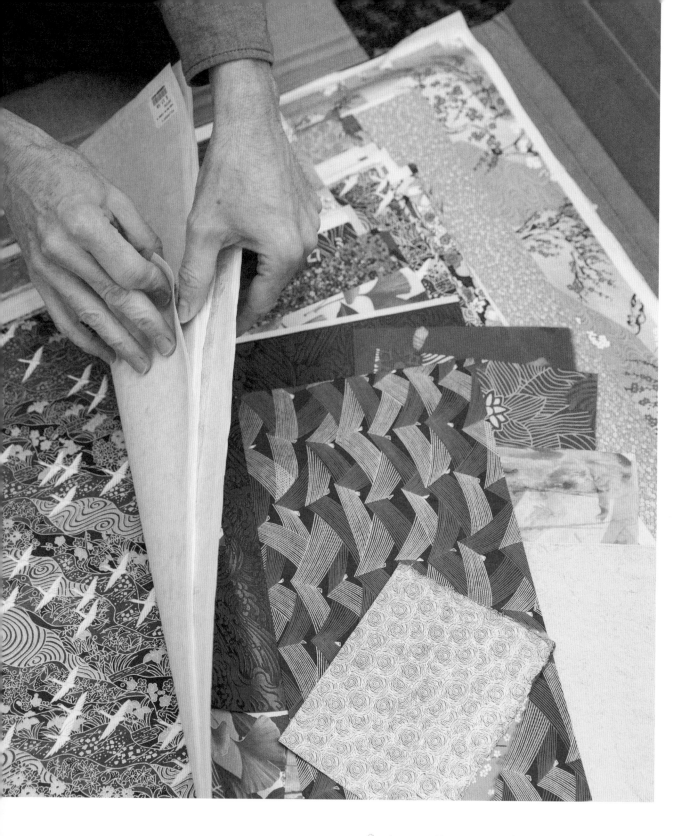

Japanese Kozo paper is a favorite tool for Vass's work—
the flexibility and strength helps ensure the longevity
of a repair, and the fibrous and soft texture means
that, when applied with wheat paste, the paper melts
into the intended torn or frayed surface. Vass keeps
swatches of colors and patterns to ensure they can
always match the right color for each project.

and documents every year. But specialized conservation repair by hand is not commonplace in public libraries, and this is the truly unique part of Vass's work in service to the local Seattle area library system.

But the program is just on the edge of disappearing. At one point, his department dwindled from ten to six to a team of one, and in the years since, he has worried that the program will dissolve with his retirement. His fears are quelled by his part-time assistant and understudy, who shares his great passion for the work they do.

Vass considers it his special privilege to use the book-mending arts to save books rather than discard them. Library copies become imbued, he thinks, with the experiences and the love of the libraries' patrons, for whom the library can mean access to a world of knowledge, art, and more. "There is something alchemical about holding a book in your hand and reading from its pages," he adds, "and that can't be replicated."

A huge century-old cast-iron board cutter takes center stage in the space. It's an amazing estate-sale find that had been in bad shape after its life cutting cardboard for candy boxes and had then languished in a barn for decades.

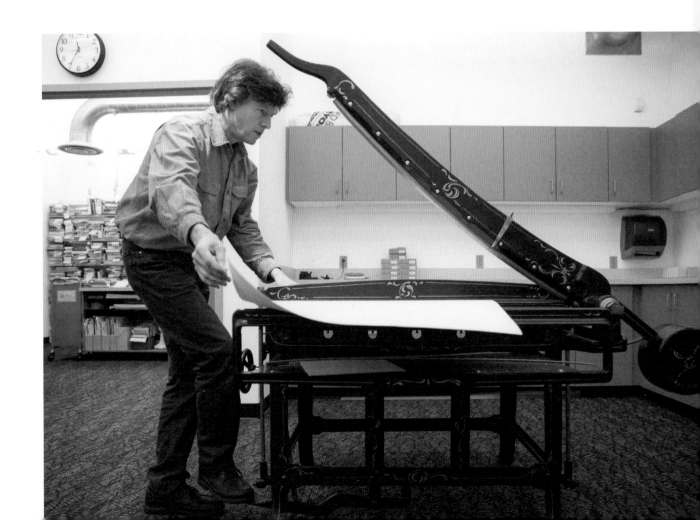

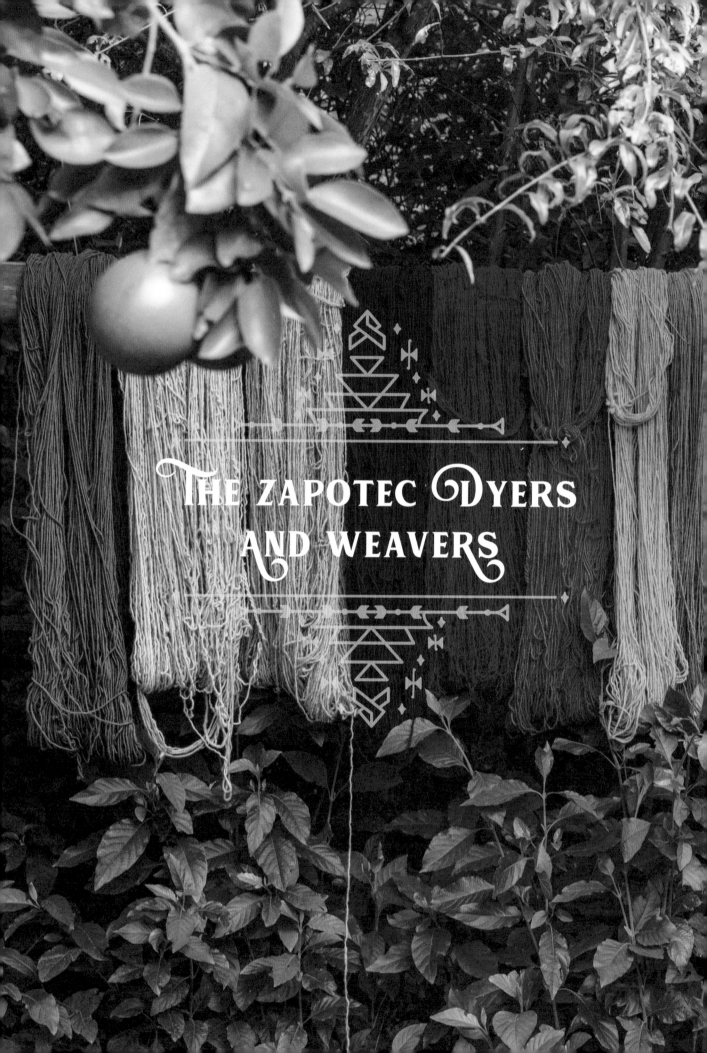

The zapotec Dyers and weavers

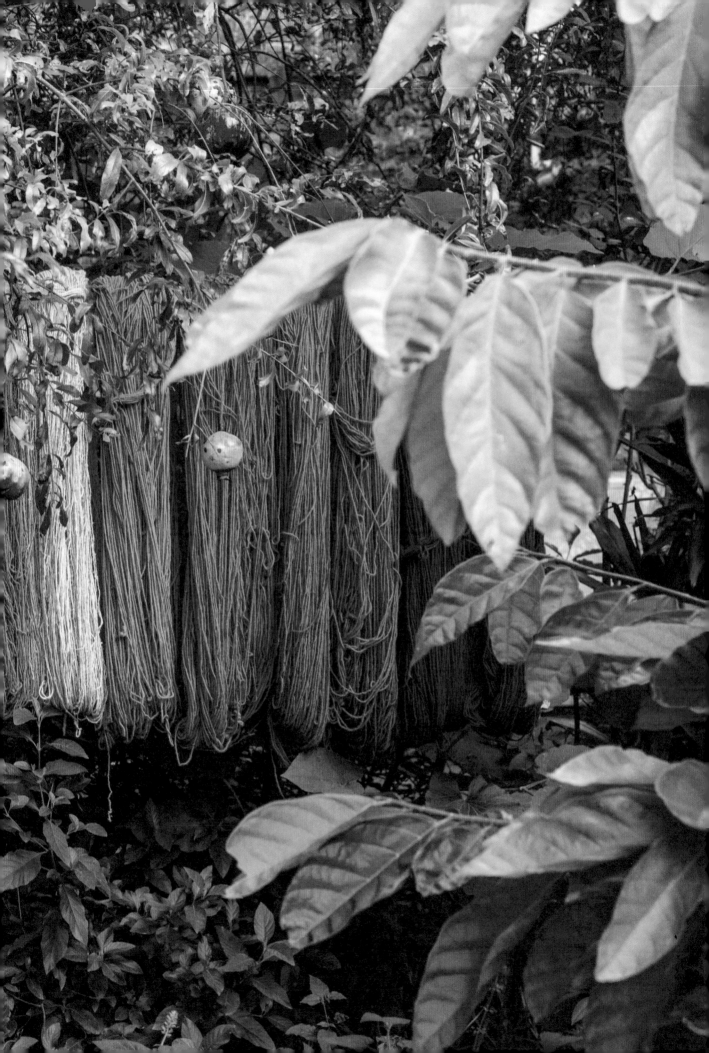

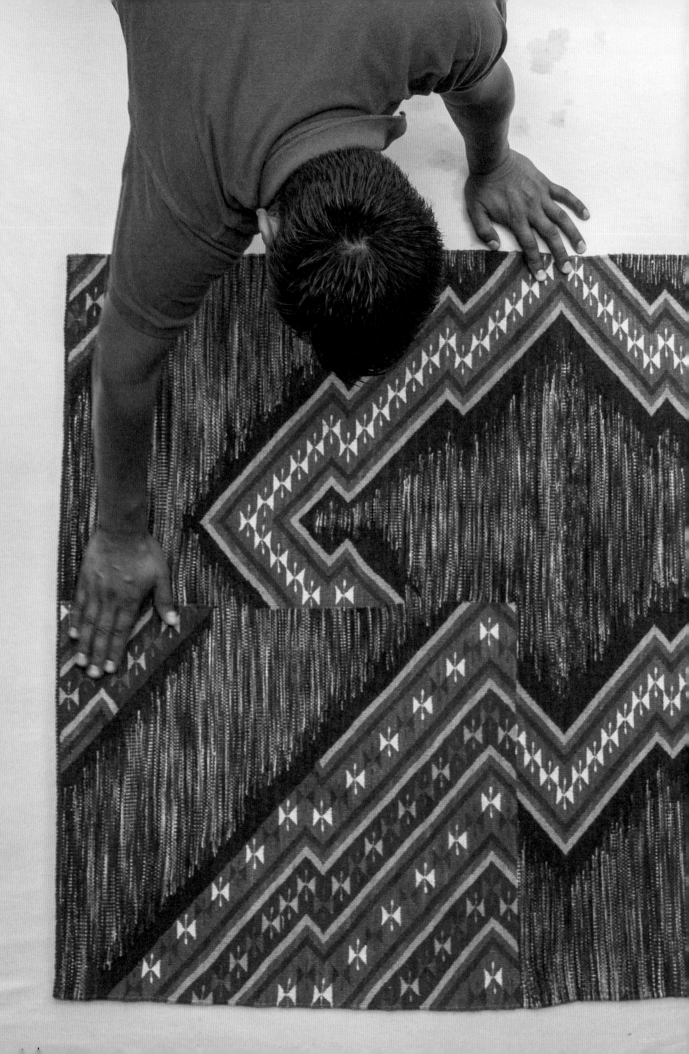

PORFIRIO GUTIÉRREZ,
PORFIRIO GUTIÉRREZ Y FAMILIA STUDIO
TEOTITLÁN DEL VALLE, OAXACA, MEXICO

The village of Teotitlán del Valle—meaning "the place of the gods," in Nahuatl—is nestled at the foothills of the Sierra Juárez mountains, about thirty miles east from Oaxaca City. The village has been home to generations of indigenous Zapotec weavers and textile makers for longer than living memory—it's an ancient homeland. "I can only imagine what's under the soil," says artist and weaver Porfirio Gutiérrez of his ancestral home, where he and his family still live today. "It's a community on the original land; I live with my ancestors."

Gutiérrez was born into a weaving tradition that can be traced back twenty-five hundred years. Pre-Columbian Zapotec weavers used plant fibers for their yarns and traditional backstrap looms (a type of simple, portable loom), and they knew the secrets of local plants and cochineal beetles that would yield colorful dyes for their textiles. The arrival of the Spanish in the fourteenth century introduced larger four-pedal upright looms, as well as the churro sheep, whose soft wool became the preferred medium for yarn today. Through it all, the weaving tradition has remained hereditary in a village comprised of artisans—as many as two thousand looms are used by the dozens of weaver families, which

Zapotec weaver Porfirio Gutiérrez has found the most inspiration in the ancient patterns and designs of his ancestors, seen in the ancient ruins of nearby Mitla, which date to 500 B.C.E. "Even early on," he says, "I began to have a deep understanding of identity, and the importance of my culture." Gutiérrez often uses symbols for corn, beans, and squash—the sacred seeds that sustained the lives of his ancestors and continue to give life to his people today. Elders would talk frequently of the consequences and joys of getting enough rain, and the quality of the growing season needed to yield a good crop. "We have much gratitude today for those ancestors who domesticated corn thousands of years ago," says Gutiérrez, explaining how his father still places corn on the altar as a thank you to the gods.

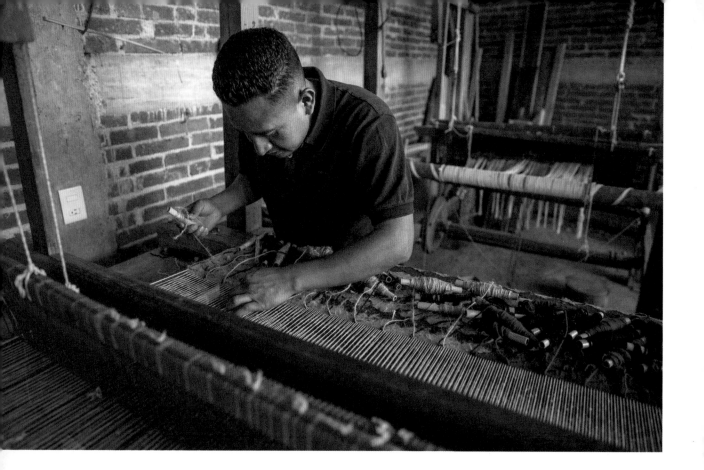

In his earliest memories of being involved in the family business, Gutiérrez recalls waking up early for the pilgrimages into the hills above the village to collect plants needed to make dyes. "My parents would tell the stories: the plant names, the collecting seasons, and how different colors result according to the amount of sun or rain, or by where the plants have chosen to grow." Pomegranate, tarragon, pecan leaves, cochineal beetle, tree moss and lichen, indigo, *muítle* (an orange-flowered evergreen shrub), and *sapote negro* (a local fruit in the persimmon family) are the main ingredients that produce the Zapotec color palette.

form well over three quarters of the total population, Gutiérrez estimates.

"The knowledge is passed down through stories, by oral history," he says. "There is no other method than to learn from those who know the old ways." As a child, he first learned to wind yarn on bobbins and helped groom the wool for spinning yarn. He recalls playing under the looms and watching as designs emerged under the skilled hands of his father and other family members. When he turned twelve, his father taught him how to weave and use the loom, and one of the first finished projects he remembers making was his own bag to take to school. Early on, Gutiérrez was hooked by the creative freedom that comes with crafting your own designs and patterns, while also incorporating traditional designs like *caracol* ("the snail") and *ojo de dios* ("God's eye").

Gutiérrez still delights in the freedom of designing patterns. He has also begun incorporating the pre-Columbian plant fibers to more closely represent the

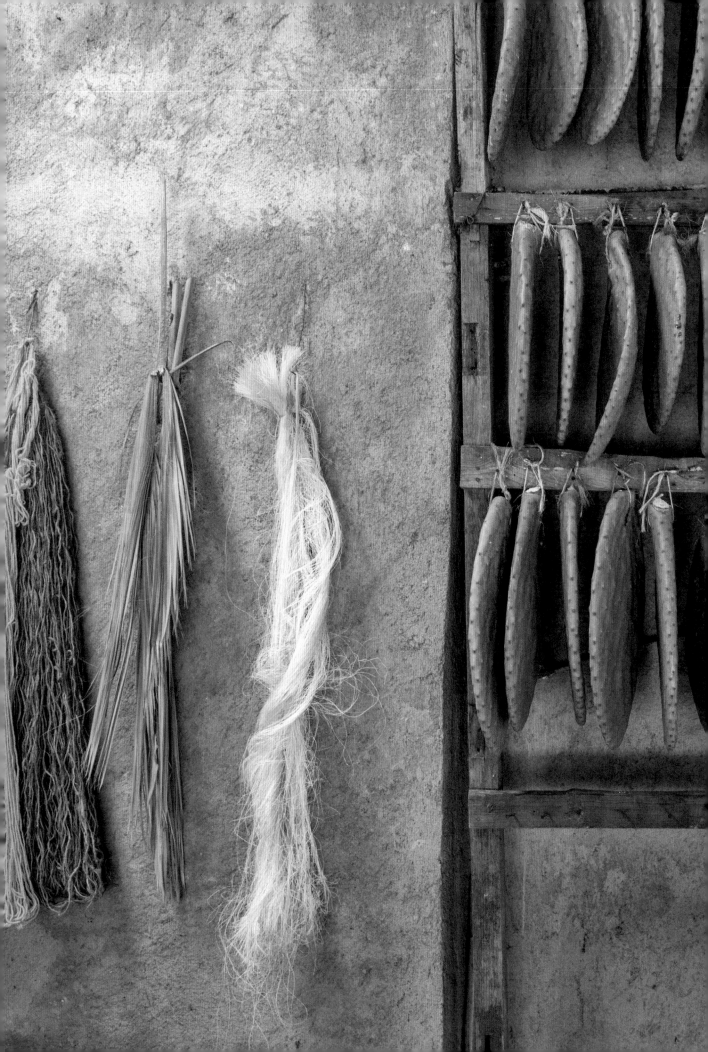

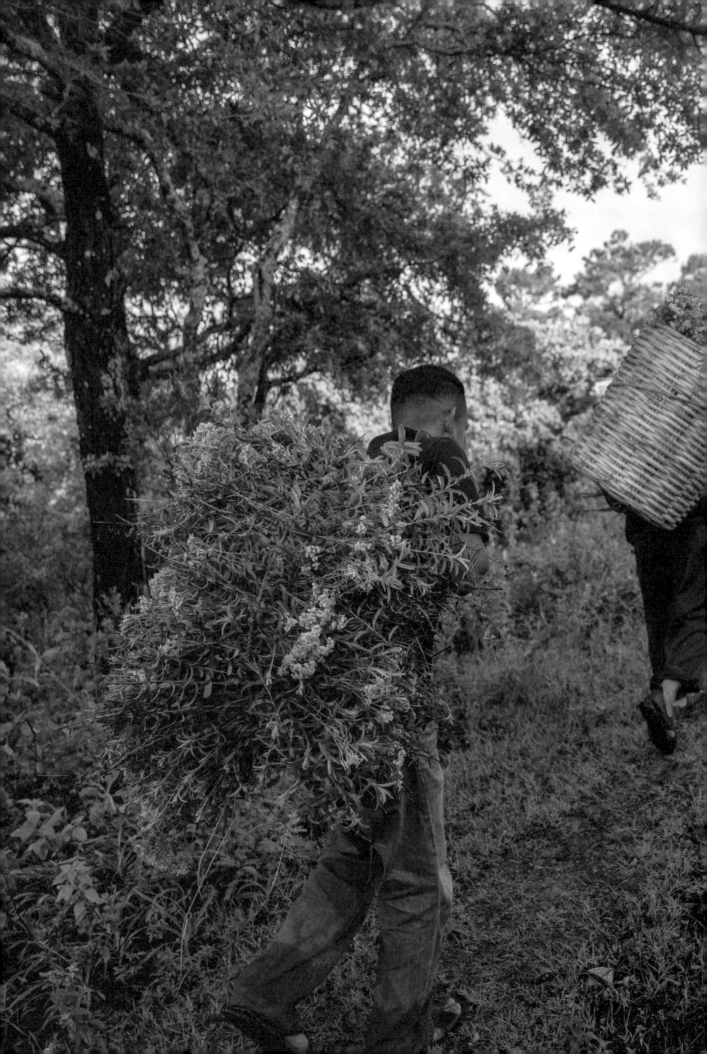

work of his ancestors. The coarser, thicker, tougher fibers present a difficult challenge to weaving, but it's a challenge he embraces, and gradually his understanding of them has grown. "The blessing is greater working with those plant materials. I come to work understanding that I'm not imposing on nature, but working in harmony. We never try to impose. We welcome the challenges. The story of our weaving is also a story about the materials."

The majority of the plant materials his family uses for weaving and in dyes are wild rather than domesticated. Some grow naturally in the family's garden, while others—like the marigold and tree moss that produce rich saffron and pale-yellow dyes—are collected on foraging trips up in the hills. The cochineal beetle is the source of vivid carmine red, and a nearby village specializes in cultivating the insects on prickly pear cacti. Another village grows *añil* (also known as Guatemalan indigo, or small-leafed indigo) and processes the deep indigo dye, a particularly time-consuming hue to create. Still another neighboring town raises and farms the churro sheep whose wool the weavers of Teotitlán use in their blankets and rugs. "Communities in Oaxaca have always come together with their specialties to trade," explains Gutiérrez.

But Gutiérrez's family is one of only a few families in the village who use natural, traditional materials for their dyes, since the affordability and variety of colors offered by synthetic dyes (first introduced in 1850s) has nearly driven the knowledge into the past. Gutiérrez, returning home after a decade of living in the United States, was devastated by the pervasiveness of the often-toxic synthetic dyes and encouraged his family to revive the old practice for its beauty and its sustainability. He established their family studio and has dedicated his time to educating and raising awareness of the Zapotec ancestral traditions. Today, the number of

families using traditional all-natural dyes is estimated to be less than 5 percent of all the weaving families in the village. Gutiérrez knows that the art is still on the verge of disappearing.

Today, Gutiérrez is dedicated to passing the traditions on to new generations of weavers in his community who wouldn't otherwise have the chance to learn the ancient Zapotec techniques. As a result of his work, in 2017, he was awarded by the Smithsonian's Artist Leadership Program at the National Museum of the American Indian. He frequently travels to exhibit his work and to give lectures and demonstrations on the Zapotec world of color, at events like the International Folk Art Festival in Santa Fe, New Mexico, and at major institutions like Harvard, whose Forbes Pigment collection has archived samples of the Zapotec pigments for study and preservation.

"Our work is a process of honesty and integrity, using traditional methods that are natural and sustainable," says Gutiérrez. Their goal is to make their work not the exception, but the standard.

Gutiérrez's sister Juana is the family's master dyer. Her understanding of the indigenous plants and the dye processes is that of an experienced chemist—she is able to alter and adjust each stage to achieve a perfect hue, or for highly accurate color matching.

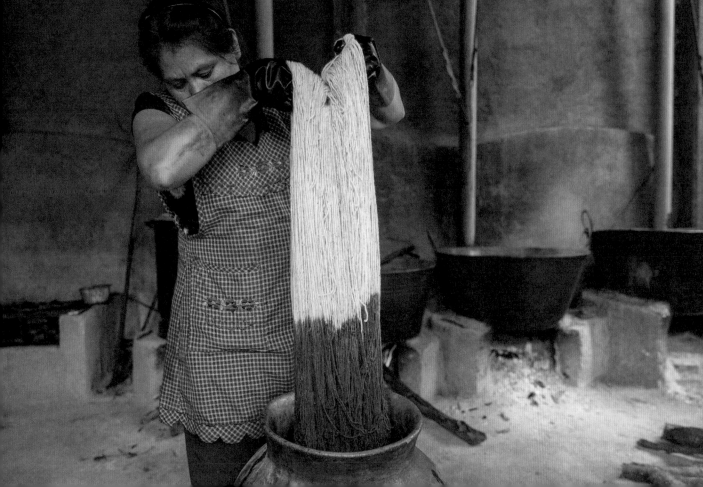

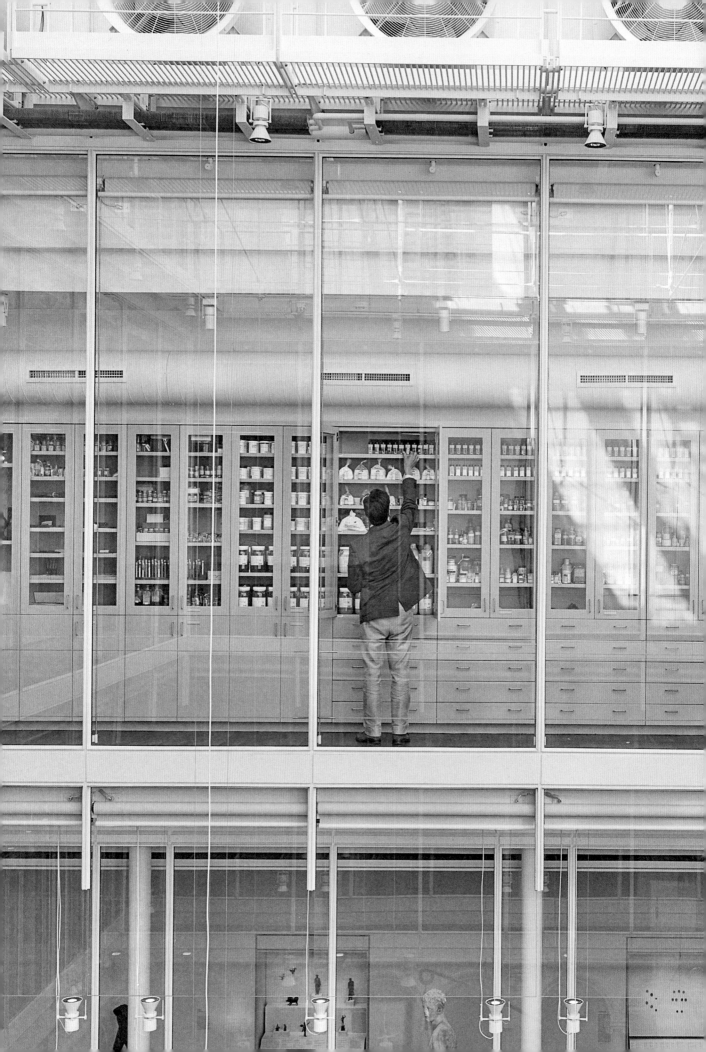

A Tour of
HARVARD'S FORBES PIGMENT COLLECTION

By Narayan Khandekar, director of the Straus Center for Conservation and
Technical Studies and curator for the Forbes Pigment Collection

On the fourth floor of the Harvard Art Museums is a collection of some twenty-five
hundred pigments. It was instigated in the early twentieth century by the museums'
second and transformational director, Edward W. Forbes. Forbes set about to change
the practice of museology by introducing increased levels of accountability, transpar-
ency, and integrity to students passing through the Museum Course at the Fogg Art
Museum, his laboratory for art. Part of his revolution was to understand the materi-
als and techniques used by artists, so that he could determine how a work of art was
made; how it has changed over time; what is original; what is a later addition; and,
sometimes, what is a forgery. The pigments (and an equally impressive collection of
binding media and varnishes) were brought together as standards to positively identify
pigments from a work of art.

Ninety years later the library is still being used for the same purpose, and as
new pigments or gaps are found, they become incorporated into the collection. A number
of pigments have unusual origins, which show the length to which people will go
in order to find an exact color.

Tyrian purple, according to legend, was discovered by Herakles's dog getting a purple
snout from eating mollusks on the beach. In fact, it comes from the murex mollusk,
and twelve thousand are needed to make 1.4 grams of pigment. It was used on Roman
senators' robes and on imperial garments, representing prestige and social status, until
mauve was synthesized by William Henry Perkin in 1856. I have only found Tyrian
purple once on a painting, a late thirteenth century Madonna and Child in the J. Paul
Getty Museum by the Master of St. Cecilia, indicating just how rare it is as a pigment.

The semiprecious stone lapis lazuli, from which genuine ultramarine is prepared,
was only available from a quarry in Northeast Afghanistan and had to be transported
down from mountains, over land, then to Europe by sea (ultramarine means "from

Harvard University is home to an incredible collec-
tion of color: Arranged by the color spectrum in a
vibrant technicolor array, the bottles, tubes, and
glass containers hold at least twenty-five hundred
pigment samples from around the world and
throughout history. Dr. Narayan Khandekar, director
of the Straus Center for Conservation and Technical
Studies and senior conservation scientist, curates
the Forbes Pigment Collection as well as the
Gettens Collection of Binding Media and Varnishes.

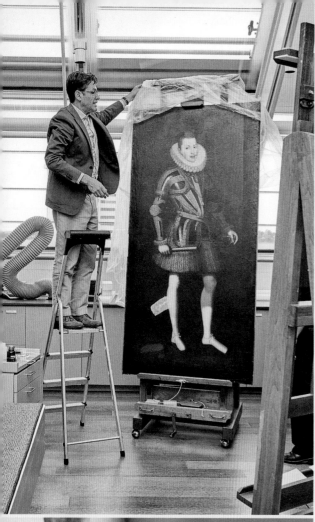

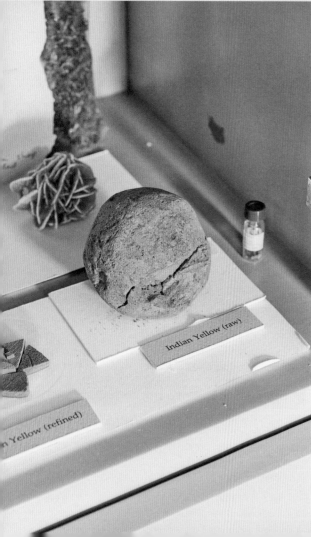

Indian Yellow (raw)

n Yellow (refined)

beyond the sea"), making it a very beautiful and rare commodity costing as much as gold, until a synthetic version, French ultramarine, was developed in 1826.

Recently, we were able to confirm the use of black (manganese dioxide, from inside dry cell batteries) by Aboriginal artists from Groote Eylandt, an island in Australia, in the 1940s. There have been written accounts, but this was the first physical evidence of the practice. It is made all the more compelling when one considers that Groote Eylandt is a significant source of naturally occurring manganese dioxide ores, which the artists used as well as preparing a glittery charcoal black, revealing that a nuanced understanding of black was an important part of their artistic practice.

Mummy brown is made from the resinous material applied to the wrappings of Egyptian mummies. Although studied as a material, it is yet to be identified on a work of art, and disappeared with the ever scarcer supply of mummies in the early twentieth century.

Another pigment that disappeared in the early twentieth century is Indian Yellow, made from the dried urine of cows fed only on mango leaves. It was widely used in Indian painting and starts appearing in the palette of British artists such as J. M. W. Turner and Thomas Gainsborough in the eighteenth and nineteenth centuries. We found it in a painting by the French artist Georges Seurat in our own collection (*A Vase of Flowers* 1974.100) from 1879 to 1881.

These stories reveal more than just the origin of the pigment. They also let us know the range of dates that a pigment is used.

Prussian blue was the first synthetic pigment, with a documented introduction date of 1704. The improvement in chemistry with the Industrial Revolution allowed for a rainbow of pigments to be introduced through the nineteenth century—e.g., French ultramarine (1826), cobalt blue (1802), chrome yellow (beginning of the nineteenth century), cadmium yellow (discovered in 1817, and introduced as a pigment in the 1840s), the poisonous emerald green (discovered in 1800 and commercially produced from 1814), viridian (1838), and cadmium red (patented in 1892, and used as a pigment from 1907).

Pigments that were once prevalent fall out of use and become forgotten, only to be rediscovered centuries later. The primrose or canary colored lead-tin yellow was widely used from about 1300 up until the 1730s, when it mysteriously fell from use, said to have been replaced by Naples yellow, and was only rediscovered by Richard Jacobi in Munich in the 1940s. Lead tin antimony yellow is a by-product of the glass industry, reportedly from a 1523 recipe in Murano, Italy. It was used by sixteenth

and seventeenth century artists such as Raphael, Orazio Gentileschi, Nicholas Poussin, Diego Velasquez, and Giovanni Battista Salvi da Sassoferrato. Its rediscovery was reported in 1998 by Ashok Roy and Barbara Berrie. Other examples of rediscovered pigments are metallic bismuth, which gives a grayish color, and the blue mineral vivianite (hydrated iron phosphate, rediscovered by Marika Spring in 2001), which often forms around fossilizing bones (calcium phosphate).

In addition, there are pigments that are detected, spectra collected, but for which there are no standards. Two recent examples of this are an orange pigment in the Harley Davidson Hi Fi Purple paint on a 1965 Donald Judd sculpture, and two of the red pigments in *Pewter Pot and Plate of Fruit* (1944) by Georges Braque. Researchers are working on synthesizing historical azo pigments—those that were manufactured in the late nineteenth century to the mid-twentieth century but are no longer available. As this work advances, it may clear up some of these documented but unidentified pigments in our files.

As new pigments become available, they are added to the collection. Recent additions are Vantablack (the blackest black), YInMn blue (the inspiration for Crayola's newest hue, Bluetiful), Singularity black (an alternative to Vantablack avoiding any licensing issues with Anish Kapoor), and new products made by pigment producers like Sun Chemicals—e.g., Palomar Blue 60 and Quindo Violet 55.

The aim of the collection is to maintain a current library for our own research, to share information with the public and students, and to keep future generations aware of pigments both old and new.

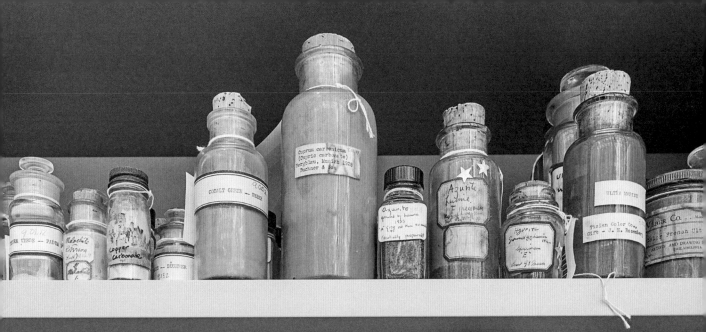

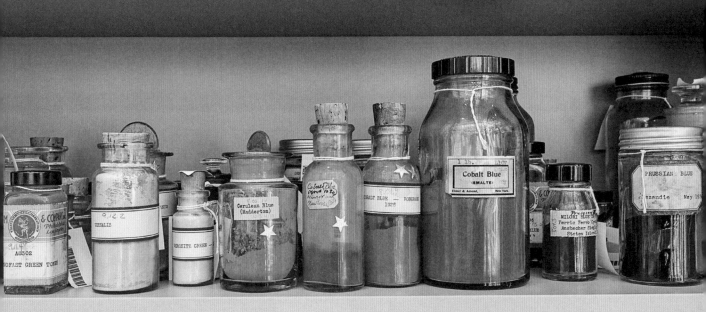

THE CASTER

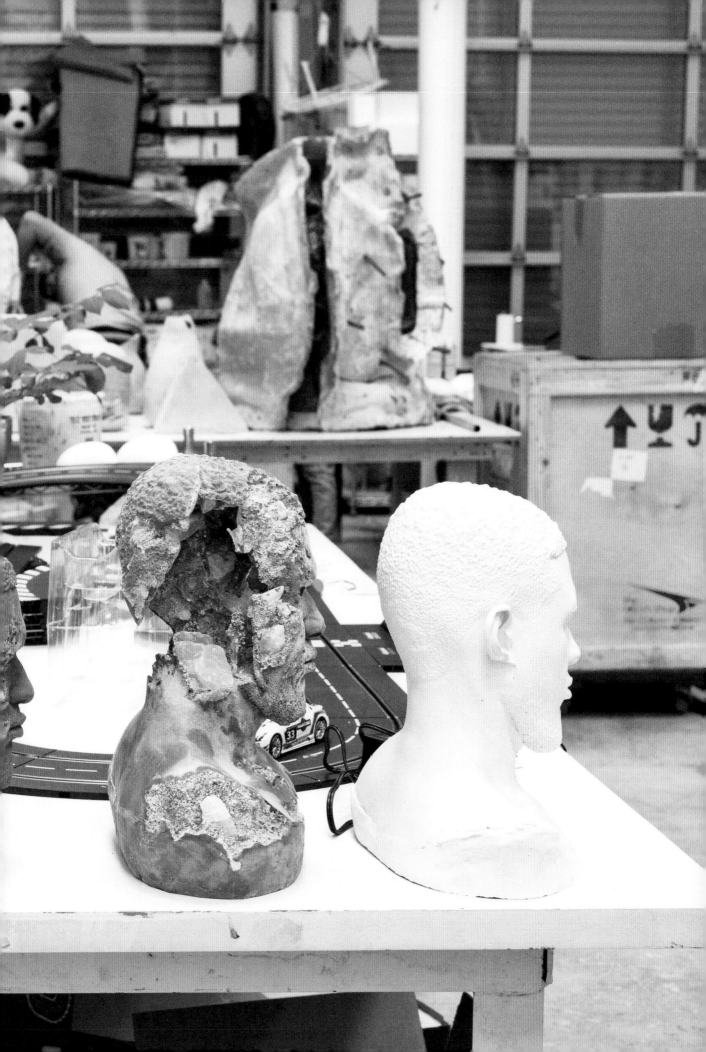

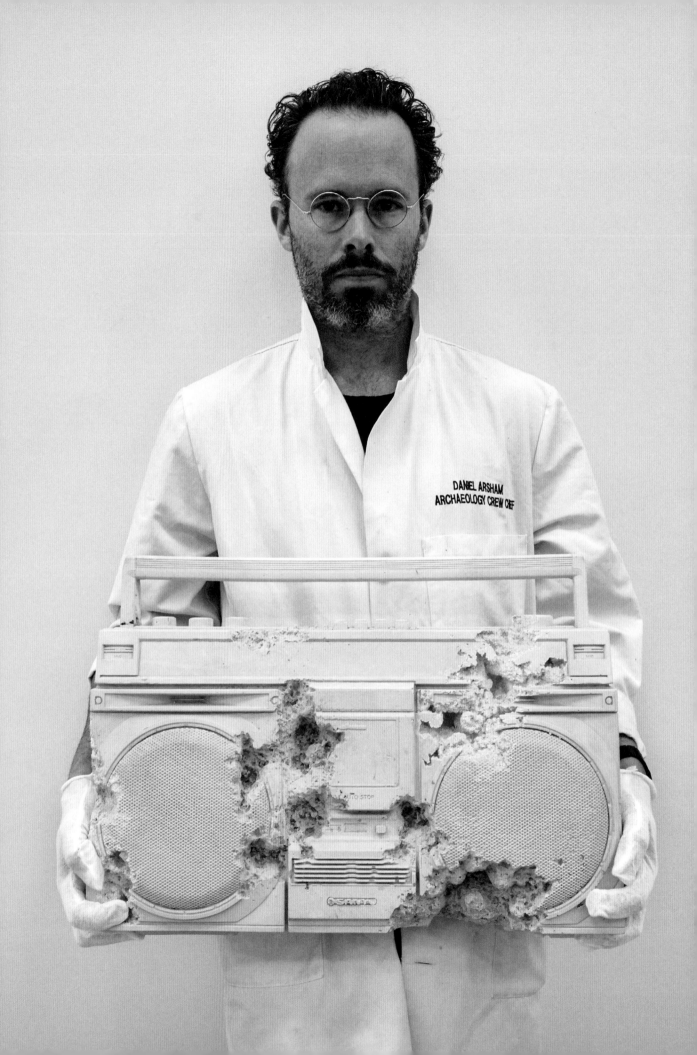

DANIEL ARSHAM,
SNARKITECTURE AND DANIEL ARSHAM STUDIO
NEW YORK CITY, NEW YORK, USA

For sculptor and artist Daniel Arsham, the future is in constant conversation with the past. In his *Future Relics* series, basketballs, athletic jackets, Goodyear tires, Pentax cameras, stereos, and other everyday objects become eroded, cracked, and eerie artifacts, cast objects that gleam in pale quartz, bright pigments, deep obsidian, and slate hues. Through his innovative architecture studio, Snarkitecture, Arsham stretches and rumples wall surfaces as if they were made of fabric. Hands reach through the veil toward visitors; ceilings are filled with hundreds of identical shoes. Arsham's high-profile collaborations with Pharrell, Adidas, streetwear brands, and more have earned him an iconic level of reverence in the contemporary art world.

Integral to Arsham's work is the masterful use of the Old-World technique of casting, which he explores and pushes the limits of by casting in unconventional media and by casting objects that present challenges to the traditional process. He often uses ash, crushed glass, quartz, selenite, or other gleaming or crystalline minerals in place of plaster or bronze, replicating items that are traditionally difficult to cast, like fabric and finely detailed technology, to uncanny effect.

After studying architecture at the Cooper Union School in New York, where he explored diverse media and traditional techniques (including casting processes), Arsham

Keeping alive the Old-World technique of casting, artist Daniel Arsham continually reenvisions what it can do. Objects from Arsham's own past and present seem to be salvaged from a future archaeological site; familiar objects from the everyday and nostalgic items from Arsham's childhood are turned into artifacts of a lost past.

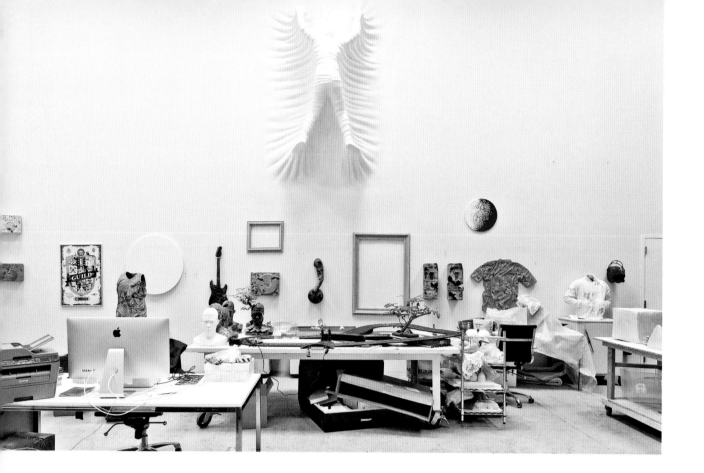

In Arsham's studio, the basic process wouldn't look very different to casting artisans of the past. His master mold-maker works with the selected objects, first prepping them with clay to seal areas where the silicon (used for Arsham's mother molds) shouldn't go, or to build up areas of flat detail that the poured mold wouldn't be able to capture. The mother mold is split in half for easier removal later, and the substrate for casting (perhaps ash, or fine selenite) is poured into the cavity between the remarried halves.

initially decided to pursue painting. In 2009, he was visiting Easter Island to paint its cities and towns and the still-mysterious Moai monuments. While there, he was struck by the activity of the archaeologists, who were mainly re-excavating the presence of previous generations of archaeologists—everyday objects from just decades past were pulled from the earth, collected, and recorded as carefully as ancient artifacts.

This experience gave Arsham the idea of reverse-engineering archaeology, turning everyday objects into artifacts. Casting, an Old-World process, was a natural choice for transmutation—like fossilization in hyperspeed—and the use of volcanic ash and other lithic-based materials enhanced the aged effect, aesthetically echoing the idealist sculptures of antiquity, or the preserved remains of Pompeii.

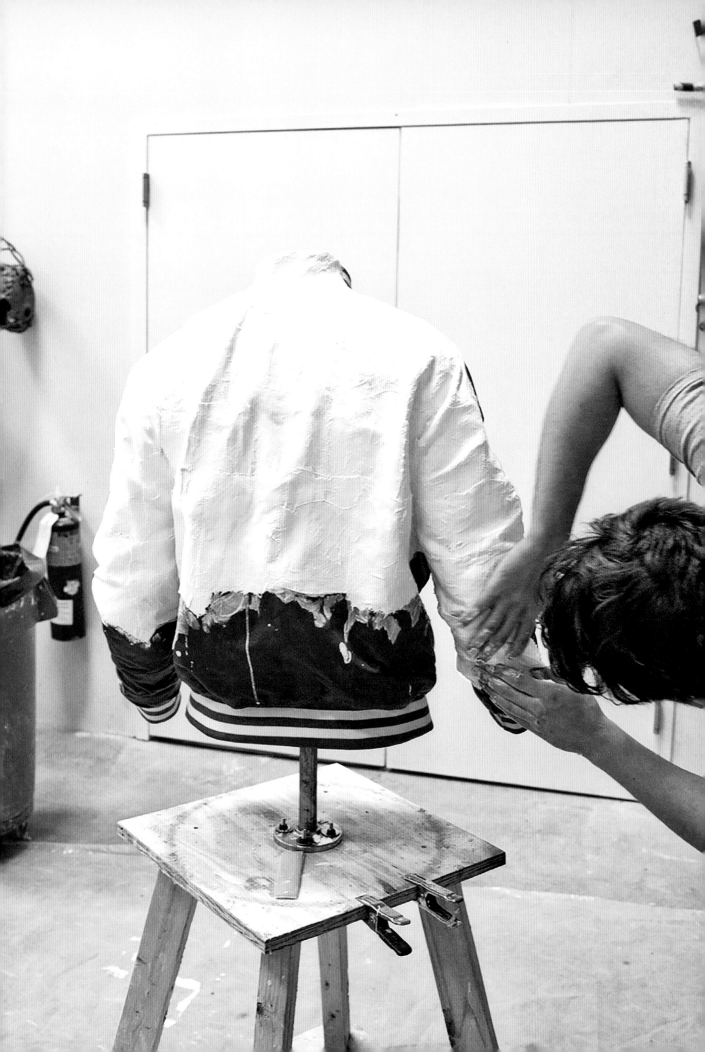

The casting tradition stretches back as far as the Shang dynasty in China and the Assyrian kingdom. It spread across continents and developed through the centuries to the large-scale commercial and industrial casting used today around the world.

"The process is still very traditional," Arsham says, but he notes how the upgrade from plaster or wax mother molds (or, further back in time, clay or sand molds) to silicone today captures the detail of the original objects with amazing clarity and with a greater truthfulness. Arsham and his studio have a masterful understanding of the behavior of the media they use. They guide what were once chaotic effects, like erosion or breakage, to occur intentionally—perhaps to expose the raw, geologic interior of an antiquity-inspired bust and emphasize its crystalline medium, or to crack along the edge of an otherwise perfect camera.

Arsham has created, written, and directed a multipart short film series, culminating in the release of a trailer for a feature-length film starring Juliette Lewis and Mahershala Ali—to be released in 2089. According to Arsham, the film takes the body of work he's built over the years, that replicates objects from the present as if they were uncovered on some future archeological site, and sets them in a narrative. "These objects create breaks in time and they expand and collapse it by bringing us outside of our current moment."

THE ANTIQUARIAN HOROLOGIST

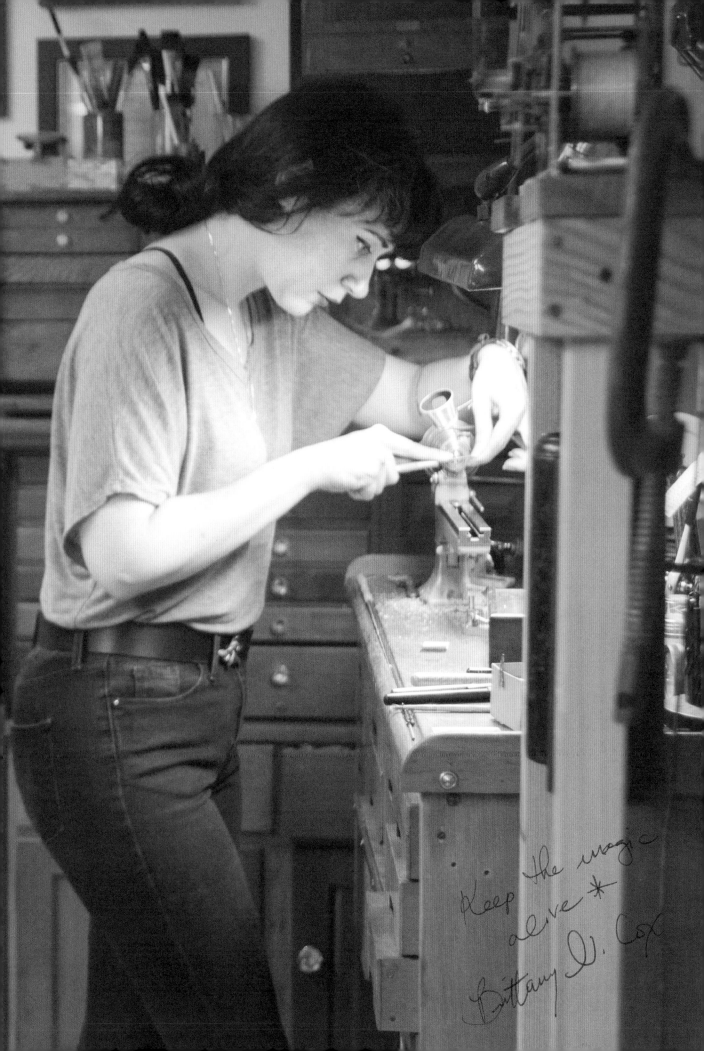

Keep the magic
alive *
Brittany N. Cox

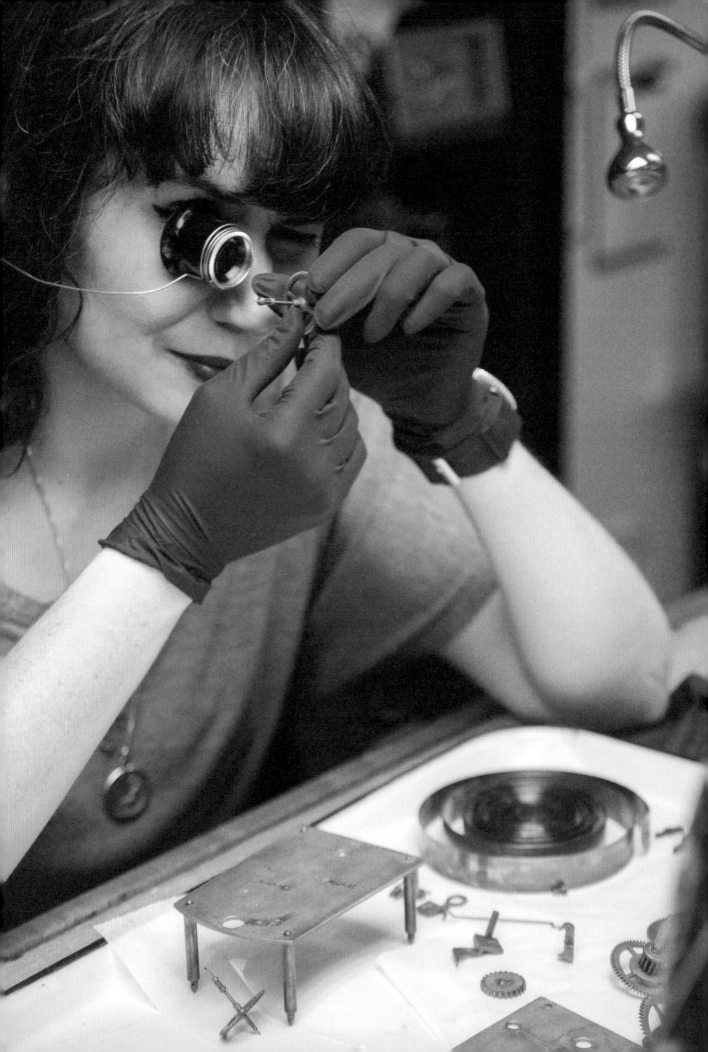

BRITTANY NICOLE COX,
MEMORIA TECHNICA
SEATTLE, WASHINGTON, USA

Antiquarian horologist Brittany Nicole Cox is a modern-day sorcerer. Early on in horological history, she says, "people often thought that horologists were doing magic." She demonstrates an automaton of a tiny caged bird with brilliant feathers that turns its head back and forth while twittering a very convincing birdsong. The Harry Potter–ness of it all wouldn't escape many viewers today, which makes our ancestors' assessment seem not so far off, and Cox agrees. The pieces that captivate her the most are automata like this one, pieces that use watch or clock-based mechanisms—just springs, wires, brass, and steel—to create an illusion.

"I feel privileged to bring a little magic into everyday life," says Cox, who describes her role as that of a mechanic from the seventeenth century. In fact, she is one of perhaps two people in the United States with a master's degree in conservation specializing in clocks and related dynamic objects. Cox collected music boxes when she was young and was always fascinated by the inner workings of things. If she had known that she could devote her whole life to working with mechanisms, she says, she probably would have started her practice much earlier.

From her private studio, she specializes in the mechanics of watches, clocks, automata, and mechanical musical objects from past centuries, particularly those made in England and across Europe, which clients send to her from all over the world. The caged bird is one

Through her workshop, Memoria Technica, Cox provides restoration and conservation, as well as bespoke custom services, for clients all around the world. Cox trained at one of the few remaining programs for clock conservation and horological mechanisms, at West Dean College of Arts & Conservation in West Sussex, England.

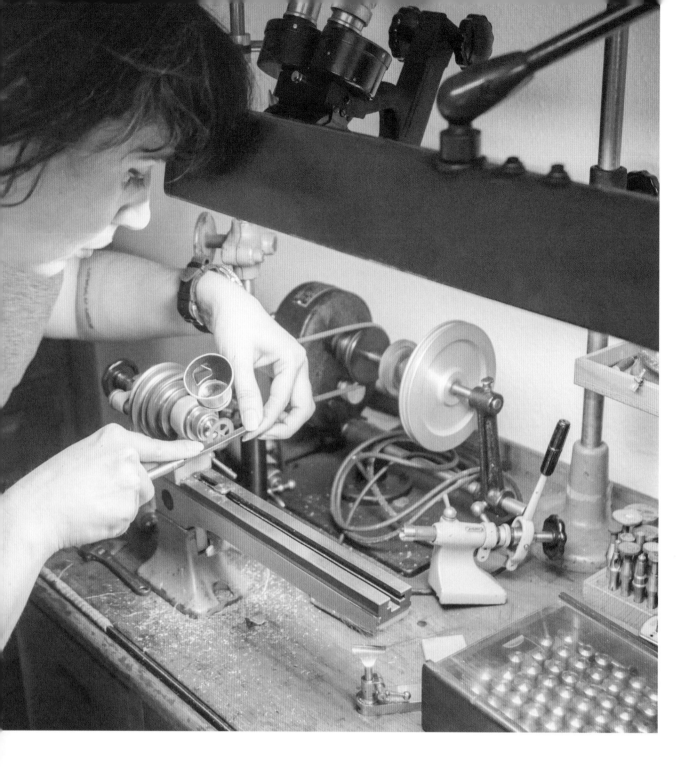

Dynamic machines, particularly automata, are among Cox's favorite pieces to restore, for their fascinating mechanical complexity, but more so for their ability to imitate life. Cox continues to research the history of the objects she restores. She's aware of the unique position she's in to bring attention and understanding to her beloved work. In addition to developing a book about her work, she devotes time to sharing what she does through workshops. She also speaks at events to promote the importance of horological conservation and other disappearing arts that go hand-in-hand with her field, like guilloché (or machine turning), the process that creates the detailed patterns on the backs of watches, as well as hand-engraving, gilding, and more.

of hundreds of fascinating and unique objects from the past that she has brought back to life. Her studio is full of other projects in various stages of repair. Inside a nineteenth-century German music box that Cox is diagnosing, the large musical cylinder (the tube covered with teeth that are plucked as the cylinder revolves, generating the tune) is not the only music-making mechanism. Just adjacent is a perfect re-creation of a drum in brass and a row of chimes, which will be struck by tiny drumsticks, plus an intricate set of brass bees that hover over the chimes. Under a glass cloche nearby, a carriage clock's inner workings quietly whir and click as it undergoes testing.

Almost as fascinating as the pieces Cox brings back to life are the antique machines and tools of clockmaking that line her cozy workshop space. None appear to be any newer than the mid-twentieth century. A dozen large drills and lathes and other fascinating, specialized machines came from the vast workshop of a former watchmaker in Connecticut. His tools and machines had in turn come from the old Bulova Watchmaking Factory in New York's Sag Harbor, after it closed in 1975. Their trademark green—"Bulova Green," says Cox—a unique hue somewhere between mint and moss, still gleams on the old machines. In a sense, she inherited them after helping the watchmaker's family sort and find new homes for his estate.

The passing down of these machines through generations of watchmakers and clockmakers to her workshop is profound to Cox. Her work in horology— the study of time—means that she can't help but

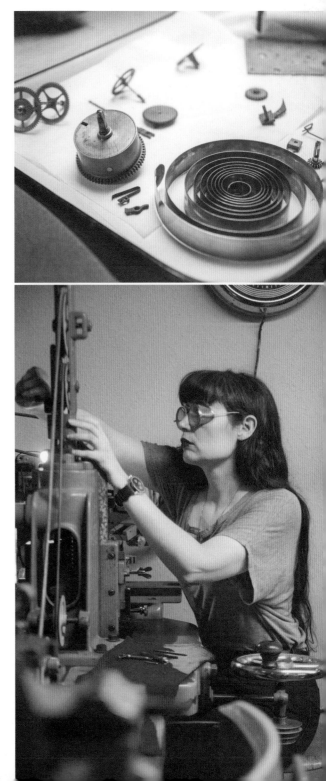

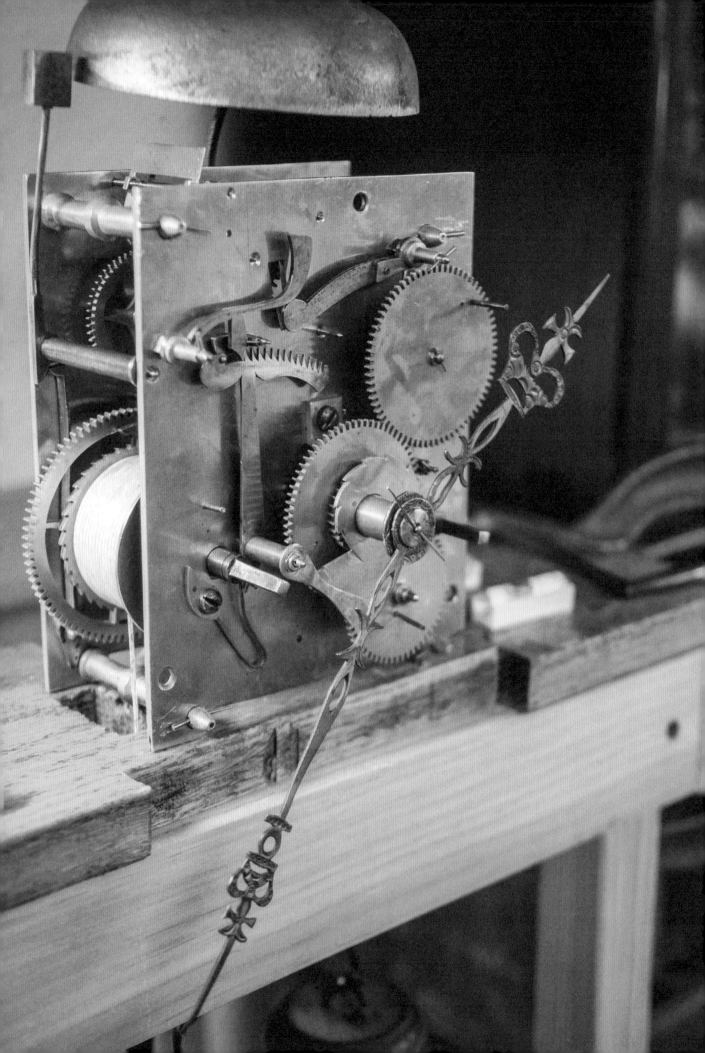

consider the effects and meaning of time. Entropy, the gradual decline into disorder, can mean that the pieces she treats and repairs have succumbed to the ravages of the years and centuries, and her job is often to combat that toll. But as a certified conservator, she's also ethically bound to make decisions about whether to maintain and preserve the traces of past horologists and past attempts at intervention, rather than heal the clock to better working order. It's a question of history and of storytelling, she says. "At a certain point, it's the story of the timepiece, and I do my best to give it voice."

"These craftsmen made things for the sake of beauty and delight," says Cox, in awe over the level of skill and artistry that was all done by candle- or gaslight. Deep polished wood, gleaming brass, ornate gilding, and exquisite engraving, enamel, and inlay in the pieces Cox treats are all constant reminders of the astounding creativity and precision of the artisans of the past.

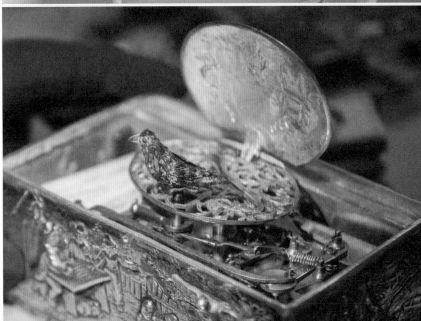

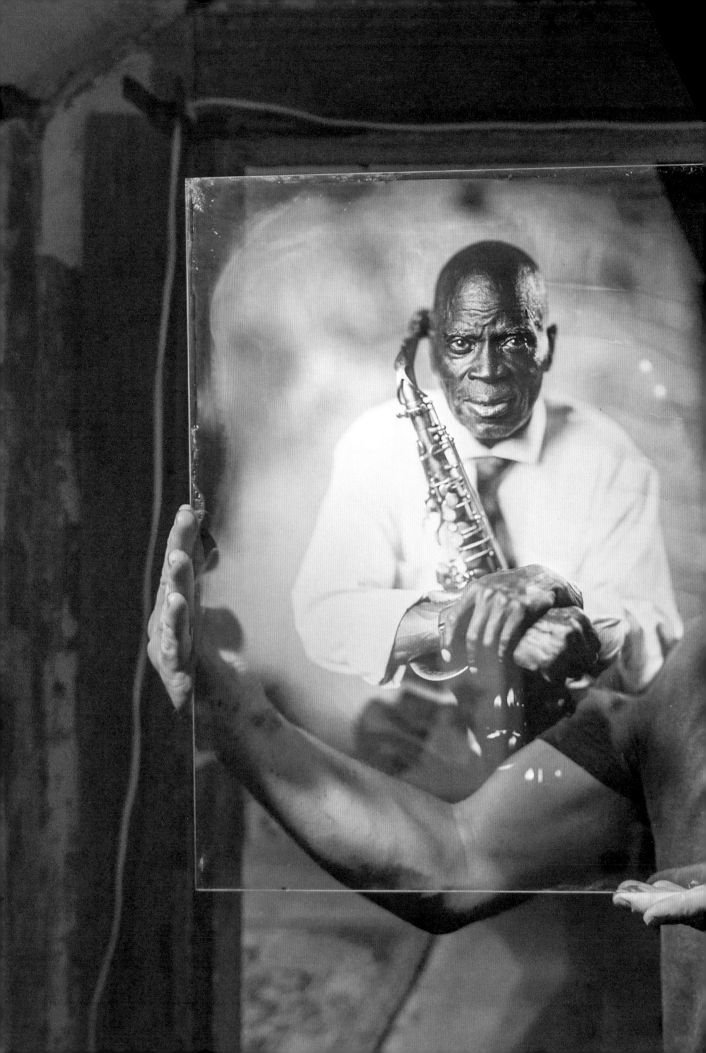

THE WET PLATE PHOTOGRAPHERS

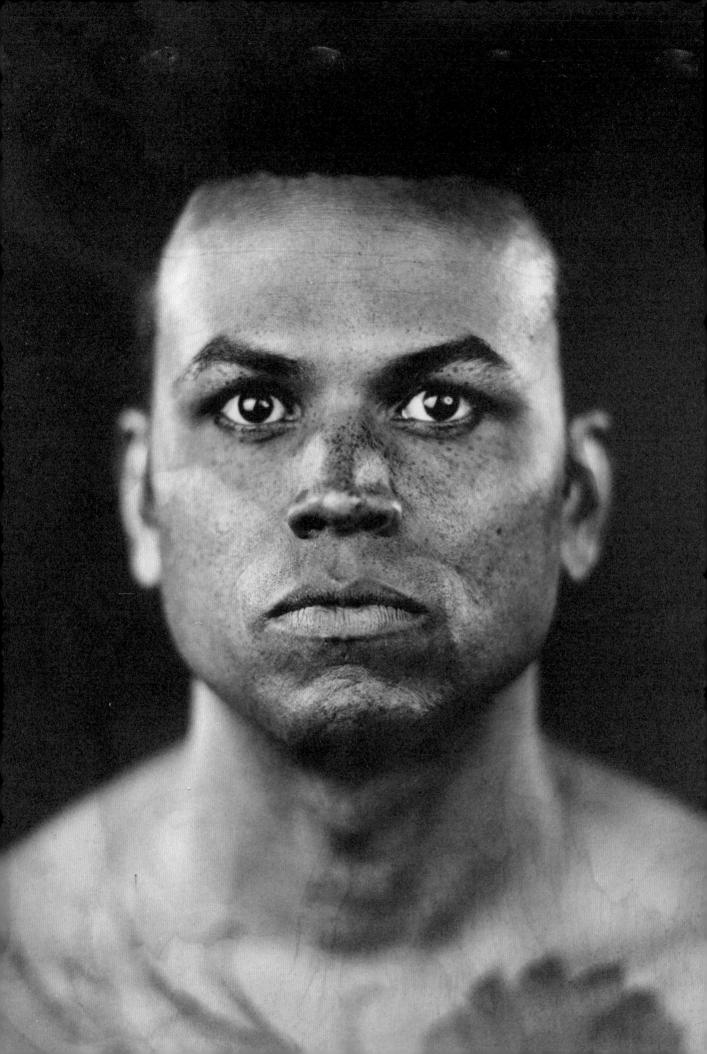

ASHLEY JENNINGS,
ALCHEMY TINTYPE STUDIO
PORTLAND, OREGON, USA

RAY BIDEGAIN,
PORTLAND, OREGON, USA

GILES CLEMENT,
NASHVILLE, TENNESSEE, USA

I f you've seen the black-and-white tintype portraits of American Civil War soldiers and families from the 1860s, you may have been struck by the almost aggressive intensity of the subjects. Stoic faces with piercing gazes, nearly every hair, wrinkle, and texture in sharp focus—these are portraits that are hard to stop looking at. If you look closer, you'll notice that there is also a silvery gleam to a tintype, and luminosity in the transparency of a glass ambrotype, which contribute to a feeling that the image has captured some presence or life. If you have the chance, you may even notice a botanical scent—once the image is made, it is sealed with a coating of shellac, sometimes tree sap, and lavender oil to ensure the archival quality of the image.

Today, Alchemy Tintype (which has pop-up studios in Portland) and photographer Giles Clement (who tours the eastern half of the United States) are not much different from Civil War–era photographers like Mathew Brady, who followed Union soldiers from camp to camp. Brady used mobile darkrooms housed in a covered wagon to record daily life as

"I like the idea of communicating someone's story through portraiture," says Clement, one of the best-known tintype and ambrotype photographers working today. His portraits of celebrities Channing Tatum and Jenna Dewan, Fiona Apple, Questlove, and Elvis Costello have gained particular attention. Clement thinks that the appeal of these portraits is in their physicality, which is missing from most photography methods today. The portrait is nearly transparent at first— but when it's held against a dark background, the image appears, floating in glass.

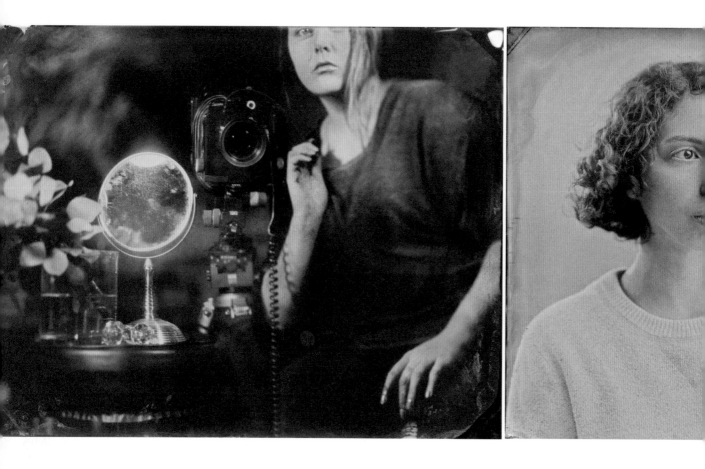

well as the aftermath of the war (a venture previously unmatched as a visual record of war). Over a century and a half later, portraits are still the subject of choice for today's tintype and ambrotype photographers. And to Alchemy and Clement, the intent is still capturing the human experience.

"There's an honesty to it," says photographer Ray Bidegain, both of the wet plate photography process and of the stunning images captured in the tintypes and ambrotypes. The difference in the two types is that the former is an image created in a chemical emulsion on a tin surface and the latter is created on glass. For Bidegain, Ashley Jennings, and Clement, this honesty and authenticity is at the core of why they prefer the process over more contemporary (and arguably less cumbersome, messy, or noxious) photographic methods.

Analog methods, especially alternative (non-film) techniques like ambrotype and tintype, are seen as inherently truthful because of the necessary presence of the human hand at every step. The ease, efficiency, and consistency of digital are invaluable tools and accomplishments in the photographic tradition. But the computer at the heart of it all does a certain amount of sampling, estimating, and reinterpreting what it sees to output an idealized version of the world outside.

Jennings discovered her love of
alternative photographic processes
during a semester abroad in Italy
in 2007. Today, she explores and
pushes the boundaries of wet plate
processes with the Alchemy Tintype
Collective, in addition to working in
commercial digital photography and
fine art. Portraits continue to be her
favorite subject, in any format.

Wet plate photography, on the other hand, is a pains-
taking process of steps that are each a new opportunity for
imperfections. First, the photographer balances the glass or
tin plate between their fingertips and carefully and quickly
pours a syrup of salted collodan over it, tipping the plate
to cover the surface. The collodan forms the base for the
ether, idodide salt, and sliver nitrate bath that is added next.
The literally wet plate is now light-sensitive and ready for
the camera, but only for a window of roughly 15 minutes
before the chemicals dry up and their sensitivity to light
expires. The drier the plate, the less sensitive the coating
is to light, and the longer the exposure time. That means
the photographer must coat the plate, then carefully load
it into the large, boxy camera and expose it to light focused
in by the camera lens before the 15 minutes pass. The drier
the plate, the less sensitive the coating is to light, greatly
increasing exposure time. The silver molecules on the plate

Much of the intensity in tintype
portraits, says Bidegain, is owed
to the way the medium reinter-
prets color. Blue, especially in the
eyes, becomes piercing, almost icy.
Anything red becomes deep black.
The chemical processes and the
imperfections in the wet plate forma-
tion can also add ghostly forms
and flecks, which lend an eerie,
otherworldly effect.

realign in reaction to the light and form a negative of the image perceived by the camera. The plate (still kept in the dark) is immediately taken to be processed through various chemical baths, so that the latent image in negative becomes a positive—and the only copy of the image captured.

It might not sound like the most practical or portable process. But just like Brady and other wet plate photographers of the past, Clement is often on the road with his intrepid partner, Kendra, and their pup, Zeiss. The trio travels with their huge homemade camera, light kit, and mobile darkroom in pursuit of Clement's stunning ambrotype portraits. He has captured New Orleans Jazz & Heritage Festival musicians, celebrities like Questlove and Nick Offerman, artists, models, and everyday humans in his luminous ambrotypes. His latest goal is to open up the process from beginning to end as a learning opportunity. He has found that most viewers are eager for a peek behind the curtain.

But perhaps even more so, people are endlessly fascinated by the way they look in their portraits. "Tintypes and ambrotypes reflect the way we see ourselves," says Jennings, a former student of Bidegain's who now runs the Alchemy Tintype Studio. "They show what we see when we look in the mirror every day, our mirrored self, and at least to ourselves, it's the more familiar version."

As historical media, tintype and ambrotype have a way of collapsing time, too. Both Jennings and Bidegain describe the very personal, sometimes visceral reactions their subjects sometimes have to seeing

Clement made waves when he was the first to shoot an aerial tintype—using a drone. While not his most artistic work, he admits, the triumphant photo shows Clement and his team from a bird's-eye view, standing in the insect-like shadow of the hovering drone.

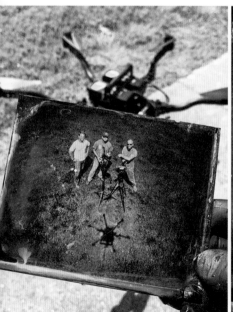
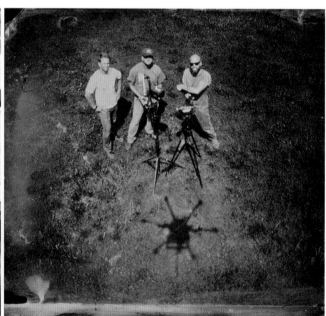

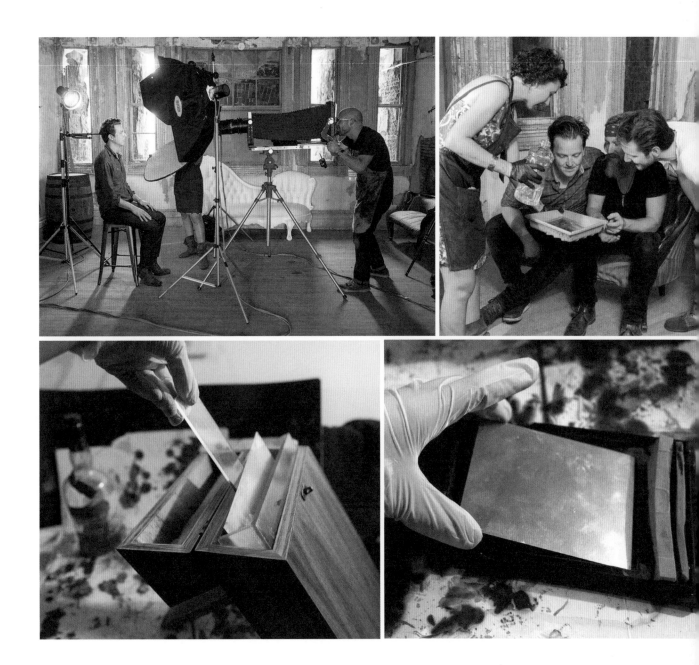

themselves in tintype. An African American friend of Jennings, who sat for her during one of Alchemy's pop-up events, was stunned to see himself in the medium that could have depicted his slave ancestors. In the filter of the medium, it seemed no time might have passed. A friend of Bidegain's from Japan was sure Alchemy had not captured him in the image, but his grandfather, long passed away. In tintype, Jennings sees the same wrinkle patterns emerging in her own face that she knew and loved on her mother's face.

For Clement, it's the multistep process and the longer exposure needed to create the wet plate image that make it so well-suited for portrait-making, unmatched by other media for the way it captures that honesty. "There's something important about how slow the process is," he says. "People put on a mask of who they are and the process helps them slow down, and that veneer often falls away."

The Wood Type Printers

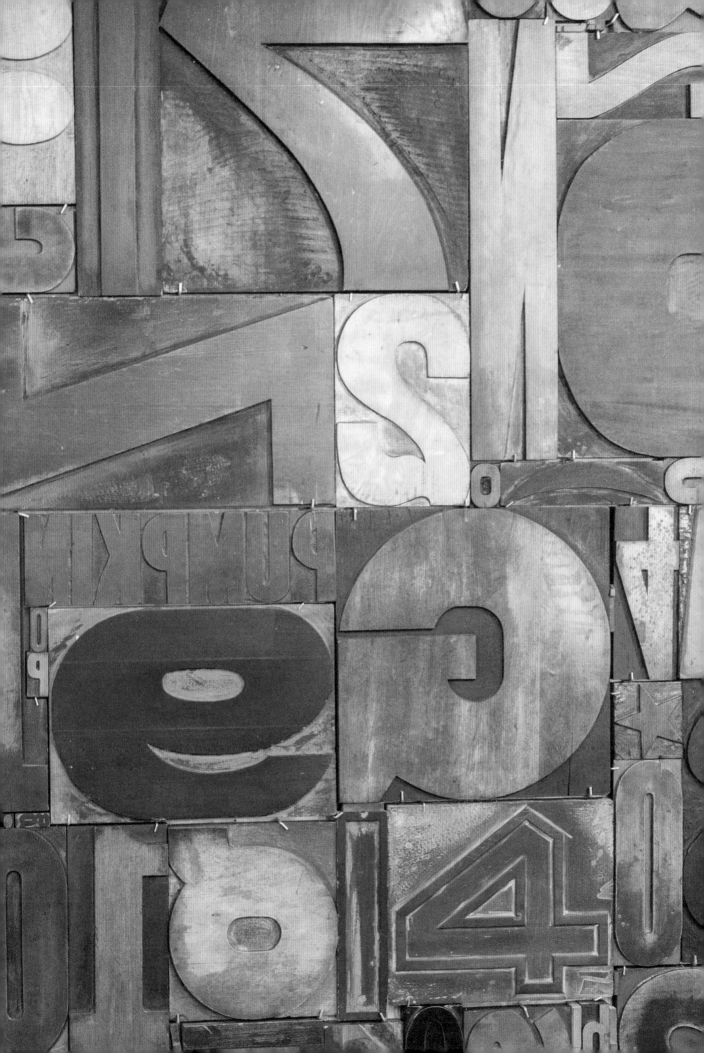

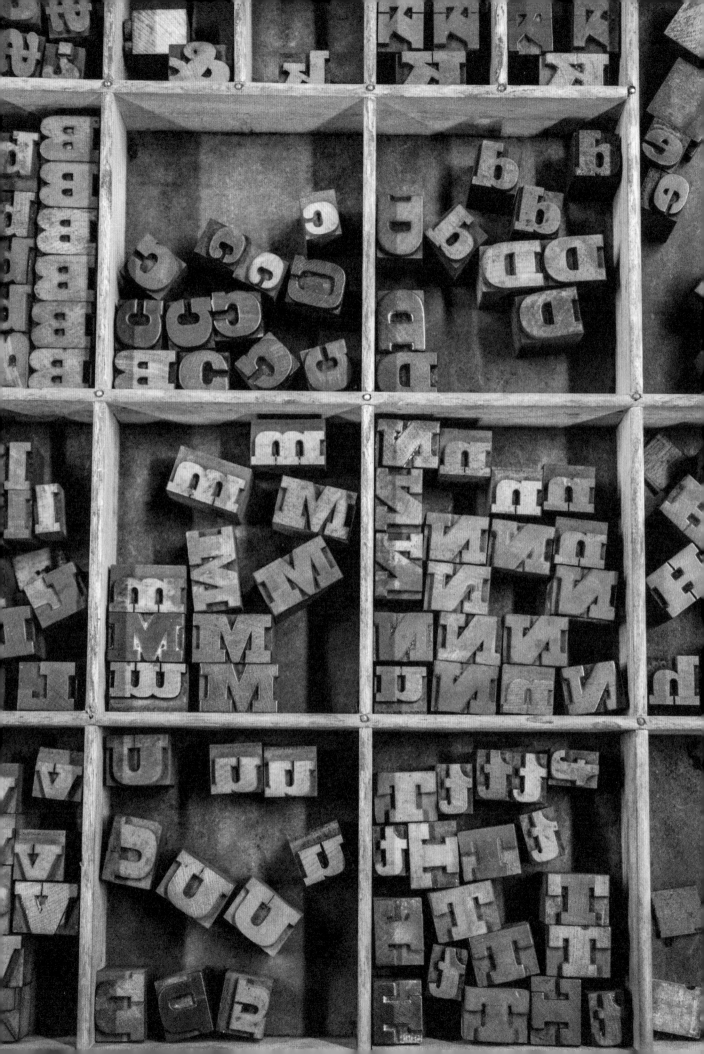

JIM MORAN,
THE HAMILTON WOOD TYPE & PRINTING MUSEUM
TWO RIVERS, WISCONSIN, USA

J im Moran says he is a printer because he really had no choice. "I was always interested in the printed word, whether it was a book or a broadside," he says. To be a printer is a means not only to artistic expression, but also to communication through the written word, "and I find that endlessly fascinating." Growing up, he would visit his father and grandfather's printshop. Moran's Quality Print Shop, in the Green Bay area, was originally founded in 1919 as The Quality Print Shop but renamed after his grandfather took over ownership in the early 1940s. When Moran was ten years old, his father and grandfather showed him how to print his own name on a small business card with metal type—whether he knew it or not at the time, he was hooked. Years later, as a young man, he would leave for college and work other jobs, but somehow he always found himself back as a pressman, and eventually as a master printer, at the family shop.

Moran's Printing finally closed its doors in 2001 after decades of decline in business—cheaper, faster, digital technologies were reducing demand for the old mechanical industry. Moran's father suggested that they donate their ruling machine (a nineteenth-century device that prints lines on paper) to a new museum for wood type printing that had opened

Wood type fell out of common use in the first half of the twentieth century, but at the Hamilton Wood Type & Printing Museum, the practice is very much alive. The museum aims to have most of its holdings—printing machines, wood type, and wood blocks—accessible for printing, research, and education.

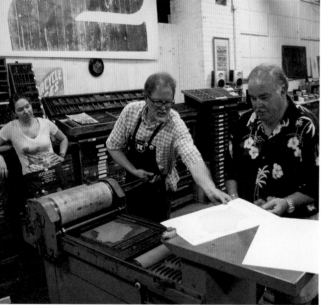

in nearby Two Rivers. The Moran family company had mainly used metal type, but they did use Hamilton Type and cabinets for some projects.

The Hamilton Wood Type & Printing Museum was founded in 1999 and, according to its mission, is "dedicated to the preservation, study, production, and printing of wood type." Intrigued by the growing collection, and by the fact that he knew how to use and maintain much of the equipment, Moran spent the next decade volunteering at the museum, along with his brother Bill, and also continued to donate equipment and wood type. But over the years, he worried that the collection was being underused. "I kept thinking about all the ways the museum could share its holdings and knowledge, and I was determined to find a job there," Moran recalls. Today he is the museum's director. He also hosts letterpress workshops and spends much of his time helping archive the collection.

The history of wood type begins as early as the late 800s C.E. in China, with wooden stamps of the Buddha. In the Western tradition, as printing technology advanced in Europe over the centuries, wooden type remained an important medium. Whereas metal type could be uneven or form cracks while being made, wood type was favored for its smooth and even surfaces. With the Industrial Revolution, American wood-type producers introduced lateral routers that eliminated some of the painstaking hand carving necessary

What does it take to be a master printer? "Time," Moran says emphatically. "While there are a lot of good printmakers, the printer needs a lot of technical understanding to handle the machines at the high level they need to." It's the nature of the presses and their age that require not only mechanical knowledge, to fix technical issues as they arise, but also design and typographic knowledge, for the hand-setting part of the press.

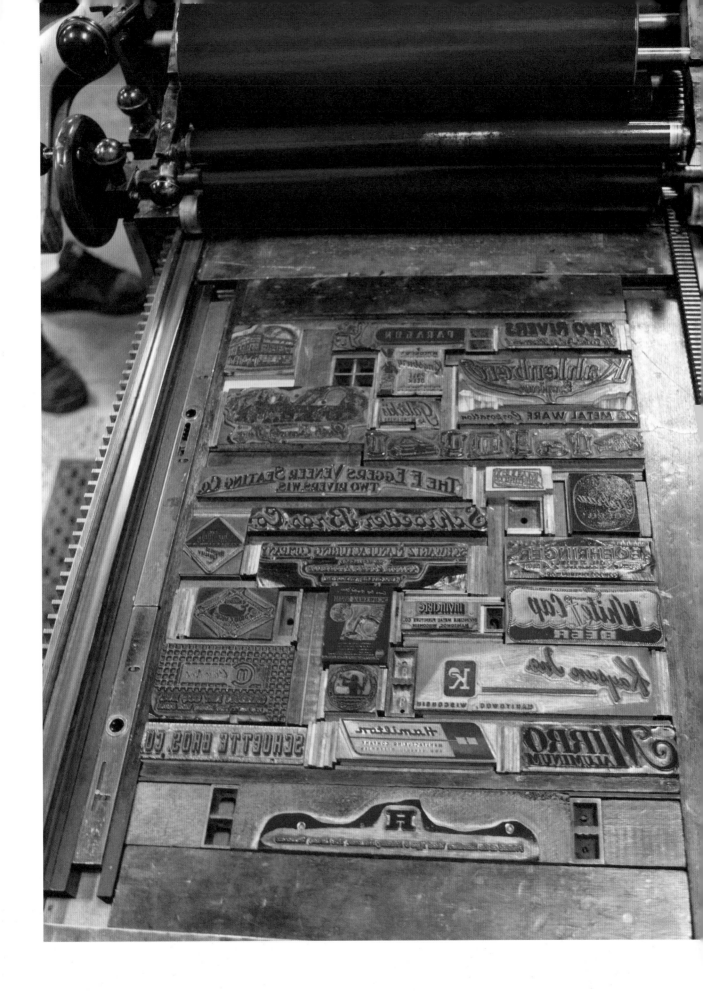

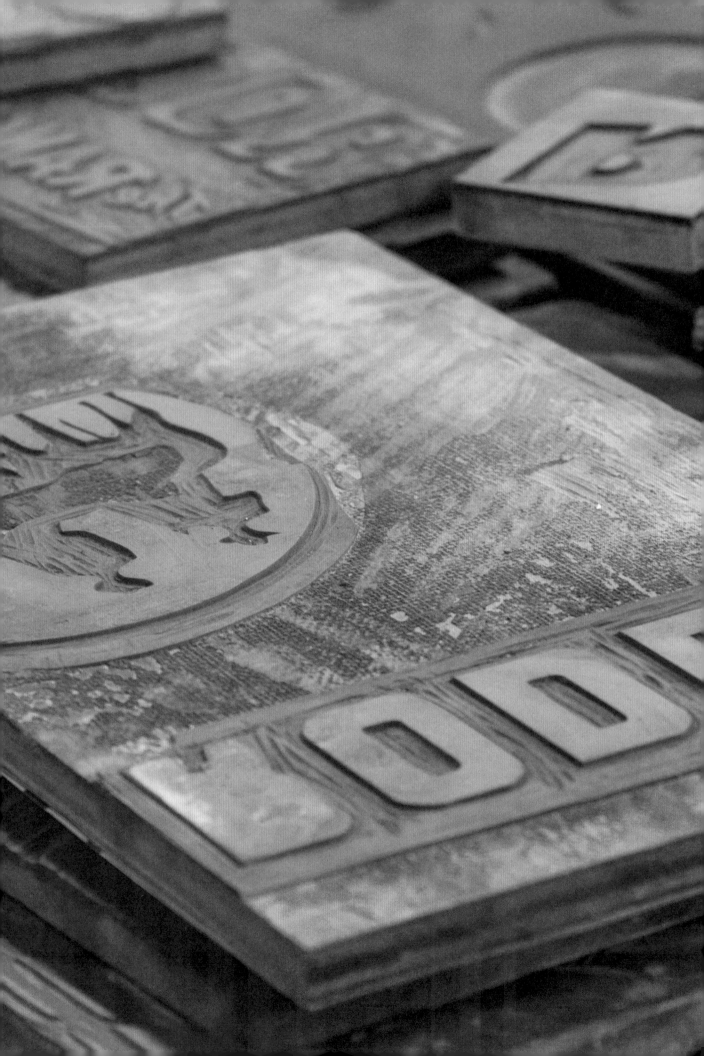

to make wood type. In 1880, Two Rivers' own James Edward Hamilton innovated further on the wood type process when he responded to the local newspaper's need for a special poster advertisement. The prototype he made was so successful that he refined it to become the famous holly wood type production method, and the J. E. Hamilton Holly Wood Type Company was born. The method was such a huge improvement, cutting costs and time so much, that its popularity exploded with newspapers and printers across the Midwest. By 1895, Hamilton had acquired or forced out of business the major competition in wood type production. But the boom began to wane in the 1950s, as technology and cost efficiency improved for other printing technologies. Gradually, wood type was phased out of its former place in print production.

The Hamilton company shifted with the winds of change, moving away from type to type-storing cabinets, and later to furniture for use in dental and medical offices and labs, as well as drafting tables and more. Today, it is known as Hamilton Laboratory Solutions and manufactures laboratory furniture and fume hoods.

The original Hamilton legacy is preserved by the museum in Two Rivers, and under Moran, its collection has steadily grown. Sadly, he admits, part of its growth is due to many academic programs downsizing and phasing out wood type and other printing methods. While the museum has gained valuable collections, it's at the cost of those objects being lost to a potential next generation of printmakers. But with Moran at the helm, the museum has begun a strong educational initiative that puts the immense collection to work. Active use is not only integral to passing along the process to

Wood was cheaper to produce initially, so as commercial printing expanded with the Industrial Revolution at the start of nineteenth century, wood type literally scaled up with it. By nature, wood type was lighter in weight than metal, Moran says, so the museum often receives huge printing blocks like these.

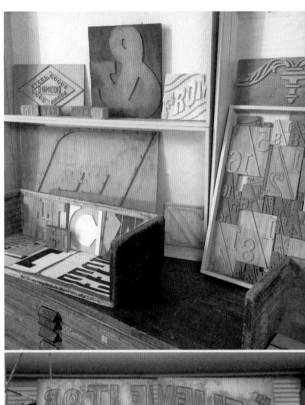

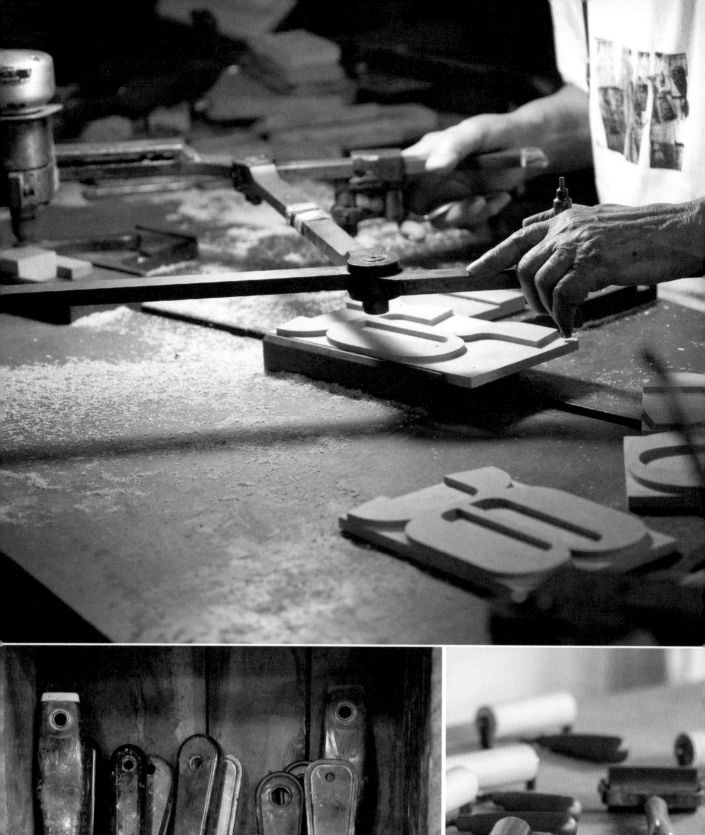

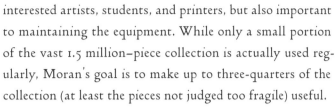

interested artists, students, and printers, but also important to maintaining the equipment. While only a small portion of the vast 1.5 million–piece collection is actually used regularly, Moran's goal is to make up to three-quarters of the collection (at least the pieces not judged too fragile) useful.

Through collaborations with universities, the Type Lending Program, artist residencies at the museum, a host of onsite classes, and an ongoing digitization process to create an accessible online type database of Hamilton fonts and other unique styles represented in the collection, Moran hopes to remain a strong resource for the design community. At the heart of it all, the preservation of wood type comes back to preserving a means of communication. "Everything is so digital today," he says. "But there is a special beauty in a well-printed piece in that it is attractive, but the handmade methods pass along more than the content—they show the story of their making."

THE CASSETTE TAPE MANUFACTURERS

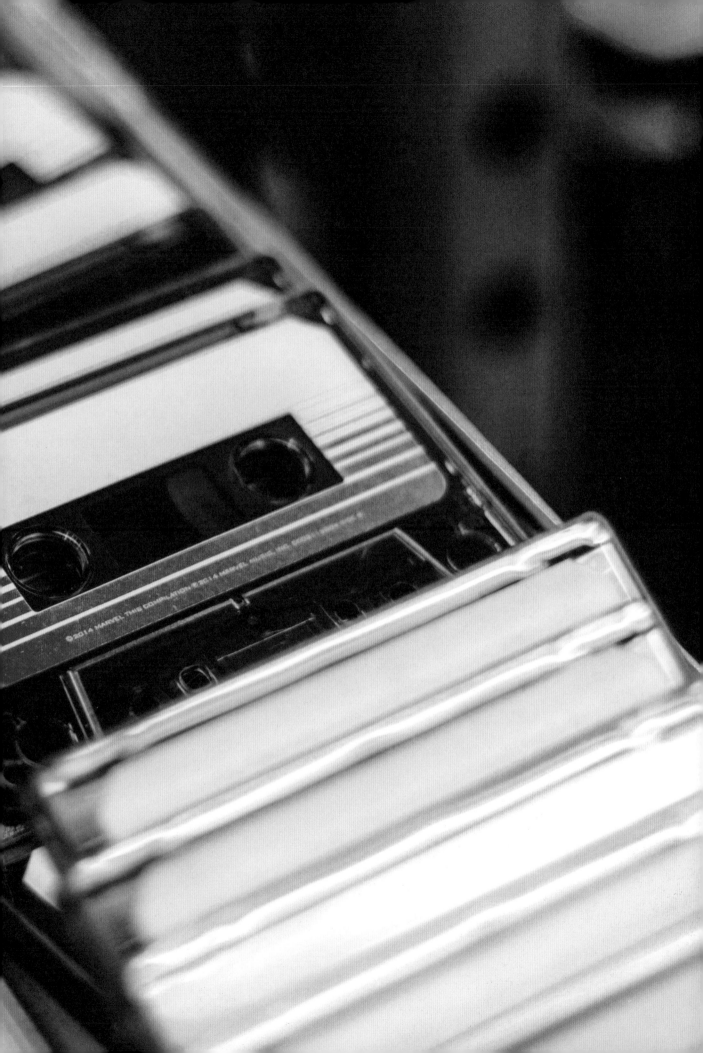

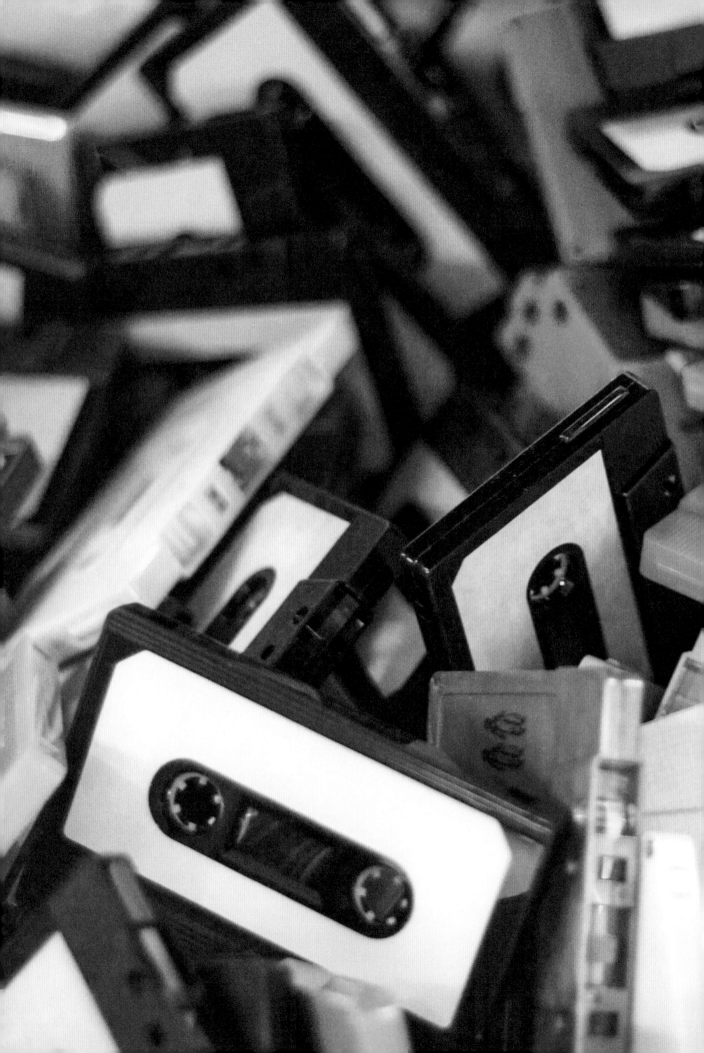

STEVE STEPP AND ROBERT COVERSTON,
NATIONAL AUDIO COMPANY
SPRINGFIELD, MISSOURI, USA

"We are like a printing press," says Robert Coverston, chief technician for the National Audio Company (NAC)—the last cassette tape–making company left today. "Clients can specify the cassette color and the kind of case, and they provide the graphics, liner notes, and the audio. And we put it all together." The NAC has held on to their analog technology out of pure "stubbornness and stupidity," according to NAC president Steve Stepp. And while the demand for cassettes on the broader market has disappeared since the early 2000s, taking cassette production with it, the NAC has remained the sole holdout, and it's redounded to their benefit: As of 2017, the company was producing more cassettes than ever before.

Stepp recognized the special qualities of cassettes not long after he founded the NAC with his father in 1969 as a blank media supplier. "I knew they were going to be a big deal," he says, and soon much of the company was devoted to duplicating tapes for spoken word clients and producing instructional content and narratives (or books on tape), although not much music. But just as cassettes displaced vinyl in the 1970s, CDs soon overtook cassettes as the music industry's preferred format. In the early 2000s, most companies discontinued their cassette-tape production. The NAC acquired much of the deprecated

The quality of master recordings has improved so much that their cassette sound is better than ever—as Stepp put it, "Little tape, big sound!" Stepp's favorite recent cassette release was the *Star Wars: The Force Awakens* soundtrack. The NAC also made the cassette edition soundtracks for *Spotlight* and *Guardians of the Galaxy 2*, and Stepp has been blown away by the success of the format.

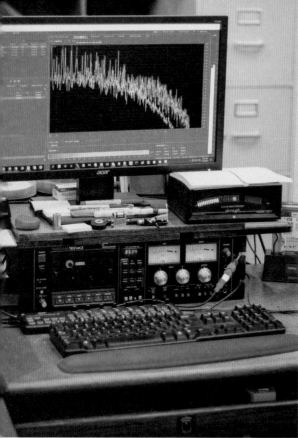

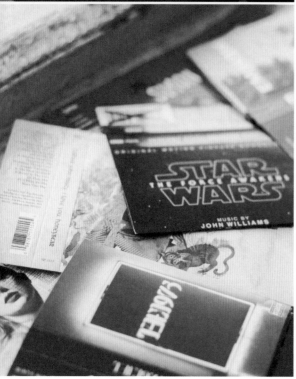

cassette-duplication and tape-winding equipment—a very valuable move, because the companies that once produced the machinery have long disappeared.

For the last few decades, the NAC has been the go-to for small runs of special-edition cassettes, and it has worked with the very companies who sold their old equipment to the NAC. Notably, in 2006, Pearl Jam approached the NAC to produce cassettes for part of a deluxe anniversary release—all fifteen thousand sets were snatched up in presale. Cassette orders from Smashing Pumpkins and Metallica followed around that time, and they sold just as quickly as the Pearl Jam run. But it was in 2010 that the NAC experienced a surge of popularity from indie bands and labels seeking the nostalgic format, and it didn't take long for the bigger music companies like Universal Music Group and Sony to take notice, followed by Disney—in 2014 the NAC produced the *Guardians of the Galaxy* soundtrack (designed to look like the cassette tape mix in the film), which promptly went platinum.

Why cassette tapes? The appeal extends not only to many indie bands, but also to the younger generations who grew up more familiar with the digital sound of CDs or MP3s, and to older music lovers who remember and love the nuances of cassette sound. "Analog brings a sense of warmth that just isn't present in digital," says Coverston. He explains that digital files are compressed in ways that affect the original harmonics, but tape can capture those nuances. And with digital, Coverston adds, "there's nothing to go back and look at, nothing to hold in your hand." The physical tape, the design of the liner notes, and pleasure of building and displaying your collection—it's all part of the analog experience. While vinyl is experiencing the same boost from the wave of nostalgia, it costs

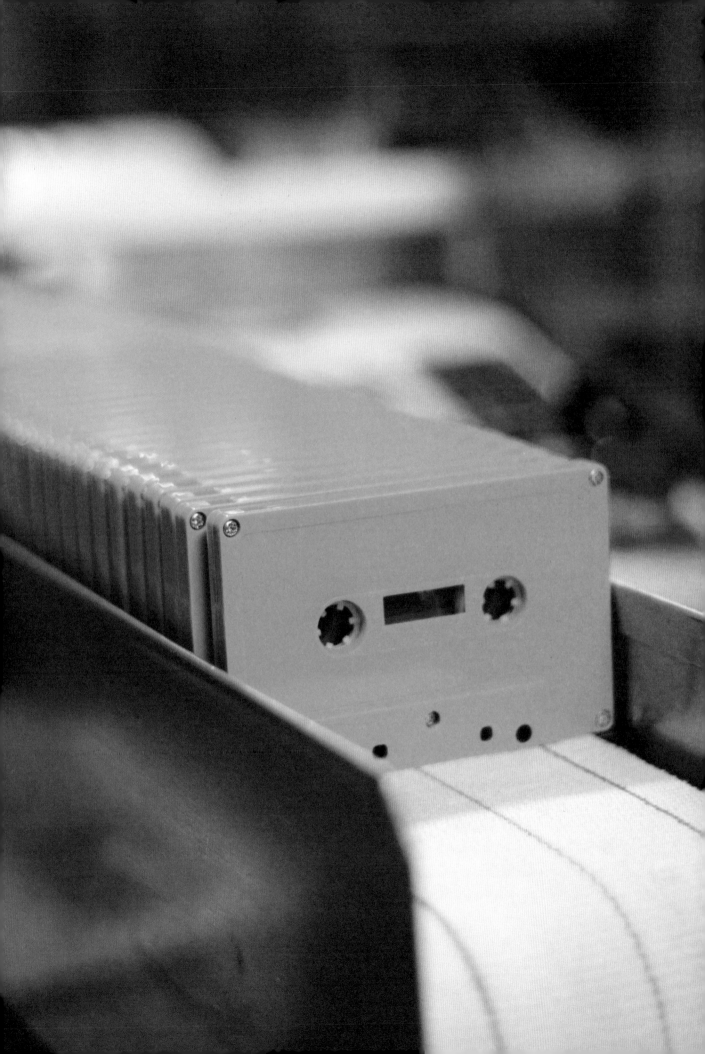

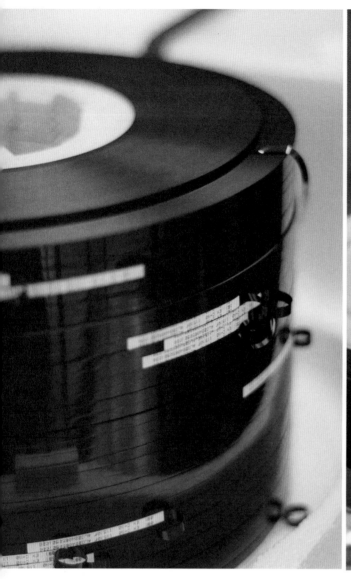

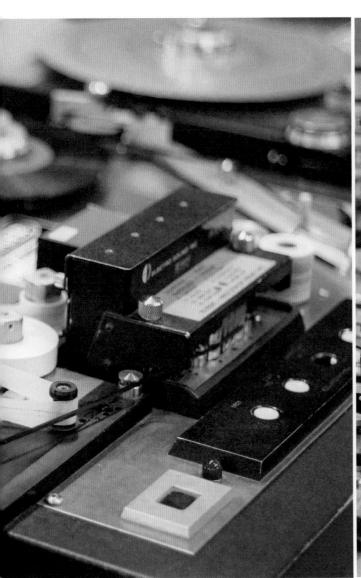
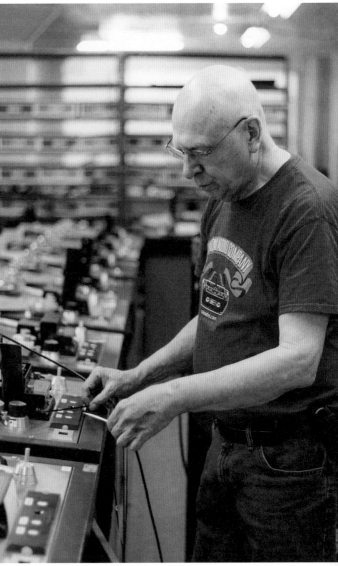

"When it comes to audio tape, we'll give it a shot," says Coverston, reflecting on the variety of challenges that clients set for the NAC. "We'll find a way to make it work." Resourcefulness and agility have been a large part of the NAC's survival over the years, and those qualities are due in large part to Coverston's incredible knowledge and skill as chief technician. Today, he worries about who might succeed him—today's younger technicians haven't quite shown the same interest, nor the broad mechanical knowledge required in his job. But more than technical knowledge, "you have to be able to think through a problem," he says, "not just come up with a Band-Aid."

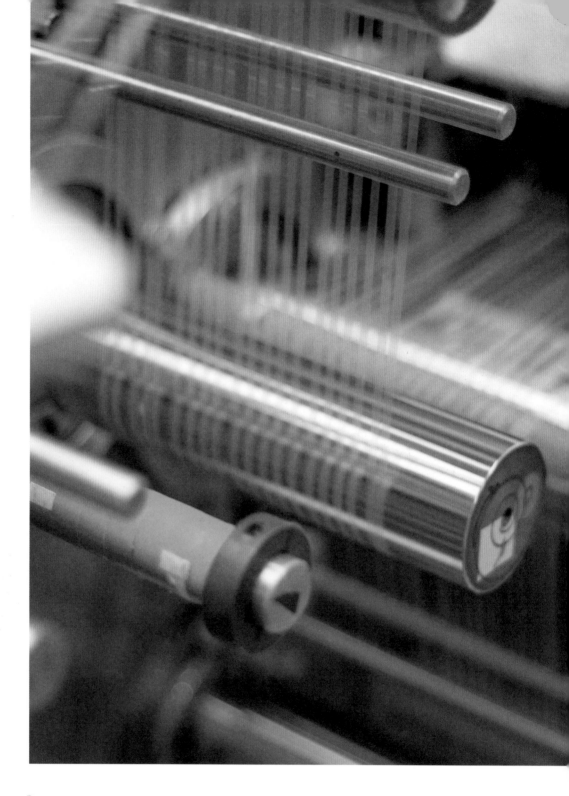

When Stepp announced that the NAC would tackle the challenge of creating their own magnetic tape, it was both an exciting and terrifying experiment for Coverston to lead. After months of researching other industries that produced similar types of tape, they eventually tracked down machinery from 1968, made for producing the magnetic strips on credit cards but now destined to be sold for scrap metal. In January of 2017, they hauled the fifty-five tons of equipment saved from the brink of extinction across the country to the NAC's factory in Springfield. Coverston and his team spent the next year modifying and reconditioning the machines—at one point working for eighteen days straight—and he's proud to say they'll produce what will be among the best-quality tape the music industry has seen yet.

thousands of dollars and requires more time to produce vinyl. Cassettes, on the other hand, are relatively inexpensive to make, says Stepp, and still achieve the analog quality that bands (and fans) are looking for.

Today, Coverston is charged with keeping the 1970s-era machines maintained and working properly for the 200–400 music releases in process at the same time, which result in as many as 2,000 cassettes daily. But, he says, "my biggest concern is to pass this trade on." Most of the people who still know the tools and techniques of duplicating cassettes and loading blank cassettes with audio, he explains, are his age (Coverston is in his seventies). It's been a struggle to find younger technicians with an interest in learning and carrying on the work, not to mention the necessary skills in electronics and pneumatic systems, and a mechanical sense for the old-fashioned sprockets and gears that keep the machines running. But Coverston doesn't plan to retire any time soon.

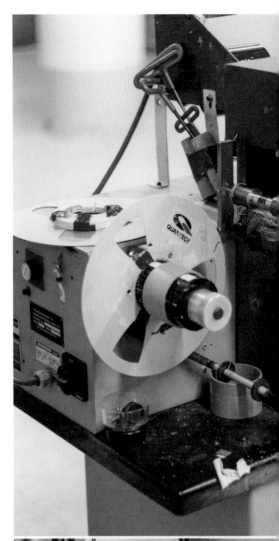

His perseverance and scrappiness is a cornerstone of life at the NAC, but the company faced its biggest challenge yet when the last magnetic tape producers (located in South Korea) recently stopped production. The NAC bought the last of that inventory, knowing that once the supply was exhausted, it would signal the end to cassettes. But Stepp was undeterred and resolved that if they could no longer buy it, they would make it themselves. Coverston and the NAC's technicians stepped up to the challenge and spent a year adapting salvaged equipment meant for producing magnetic credit card strips. The equipment is finally ready for making high-quality ferric tape that will match the quality of studio master recording tape—meaning the NAC's cassettes will be the best-sounding the mass market has heard. But Coverston and Stepp are sure that the particular aesthetic of the cassette sound—including the beloved "tape hiss," the whir of the tape passing through the cassette—isn't going anywhere.

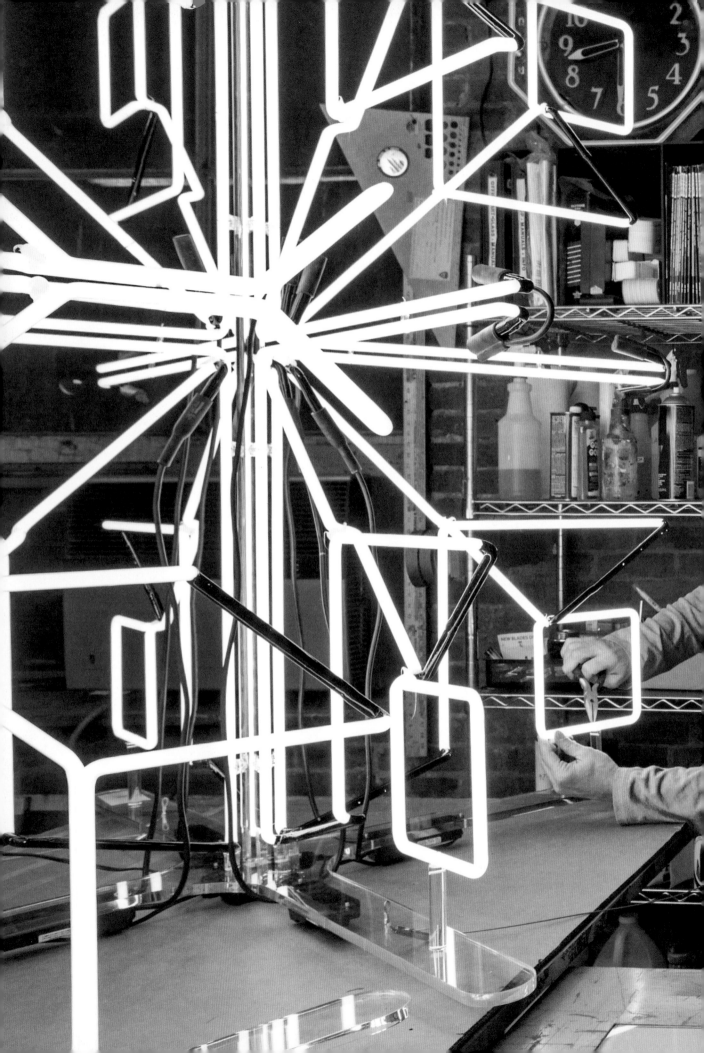

THE NEON SIGN MAKERS

JEFF FRIEDMAN,
LET THERE BE NEON
NEW YORK CITY, NEW YORK, USA

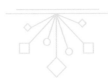

A colorful (but not over-the-top) neon sign hangs above the sidewalk in Tribeca, marking the entrance to a shop. Considering how vivid neon signs are as soon as evening sets in, it's always surprising how dull they can be in the daylight. This one is no doubt quite spectacular after dark, for its multicolored letters spell out: LET THERE BE NEON.

The shop's founder and original owner was Rudi Stern, an artist who studied painting under Hans Hofmann and Oskar Kokoschka, and who went on to create spectacular light shows for rock bands in the 1960s. He collected the vintage neon signs that were getting gradually displaced by cheaper fluorescent-and-plastic or vinyl materials, and he founded Let There Be Neon (LTBN) as a gallery for buying and selling his collection. It wasn't long before Stern began offering custom signs for clients, and the gallery quickly became a full-fledged neon signage shop in 1972, with a fine-art flair that separated it from the sign shops of the past.

Current owner Jeff Friedman was an inexperienced college kid when he started working for Stern in 1977. After just three weeks on the job (sweeping mostly, he says) he was thrown into learning anything and everything when a large portion of the company left to start a new neon studio. "I started knowing nothing," he recalls, laughing, "and then suddenly was getting a crash course in glass bending, prepping designs, and assembling

"It's an incredible medium," Friedman enthuses. "Every piece is living."

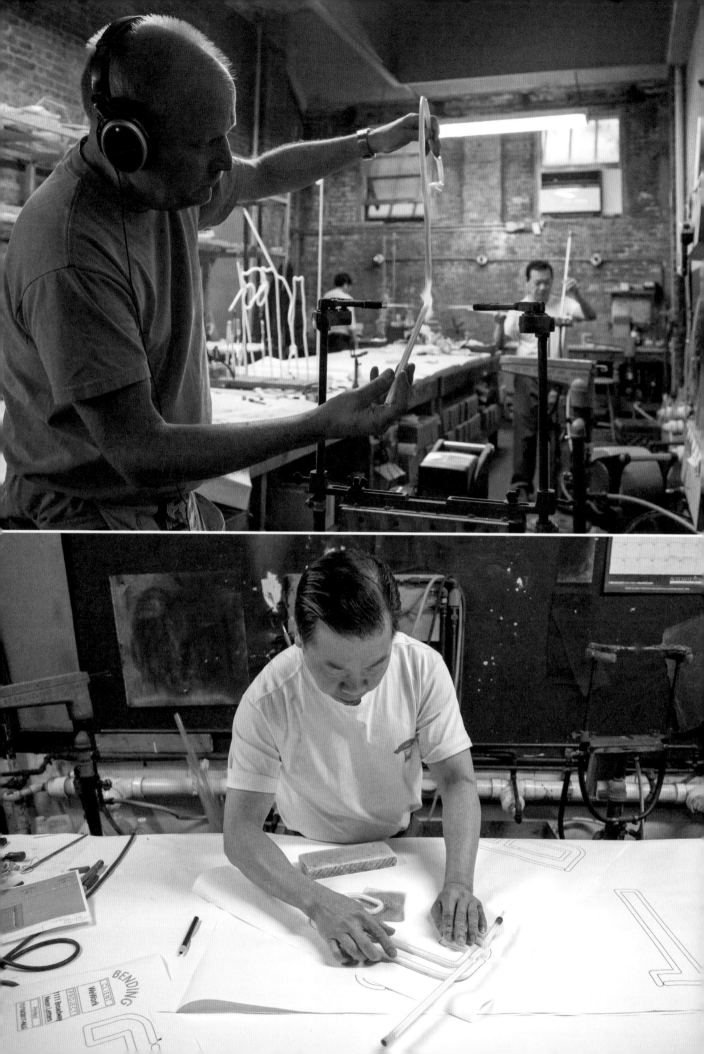

the finished signs." Friedman left the company in the 1980s and later started his own neon company, which merged with LTBN before he eventually took over from Stern (who wanted to pursue his personal projects as a light artist).

Gregarious and friendly, Friedman still works closely on commissions and projects, manages clients, and oversees quality and creative direction. The signs are still produced the same way they were when he was a shop hand, using techniques that haven't changed much in over a century of neon.

At the core of the art is the glass tubing (coated inside with phosphorous), some of which is specially made in Italy, but most of which is sourced domestically. It's stocked in every imaginable color at the shop. Boxes of the tubes are stored horizontally in what must be a color spectrum—Friedman waves a handheld black light over similar-looking pale shades to reveal that they're actually different green, blue, and purple hues. Some colors or specific shades are rare, he says, pointing out a light-green glass derived from uranium. Others are more brittle and need more care and patience from the glass bender, like ruby reds and cadmium yellows.

After the selected glass has been heated and masterfully bent by the shop's glass benders into the intended shapes, they are filled with one of two noble gases, either neon (which is red) or argon (blue). The gases alter the color of the glass and lend vividness when electrical current is flowed through the sign to turn it on—the gases' molecules, excited by the energy, produce the light that shines through the colored glass. "It's like watercoloring with light," says Friedman, describing how the colors of the gases and the glass combine to achieve just the right shade. Blue tubing with red gas becomes pleasantly pink, for example.

"But first, [every project] always starts with an idea," Friedman says. That idea could be a drawing, or even a final artwork that the client envisions turning into light. The studio's team will translate the idea into a neon digital rendering for the client's approval, and they'll confirm the glass color and the scale of the project before the team of skilled glass benders and mount builders can get to work.

In a small room lined with heavy shelves, two veteran glass benders stand at the worktable in the center of the room, skillfully heating glass tubes using various mounted burners, then swiftly manipulating a straight tube into the curve or loop or form dictated by the to-scale drawing spread out on the worktable. They often hold the in-process letters against the drawing to check size, angle, and curve. At other moments, they use rubber tubing to quickly blow into the hollow glass as it begins to cool, preventing it from collapsing. One of the tricky parts, the glass benders say, is that you have to learn to work

It takes decades of experience and a true eye for artistry to create the amazing effects in neon that LTBN is known for. The experienced glassbenders are calm and nimble and highly aware of the material limits and needs of the glass. The tubes have to be heated just enough, bent quickly (but not too quickly), and sometimes puffed with air to ensure they don't collapse.

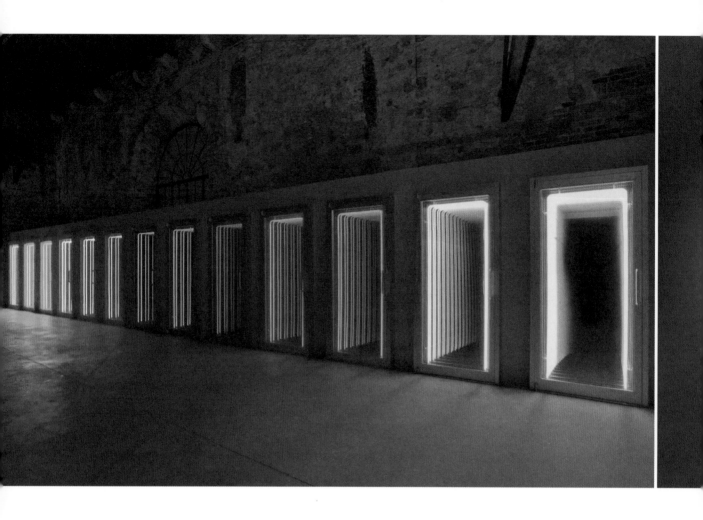

in reverse. Sure enough, the patterns on the table are the mirrored reflection of the text that's needed, so that the bends and loops that form the letters and keep them connected will end up facing the wall mount and the clean text facing the viewer can be read correctly. "NO MAN'S LAND," reads one of the patterns on the table, and glass bender Eddie Skrypa, forming the oversize O, laughs because he hadn't noticed what the text said—he was so focused on creating the forms and shapes.

"We're busier than ever before," Friedman says, ticking off big-name commissions in the city, like the sign they just created for the debut of a new Coach campaign in its big window display on 5th Avenue. In the shop, the glass benders are hard at work creating signs for two hip shared-workspace companies. Startups, Friedman says, have been obsessed with having their own neon. Part of LTBN's success is that they're one of the few shops left. In their original location in SoHo, there were at least six other competing sign shops within blocks. Those shops gradually closed, or shifted their work to other, cheaper signage media, leaving today's burst of neon fervor to the team at LTBN. And of course clients recognize the quality and skill of his team's decades-long experience.

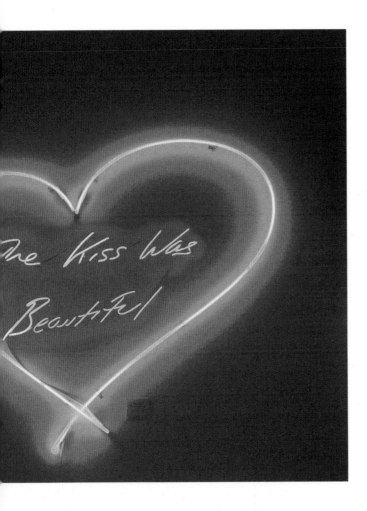

Private commissions are also booming. Friedman describes a ten-plus-foot martini glass they made for one high-ceilinged loft, but text-based designs are still the most popular. A project done in blue-green lettering reads, "so mushroom in my <3 for you"; the studio posted it on its Instagram with a caption that perfectly describes the creative and playful approach at LTBN: "We don't ask, we create." Friedman delights in the ways that the personal (and personality) can be fused in neon, and in its unique way of communicating a message. With neon, writing your love in lights is a real option too—among the most popular requests is "Will you marry me?"

Following Stern's vision, LTBN has also been a longtime go-to for artists—Tracy Emin and Iván Navarro (their work shown here), and Keith Haring, to name a few. "That process [of working with fine artists] is a lot different," says Friedman. Special attention is often needed from the designers and engineers in the shop for the incredibly custom and complex projects. One example is Olafur Eliasson's *Daylight Map* (2005), which used neon tubes overlaying a world map, their brightness synced with their corresponding time zones.

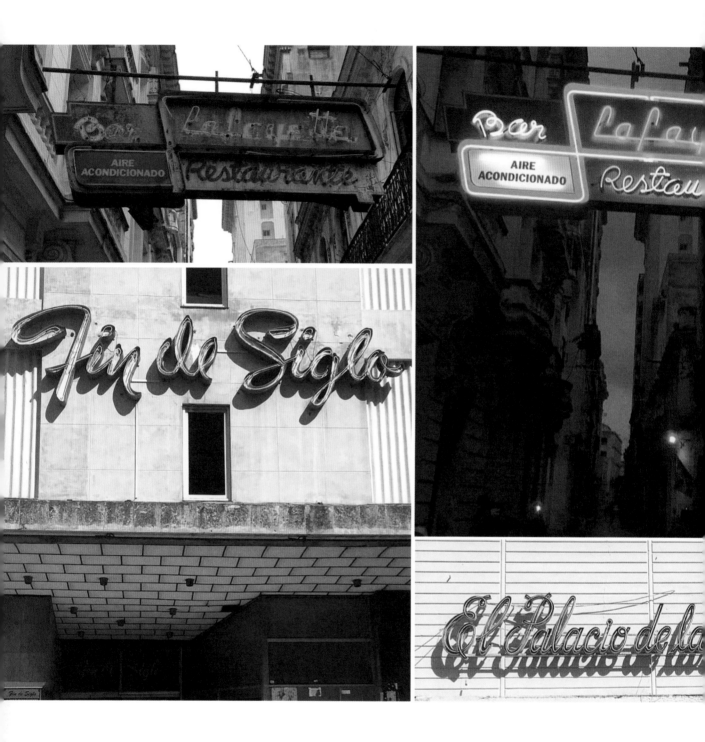

"They've got this sign that's been broken and hanging and unlit for decades," Friedman says, describing the neon sign for Bar Lafayette and Restaurant, a historic restaurant in Old Havana, Cuba. In the 1940s and '50s, Havana's streets glowed with neon after dark, but maintenance was costly, and after the tourist industry dissolved in the 1960s, many signs fell into disrepair and gradual decay. Artist Kadir López Nieves mourned the loss of the neon that he associated with the city's colorful past, so he founded Havana Light—a project dedicated to restoring Havana's incredible neon. Friedman was visiting Cuba in 2016 when he met López Nieves, and he realized it was a project that his team at LTBN could help with. In the years since, LTBN has provided restoration services, materials, and supplies—although strict laws and government embargos do not make the process easy.

But for Friedman, the continued struggle has been worth the while, especially for moments like these: "The sign [for Bar Lafayette] goes back where it was, and it's relit. The people are mesmerized!" When a hurricane hit that year, he says, there was a moment of despair when the sign was nowhere to be seen after the skies had cleared. But the neighborhood had become protective of their reborn sign, and locals had taken it down before the storm and kept it safe. "[People] get so excited about seeing something that was about to disappear come back to life," Lopéz Nieves said in a documentary on his project. "Neon, it means a restoration of hope . . . and there's nothing stronger than that."

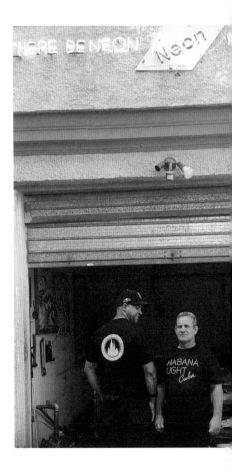

The Image Colorists

MATT LOUGHREY, MY COLORFUL PAST
DUBLIN, IRELAND

GRACE RAWSON, WHITE'S AVIATION
AUCKLAND, NEW ZEALAND

" I have always enjoyed looking at history," says Matt Loughrey. While the traditional learning part didn't come as easily, "visually I absorbed it." Now, as a colorist, he uses artful photo retouching software to give new life to iconic images of celebrities and historical figures, photos of long-disappeared subcultures, historical portraits of people in traditional costume, and other black-and-white photos, carefully applying color which he painstakingly researches to align with the era.

Loughrey credits the Internet with reviving his interest in history by offering wider access to historic images. As a personal challenge, he colorized an image, just to see what would happen. He was encouraged by his young sons' excitement over what his work revealed in the photograph, so he kept coloring more images. "I told myself there and then that the end result had an educational merit," he says, "and that's when My Colorful Past really began." His ongoing project, My Colorful Past, frequently garners new attention as he releases new sets of images, from portraits of Abraham Lincoln or of Ellis Island immigrants, to photos from NASA's archives and vintage mugshots. "The technology is here to see the past in the same way the people in historical photographs saw their world," he says, which is what many viewers of his images find so incredible.

Loughrey's work is a contemporary interpretation of a process that began in the earliest days of photographic technology. Beginning with the daguerreotype in 1839,

"The human brain is designed to see in red, green, and blue," says Loughrey, "and when the results are so accurate, it becomes of educational value as opposed to preferential." Loughrey's coloring of vintage NASA photos for My Colorful Past received the biggest response he's had yet—the images were featured in the UK's *The Daily Mail*, as well as in *National Geographic*.

and the monochromatic processes that followed over the next hundred years, hand-tinting and hand-coloring was a highly popular means of bringing black-and-white photographic prints to life. Photography disrupted the centuries-long industry of the painted portrait, and many portrait artists adapted to the changing times by becoming photographers or working as painters for photographic studios. The new processes also democratized portraiture: Where previously it had been exclusive to those with wealth and status, the more affordable and faster photographic method gave access to the masses and led to widespread popularity.

In the 1950s, color film technologies were still in their early days, so hand-colorists were used in industries like advertising, the news media, and fine art photography. White's Aviation was an aerial and landscape photographic studio in Auckland, founded by Leo White. His studio produced large prints, some as large as wall murals, to promote the beauty of New Zealand. Each image was hand-colored by one of the company's young painters, and Grace Rawson, now in her eighties, was one of those artists. While she hasn't practiced the technique in decades, she recently demonstrated her skill for a short documentary feature, *The Colourist*, by Loading Docs. "What people don't realize," she says, "is that every single White's Aviation photograph is an individual, hand-colored original. They were not prints, and that made them very special." The studio's supervisor would inspect each painting, she says, and if it met with his approval, he would sign the piece as a White's original—in white ink, of course. The slight variations and imperfections in the work of the hand-colorists is part of the charm, and the White's Aviation prints are now big collector's items.

Soldiers, immigrants, beachside bathers, and more all come into clearer focus under Loughrey's touch.

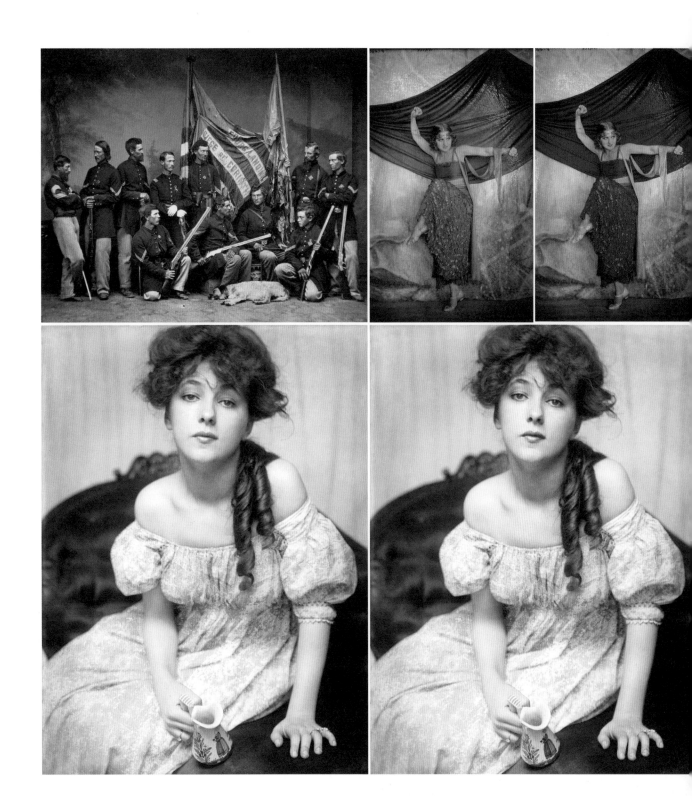

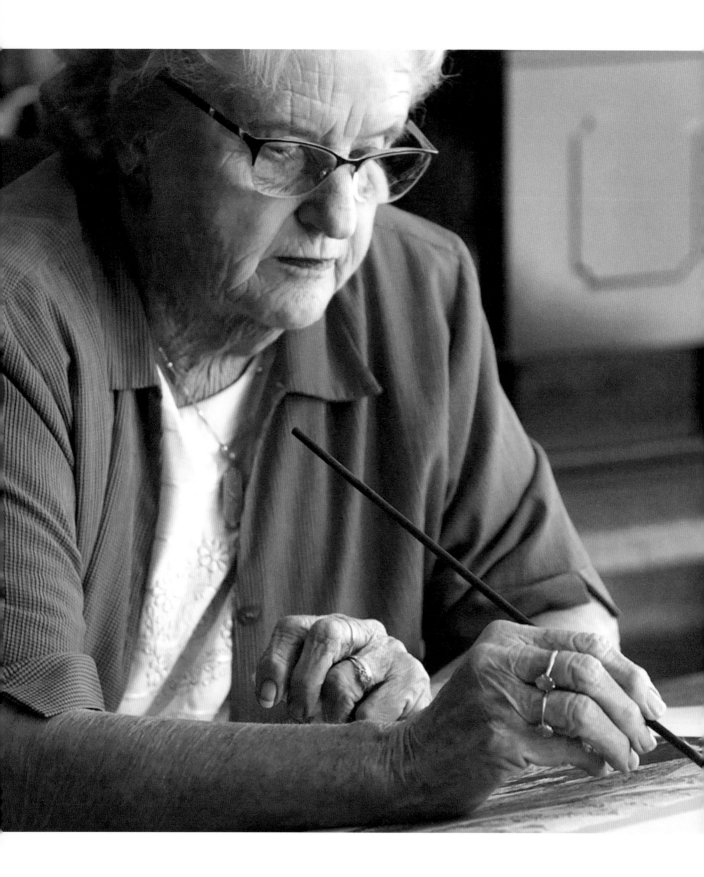

Today, it's fine artists who use the dyes, watercolor paints, or other pigments that colorists like Rawson used. This shift started in the 1960s, with artists like Robert Rauschenberg incorporating hand-coloring in his mixed-media work. Now the technique is used by artists like LA-based Shae Acopian Detar and Czech photographer Jan Saudek to create a surreal or mystical effect.

The handmade quality offered in the work of Rawson and her contemporaries, and of other artists working today, is of course very different from the meticulous precision of Loughrey's digital work. But he says that even digital colorists cannot leave the human hand behind. "The image is still hand-colored digitally," says Loughrey. "Attempts at clever algorithms or other ways to automate the process are crude and inaccurate." The human eye and hand always capture the details best, even with digital tools in hand—after all, he adds: "Life lives in the details."

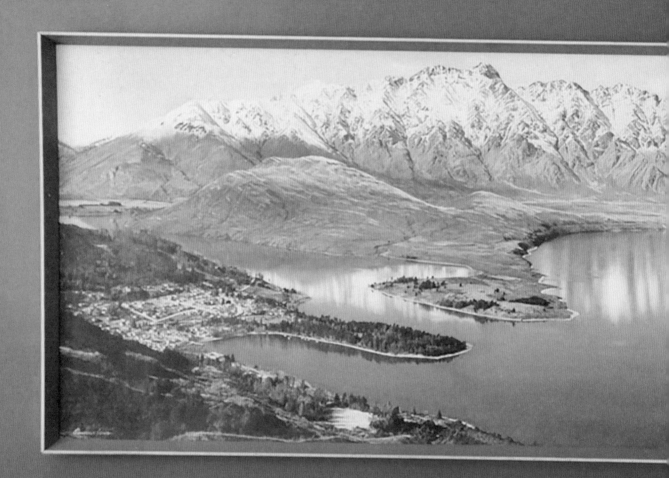

Rawson estimates that she hand painted over one hundred prints while employed at White's Aviation. Today, the images are sought after and seen as rare examples of a midcentury style, and a celebration of New Zealand's beauty.

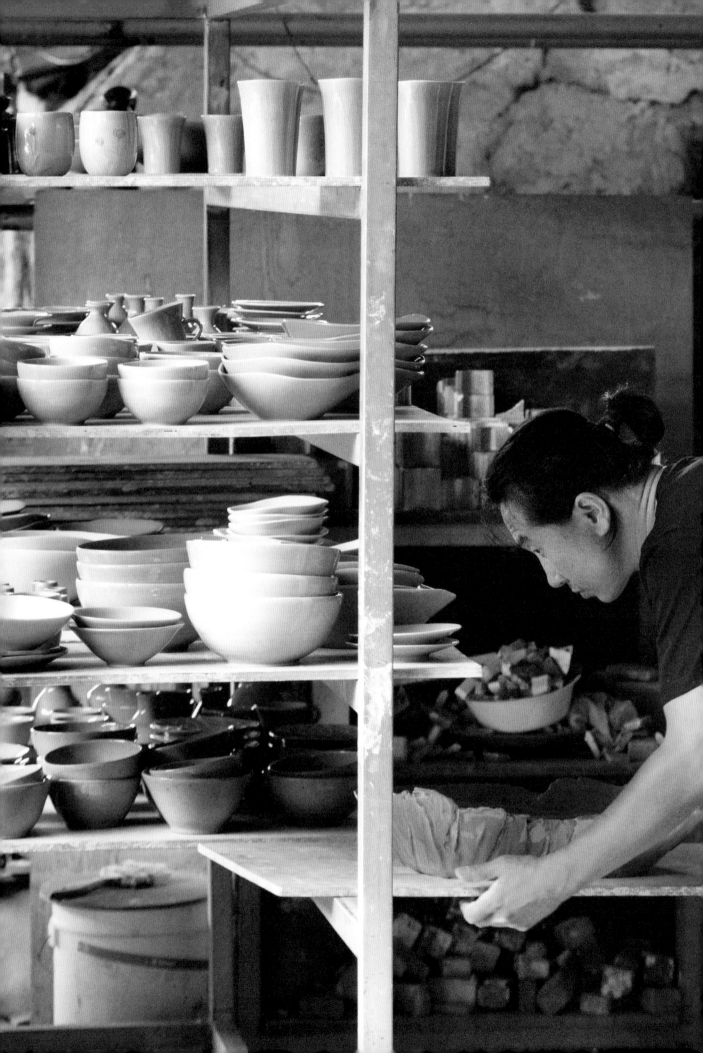

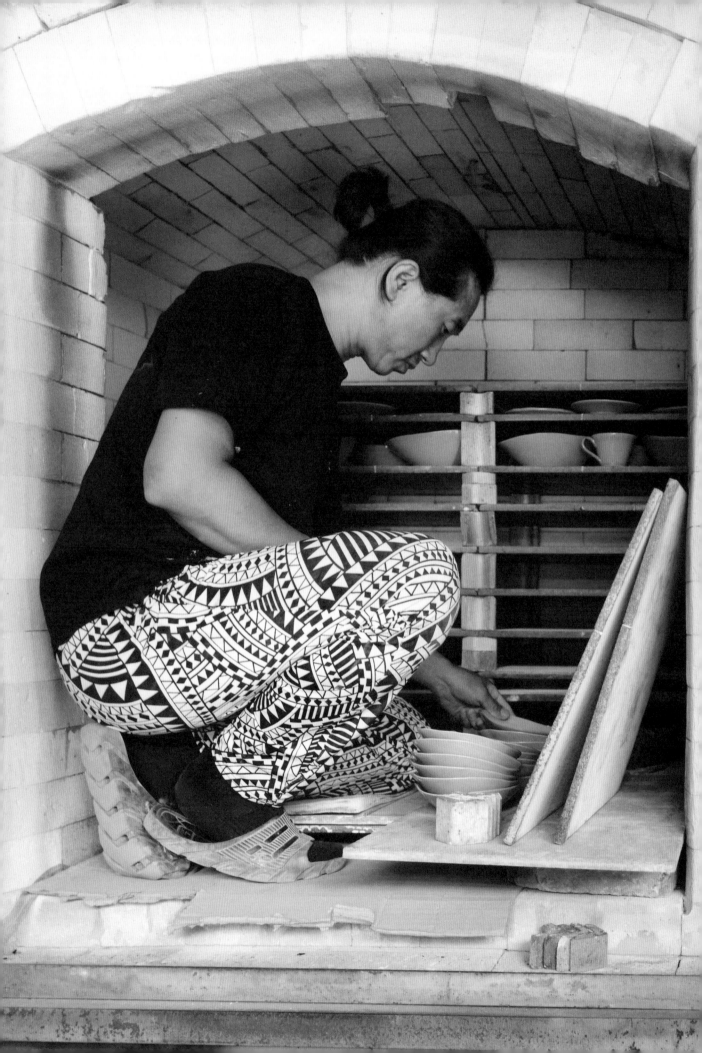

LEE EUN BUM,
GALLERY HUUE
EUMSUNG, SOUTH KOREA

Lee Eun Bum's first memories of clay are of its softness. "The first time I placed clay on the potter's wheel and the moment I started shaping, the feeling of my hand touching the soft surface was very satisfying," he says. He was also in awe of its flexibility: "The way it shapes depending on the strength of the hand, the way the body bulges, the way it does not create angles, the way it easily blends out, and the way it seems surrounded." Lee compares clay to human relationships as a metaphor for the ways in which people can change and grow under different circumstances. "The properties of clay appear to influence my life greatly," he says. Lee works in the Korean celadon tradition of Goryeo, named after the Korean dynasty of the tenth century, during which time the style was introduced.

Lee embraced artmaking around middle school, when he was sent away from his family's home in the country to study in Seoul. Yearning for his family and the pastoral life he had always known, he turned to art (especially ceramics) to help him cope, and it became an inextricable part of his life. In college, he shifted his focus to ceramics entirely and trained in traditional techniques like Onggi, Korean plaster casting, and the Japanese Bizen style of high-temperature fired pottery. When he reached his thirties, he began to recognize the special qualities and potential of the Goryeo tradition, intrigued at first by the similarity between the pottery's hue and precious jade.

The Goryeo celadon glaze is a mix of manganese oxide, quartz, and iron oxide. Celadon is fired at a high temperature in an oxygen-reducing kiln, which is built to prevent the flow of incoming air during the firing process. In the low-oxygen and hot environment, the iron oxide undergoes chemical changes and reacts with the other elements in the glaze to create the green hue; the lower the amount of iron oxide in the glaze, the greener the celadon will appear.

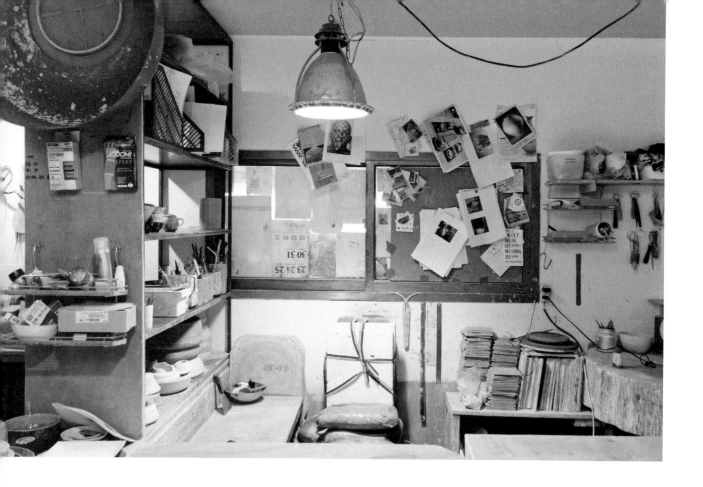

The word "celadon" was created by Westerners in the seventeenth century who thought the hue worn by a character named Céladon in a French play evoked the green of a certain style of Chinese ceramics. Although the ceramics were also called "greenware," the term "celadon" has stuck as a catchall to describe the luminous, blue-green, glazed ceramic tradition that spread from the Song Dynasty in China to become significant in Japan and on the Korean peninsula.

Goryeo potters initially mimicked the Chinese aesthetic and style closely, but by the twelfth century, the Goryeo celadon tradition was thoroughly Korean. Artisans incorporated the local *sanggam* technique, a delicate inlay process not seen in the Chinese ceramics, and the glaze shifted to an earthier, gray-green celadon resulting from the unique raw materials of the region. The Goryeo style and excellence was celebrated even by the Chinese courts. But by the thirteenth century, the Mongol invasion on the peninsula disrupted the artistic boom, and even as the celadon practice continued, the level of quality and creativity never fully recovered.

Lee researches the old Goryeo practice, and often tracks down old celadon remains around the Korean peninsula to study the broken pieces and identify the regional varieties. This informs his understanding of the interplay between clay and glaze and how that creates different effects. Over the last centuries, he notes, the globalization of Korean pottery and industrialization of the celadon process overall (in China and Japan, and on the broader market) have homogenized the celadon aesthetic to idealize pure white porcelain and a few chosen hues, which leaves out the incredible diversity that is available in the practice. He fears this may be shortening celadon's lifespan, and it lends so much more importance to his work in the Korean tradition.

The look and feel of Goryeo is inextricably tied to local materials, so Lee's work begins by making his iron-rich clay. He collects it in raw form near his studio outside Seoul, then hydrates it, adds sand or grit, and mixes it through traditional methods. This deepens the color, he says, and, compared to other white porcelains, imbues Goryeo clay with superior shaping capability that prevents cracking and sagging in the firing process. It also adds more visual interest for the range of its natural pigmenting (though it is still a white porcelain). Each clay variety presents its own challenges, he explains, so it requires different production methods and skills. The final products can turn out more speckled or more smooth, or lend to the effects of the gray-green glaze.

After the first firing, the bare clay bodies of bowls and dishes are taken from the kiln and left to

Sometimes Lee starts with a sketch, but he tends to modify it spontaneously once he begins throwing the clay on his potter's wheel, so the sketch never looks like the finished piece anyway. After the vases, bowls, or other forms are left to harden, he might incise the clay with patterns or other details before the first phase of firing.

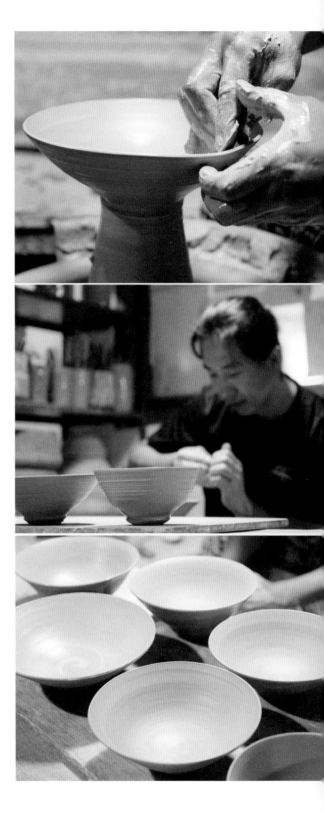

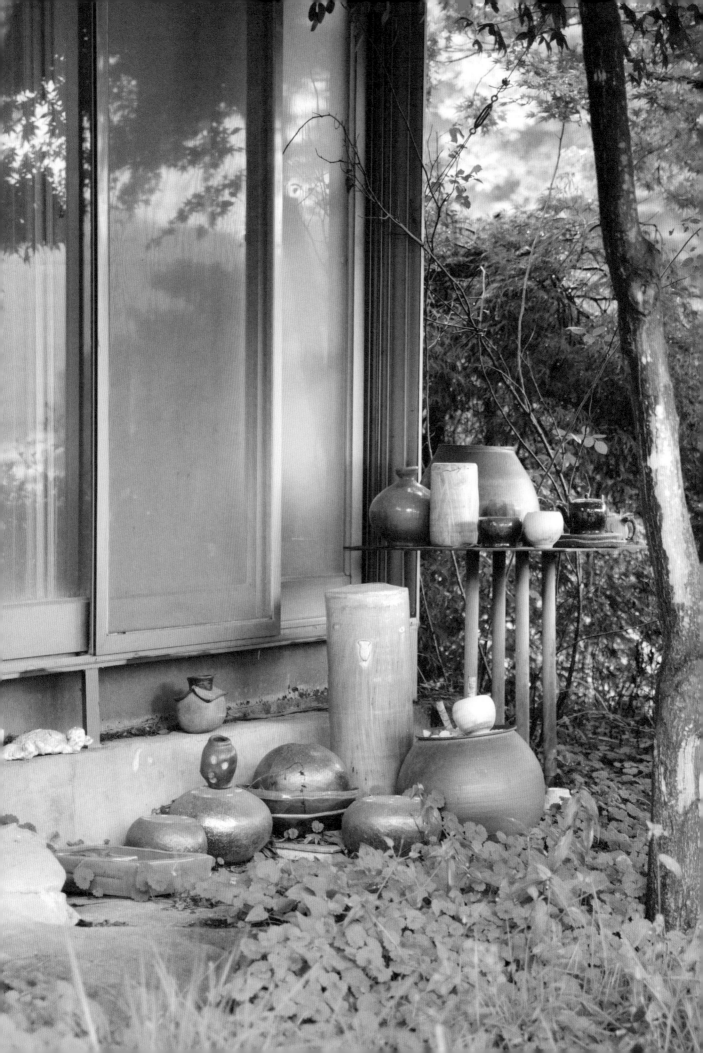

cool. Then they are ready to be glazed with the Goryeo celadon's particular balance of manganese oxide, quartz, and iron oxide—the amount of the last ingredient will determine the greenness of the final piece.

Lee follows the traditional ways, but he creates work that is uniquely his own. He views celadon as a living and breathing practice that continues to grow and mature. There is advantage in tradition, he says, because it represents hundreds of years of accumulated knowledge. But under his motto of "mastering the old to create the new," Lee departs from his predecessors by experimenting with color both in the Goryeo clay body and in the glaze, rather than prizing consistency. And unlike the tall vases and Buddhist motifs of the potters before him, who strived for perfection through balance and proportion, Lee's work draws from the imperfections and diversity in nature through playful asymmetry and unrestrained experimentation. His work is tied to tradition, but this experience of letting go, he says, has helped to forge his own identity as an artist working today.

"If you collect all the yellow leaves of a tree and compare them, there are no such thing as same shape nor same color," says Lee, emphasizing the need for maintaining variety and regional styles in the celadon tradition. He adds: "Likewise, diversity delights us and makes the surroundings flourish. To prevent life becoming simple and dull, we need to face new challenges and make diverse attempts. Shouldn't keeping and developing Goryeo celadon be part of it?"

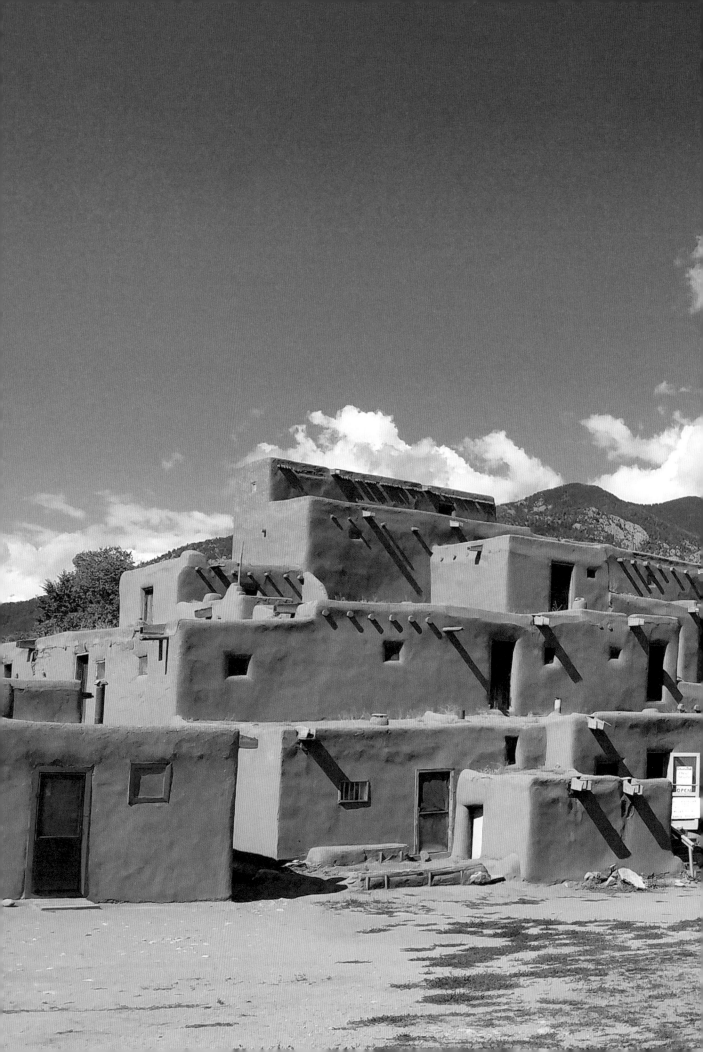

The Enjarradora and Adobe-Builders

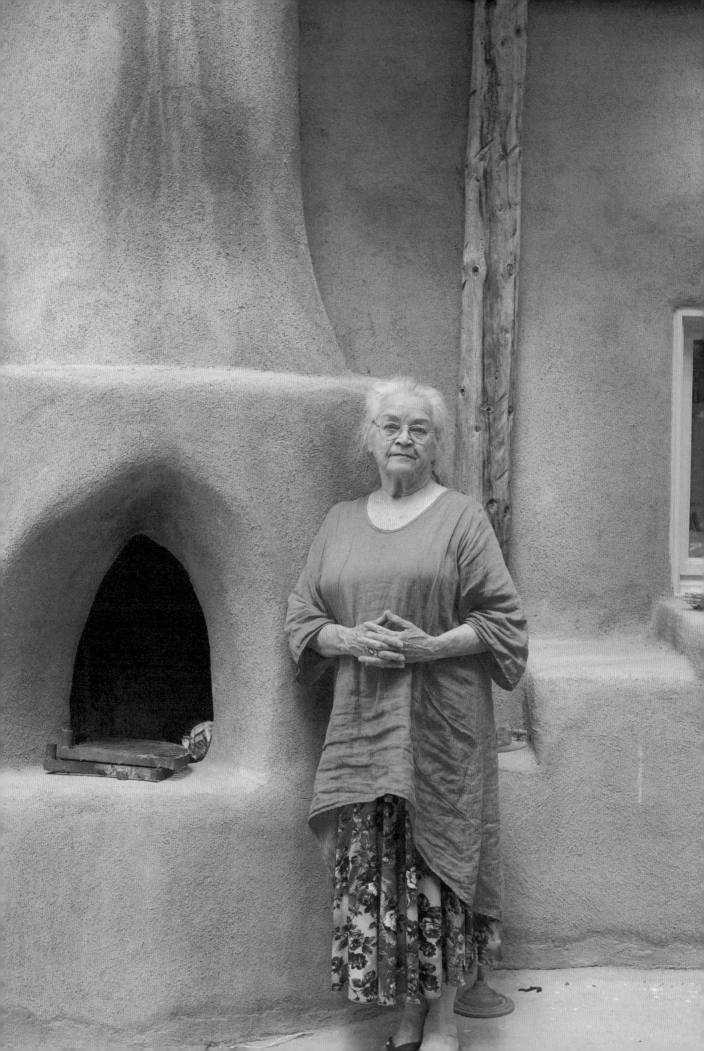

ANITA RODRÍGUEZ,

TAOS, NEW MEXICO, USA

JOANNA KEANE LOPEZ,

ALBUQUERQUE, NEW MEXICO, USA

I n Socorro, New Mexico, a small, dusty town, sculptor and multimedia artist Joanna Keane Lopez's great-grandparents earned a land grant and built her family's adobe home. "Adobe is something you have to have a relationship with," says Lopez. "If adobe isn't taken care of, it falls apart." Inspired by her family history, Lopez uses the traditional methods of adobe and contemplates its meaning in the contemporary world. "[The house] represents something that has withstood time and has had generations of family members take care of it and build onto it," she says. But while her father maintains the home today, the family thinks the US government's nuclear testing near Socorro from fifty years ago has begun to take its toll on the health of the land and its inhabitants. Without continued care, the house will erode more and more with time. "I feel like my

Rodríguez lives in the town of Taos, not far from the ancestral Taos Pueblo—a living testament to the indigenous adobe practices of the American Southwest. The nearby town of Taos was also once mostly adobe but has since been modernized. Meanwhile the pueblo looks much the same today as it did when Spanish explorers first saw it around 1540. They apparently mistook the warm golden-brown pueblo for Cibola, one of the fabled golden cities like El Dorado.

The pueblo is comprised of two immense structures, called Hlauuma (north house) and Hlaukwima (south house). It contains many individual dwellings, adjacent and stacked within the pueblo, sharing common walls (but no connecting doorways) and public space for cooking and socializing. This proximity and the sharing of space reflects and reinforces the traditions and values of Pueblo culture. "The women can cook together, watch their children together, and live among friends and generations of women," says Rodríguez, adding that instead of your grandmother living across town in another apartment, she would live next door, and could help care for the children and share her knowledge, wisdom, and stories. The knowledge of old women, she says, has always included the art of *enjarrando*, adobe-building and maintenance.

work takes on this quality of being an echo, a ghost, a memory of land-based lifestyles, something lost and fragmented and reaching to recover it, reconnect, or find some kind of inkling of continuity."

Lopez learned much of what she knows about *enjarrando* (the adobe practice) from Anita Rodríguez, an artist and builder. Rodríguez's connection with the material in turn extends from centuries of *adobera* (adobe-builders) before her. Rodríguez was born and raised in the town of Taos, near the immense, five-story pueblo of the same name that is the longest continually inhabited structure in the United States. It has housed a thousand years of Pueblo generations since it was first built by the Anasazi. The structure owes much of its longevity to the Pueblo women: Men traditionally built the adobe bricks and constructed the walls in Pueblo culture, says Rodríguez, but the women *enjarradoras*—literally "plasteresses"—were the embellishers, the finishers of the walls and floors and surfaces, and the maintainers. Women kept the interior surfaces clean and beautiful, using *alises* (colored or white clay slips that are used to paint the mud walls). They built the adobe interior furniture, the central hearth, and the outdoor *horno* (the beehive-shaped adobe oven), all with the skills handed down through oral tradition over the centuries.

But the work of the enjarradora has largely been left out from the Western narrative of adobe's architectural history, says Rodríguez. When she returned to Taos in her twenties, drawn to the practices she remembered her grandmother doing, she learned the feminine enterprise was disappearing. Adobe-building had been absorbed by the for-profit construction industry, dominated by men, and because it was no longer communal, women were excluded. "But," she says, "the men still had to go home to their grandmothers at night to learn how to properly plaster and finish their walls and floors." To the consternation and fascination of the heavily male industry, Rodríguez earned her contractor license and started her own building company in the 1970s. "It was tough to be a woman [in that industry], but that also made me famous!"

Right: Rodríguez plastering at an adobe structure for her contruction business in the 1980s.

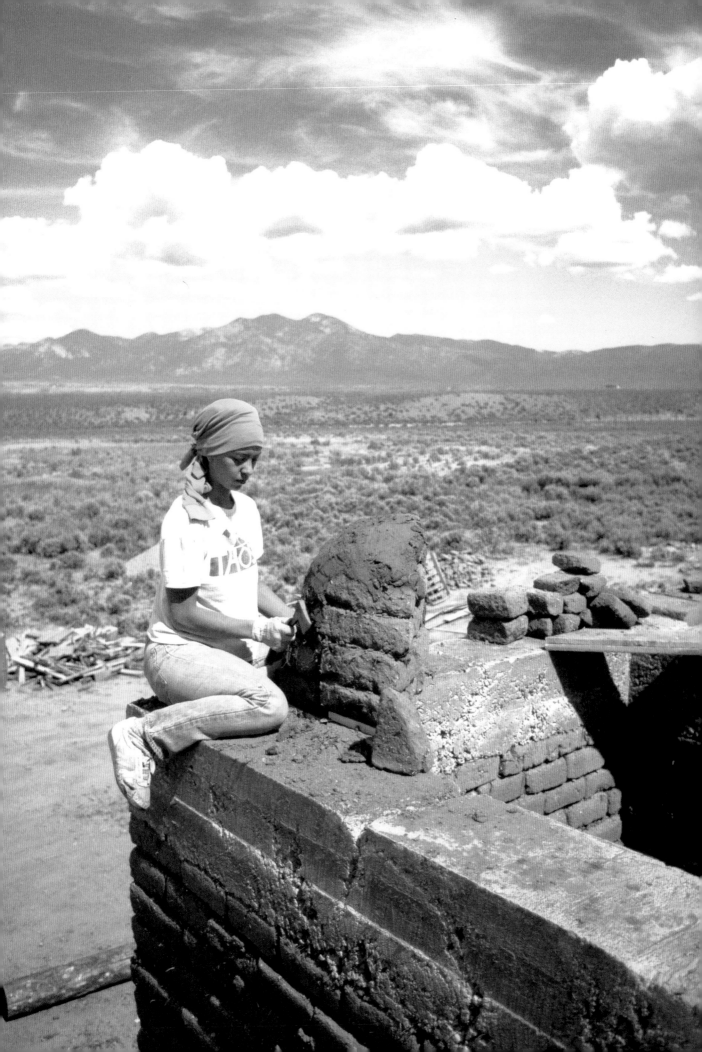

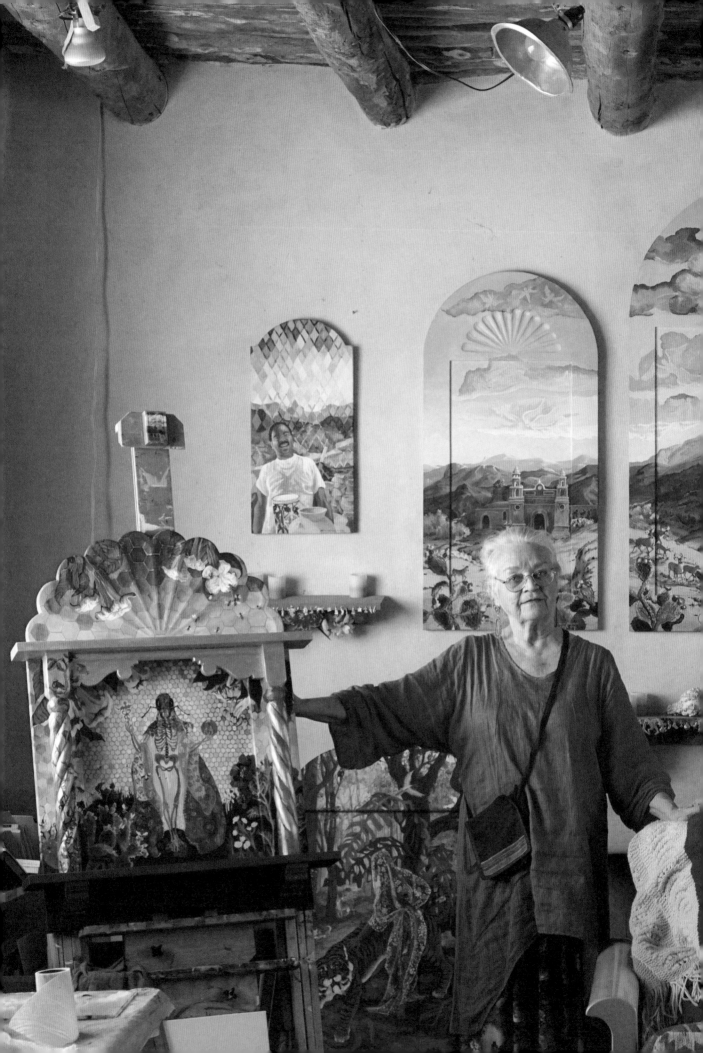

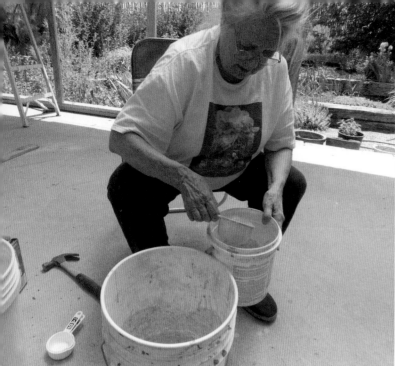
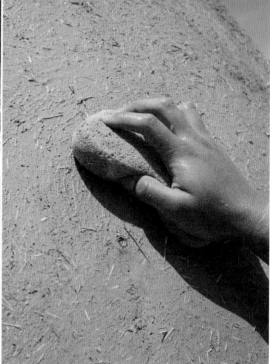

As Rodríguez's apprentice, Lopez helped dig up caliche, a white clay that occurs in geologic layers all over the Southwest. Mixed with buttermilk and painted on the interior walls, caliche helped maintain the beautiful pinkish eggshell hue of Rodríguez's self-built adobe home. With just a teaspoon of earth and liquid, Rodríguez can repair almost any crack or wear around her home, and it is this availability and accessibility of earth-building materials, she says, that will always make the adobe and earth-building process the most essential architectural technology we have. Rodríguez also channels her creativity into her colorful paintings.

Until age 47, Rodríguez devoted her life to learning the old techniques from the aging enjarradoras. She learned where to gather the dirt, clay, and sand for mixing into the perfect adobe, which won't crack when it dries into strong adobe bricks. She learned where to find any color of dirt you can imagine for pigmented walls and surfaces. And she learned the importance of keeping the practice sustainable. "We take what we need from the earth, and no more," she says, "and we thank Her for giving it." In the twenty-five years she worked as an enjarradora, Rodríguez helped restore adobe churches, municipal buildings, and other historic structures in remote areas of New Mexico, built homes for private clients, and consulted with architects and builders on the proper adobe techniques. She traveled to places around the world—including Egypt, the Middle East, and China—to teach the enjarrando style and learn about the global earthwork tradition. Back in New Mexico, she is now retired but still holds workshops on adobe techniques and has taught visiting courses at universities on adobe's sustainable construction.

It was from Rodríguez and another New Mexican enjarradora, Carole Crews, that Lopez first learned to work with alis, a traditional clay slip. They also taught her to replaster, repair cracks, and smooth away water damage in old adobe homes—she worked on Rodríguez's and Crews's homes and joined them on restoration

projects. Lopez explored enjarrando in her thesis on adobe-building for her BFA at the University of New Mexico, and she continues to put adobe in dialogue with the contemporary world. At the heart of Lopez's new project, funded by a grant from the Andy Warhol Foundation of the Visual Arts, is an adobe wall that serves as a gathering place for storytelling and performances. This project explores the concept of *resolana*, or "place where the sun shines," often a reference, she says, to the sunny side of a wall where people come together to meet and talk.

To the ancestors, and for many centuries, says Rodríguez, the adobe practice was communal: Members of a village or pueblo all lent a hand in the labor-intensive and satisfying process of mixing the adobe, building the structure with the sun-dried bricks, and plastering the whole piece to bake beneath the kiln of the sun. They worked together to create a vessel for living, spiritual worship, or community gatherings. And when adobe is no longer needed, and its carers have ceased repairing the natural wear and tear of weather and time, says Rodríguez, adobe will melt back into the earth, ready to be reused and remade.

The crescent moon–shaped walls and mirrored surfaces of Lopez's 2017 work *Persist, Repeat, Reflect* reflected the Sandia Mountains in Edgewood, New Mexico, and merged the three tons of whitewashed adobe with slices of the Southwest landscape from which it was harvested.

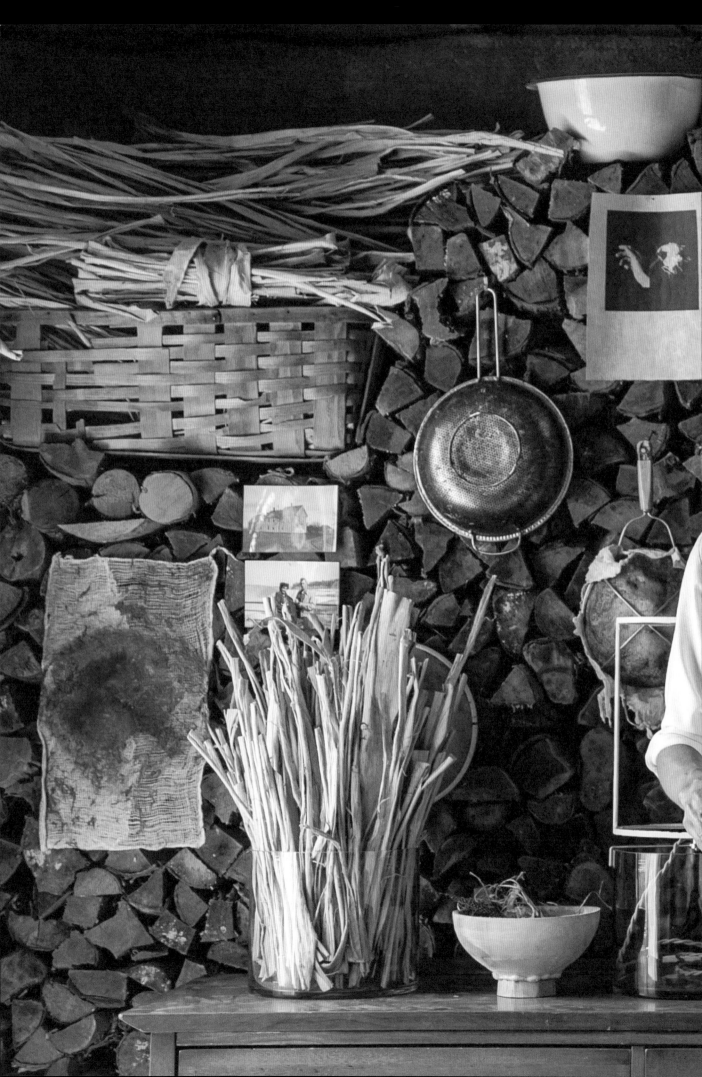

The Papermaker

STEPHANIE HARE,
SHARE STUDIOS
PHILADELPHIA, PENNSYLVANIA, USA

With coffee in hand and puppy at her feet, papermaker Stephanie Hare starts her day in the basement studio of her home. First she'll take stock of the projects and processes in progress: "I am often working on quite a few different batches of paper or other projects, so I bounce back and forth as time allows." The whole process takes quite some time, so she typically has fibers in progress at every stage.

If it's a Kozo cooking day, she'll be up early, because the process will take close to five hours from start to finish. The raw Kozo—the inner bark of the paper mulberry plant (she prefers a Thai varietal)—has already soaked overnight, and she'll add those prepped fibers to vats of soda ash and simmer them over propane burners in her tiny backyard in Philly—or at times on her family's rural property in Maine. The Kozo will cook in the caustic solution for three hours to break down its tough cellulose and will leave behind a fibrous mush. After a thorough rinse, the mush has to be beaten for several hours to break down the long fibers into a pulp. Hare still does this part without the help of machinery, although she is saving for a mechanical beater that will save time and boost her production. For now, she meditates for a couple of hours while rhythmically beating the fibers with a wooden mallet atop a granite slab. She'll then hydrate the pulp in a wide vat and add pigment, in preparation for "pulling sheets" (which will result in something that starts to resemble paper).

Hare hit the jackpot one summer after college when she agreed to a part-time gig at a papermaking studio that took her from Brooklyn, New York, to Brooklin, Maine—a very tiny coastal town in her home state.

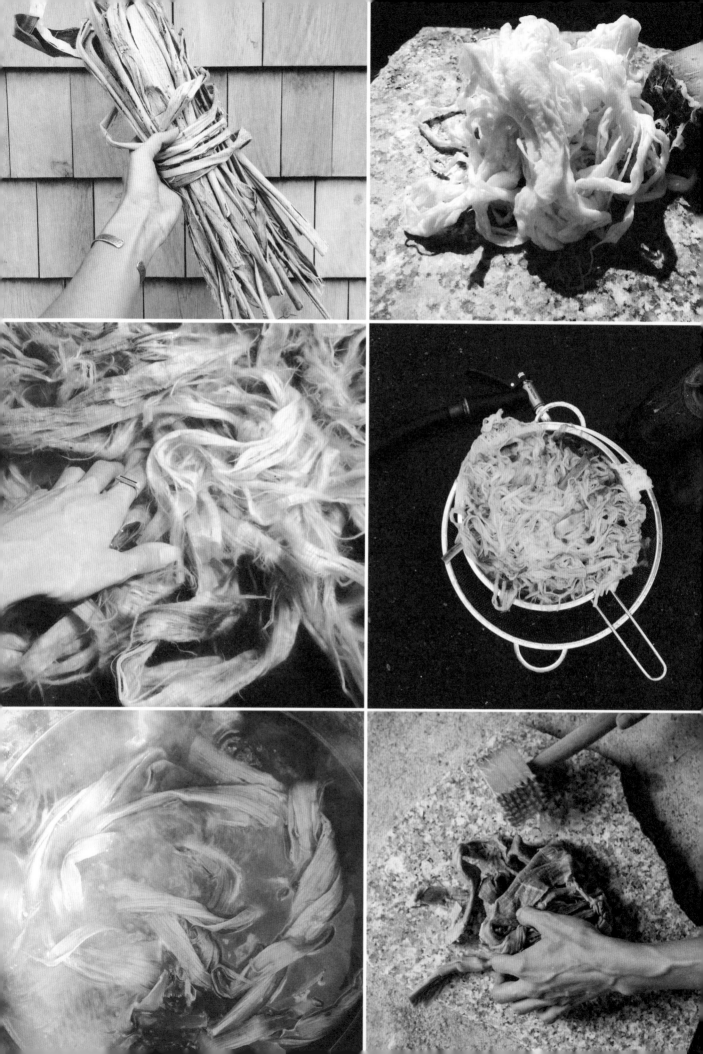

At this point, the process at SHare Studios would look familiar to papermakers from a thousand years ago. Preceded by papyrus and pressed bark, methods of early "papermaking" coincided with more popular clay tablets. The earliest known true papermaking processes were practiced in China in 100 C.E. Those papermakers also soaked and cooked their mulberry fibers (albeit over wood-fed fires instead of propane burners), and then further softened them to prepare for making smooth sheets.

Over the centuries, this manual process spread from China to Japan, Korea, and other surrounding cultures, and went west into the Middle East and eventually Europe. A major shift in the scale of production came from Islamic papermakers of the eighth century, who refined the process for quality and also increased production by the use of water-powered pulp mills. The importance of and demand for paper drove the papermaking industry further into the West, where it continued to be refined and upscaled. By the Industrial Revolution, pulp was a major industry on its own, and papermaking was dominated by the large companies seen today. Small papermaking ateliers still flourish, but the bulk of the industry has been automated and standardized.

In Philly, Hare moves her hand in a hypnotic vat of indigo pulp-swirled water. This is the part of the process she has always been especially drawn to—the not-quite-paper vat into which she swiftly submerges the deckle (the frame holding a screen, which is known as the mould). She pulls a watery sheet of pulp from the vat and gives it a "papermaker's shake"—a swift and firm action possibly as unique to each papermaker as their fingerprint. The shake drains the water from the deckle and pushes the fibers to intertwine as the collected pulp spreads evenly to the edges of the mould.

It takes hours to cook, pound, and process tough Kozo fibers down to the soft, cloudy pulp that is the most basic and key element for Hare's work as a papermaker.

Hare's favorite part of the process is the mesmerizing swirl of the pulp. "The way that the graceful, long Kozo fibers float and slowly churn together, disintegrating and blending into a cloudy abyss still hypnotizes me with every batch," she says. This is also where she can experiment with color and texture. She currently loves saturated jewel tone pigments like deep blue, forest green, and rich ruby. She's also been experimenting with adding small feathers, flecks of gold leaf, flower petals, and other plant materials to add texture and pattern, which have stunning effects for the luminaries and lampshades she also makes and sells.

The sheet will sit in the mould and drain while she pulls another sheet (she has multiple moulds to keep the process flowing, and to pull different sizes). Then she flips the drained sheets out of the moulds and presses them between stacks of fabric felts, in the part of the process called "couching." A hydraulic press flattens the stack of couched sheets to finish removing the water, and also imprints the smooth texture of the felt into the sheets. After that, Hare will either hang the sheets to dry while they're still stuck to their felts, or transfer them to a "dry box" for a smoother result that is favored by her calligrapher clients.

"There is a sort of reverence that lies at the bottom of the papermaking practice," says Hare. "I love that it's a play on the traditional practices that started in ancient China. When you really think about it, paper is one of the most important innovations ever made. It's interesting to think about how such an important craft could fade away over time to become what it is today." In many ways, she says, digital has displaced paper, and traditional papermaking has retreated into the realm of arts and crafts. She feels this gives new meaning to what was once such a simple practice. "Handmade paper is truly a unique experience," she adds. "There is a connection between the maker and the person who inevitably holds the finished sheet in hand."

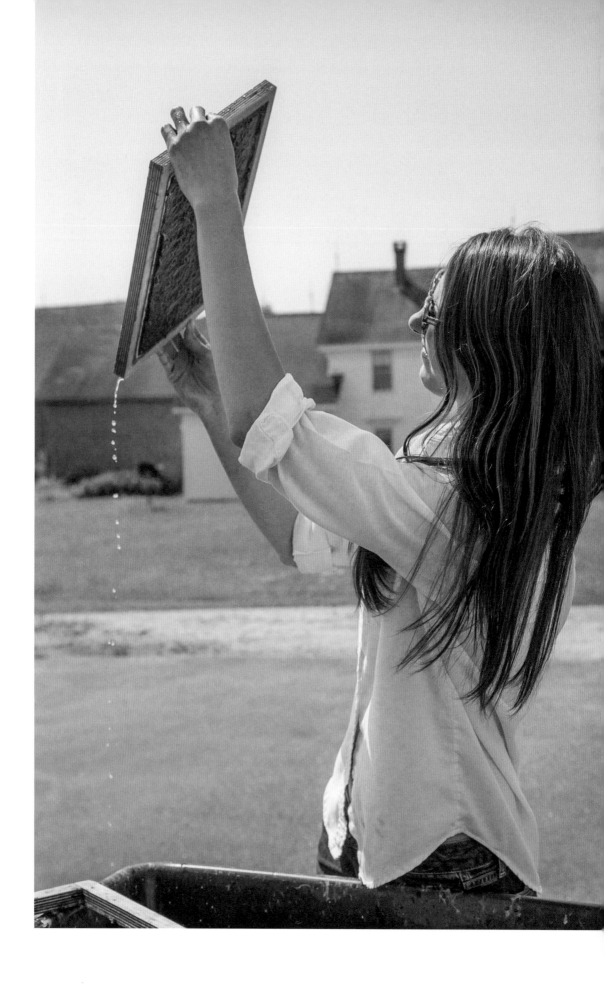

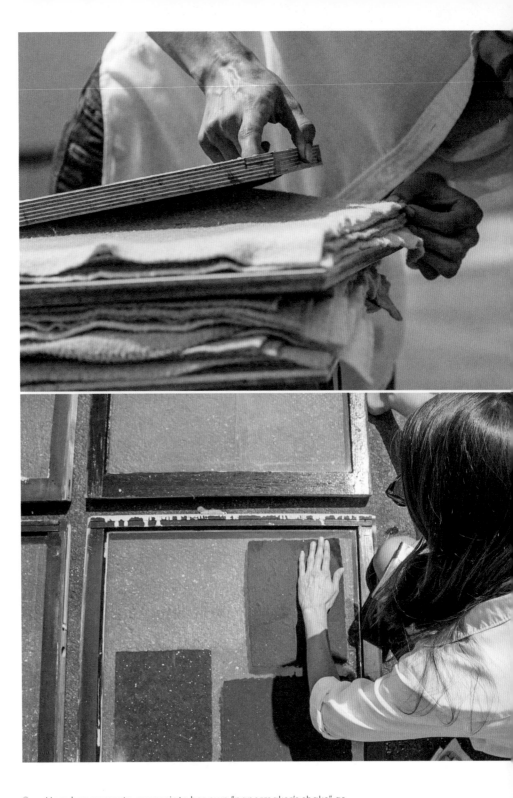

Hare has grown to appreciate her own "papermaker's shake" as her signature: "By hand-papermaker standards, my shake probably isn't the best," she says, but she loves that it's representative of the way she works, and how it captures the action. "Especially with my longer fibered papers," she says, "you can see the sort of splash and movement of the fibers as they relax into paper form. I think it adds a lovely depth to the finished sheet, and a sense of motion. I never strive to achieve a perfectly 'even' sheet. I much prefer the drama of my signature shake."

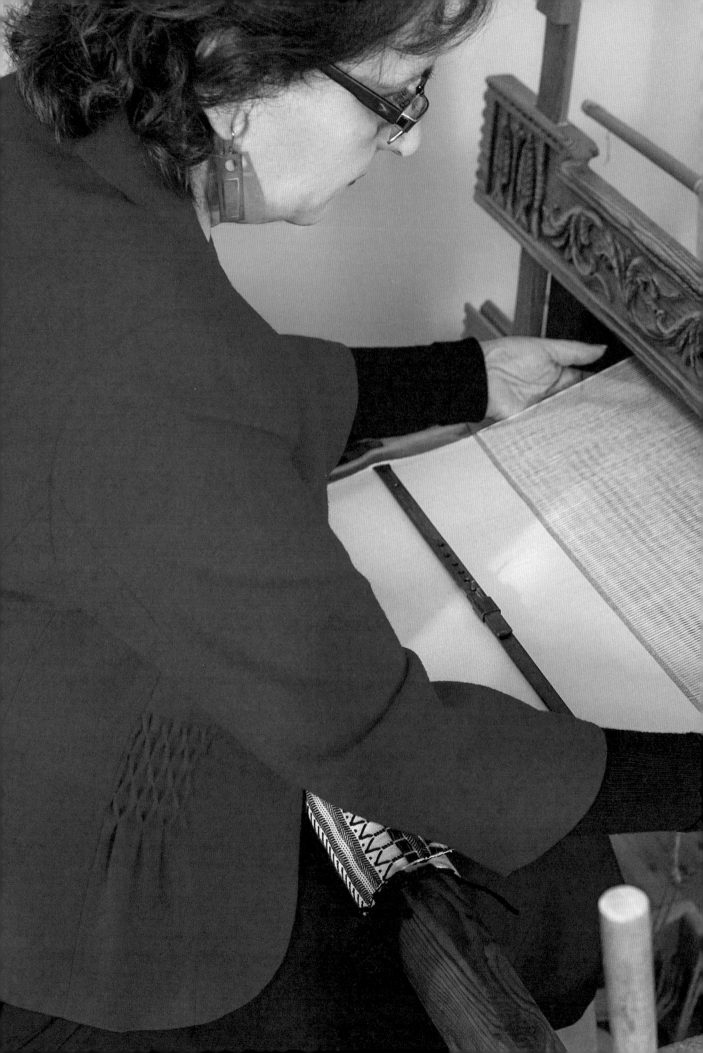

THE CYPRIOT WEAVER

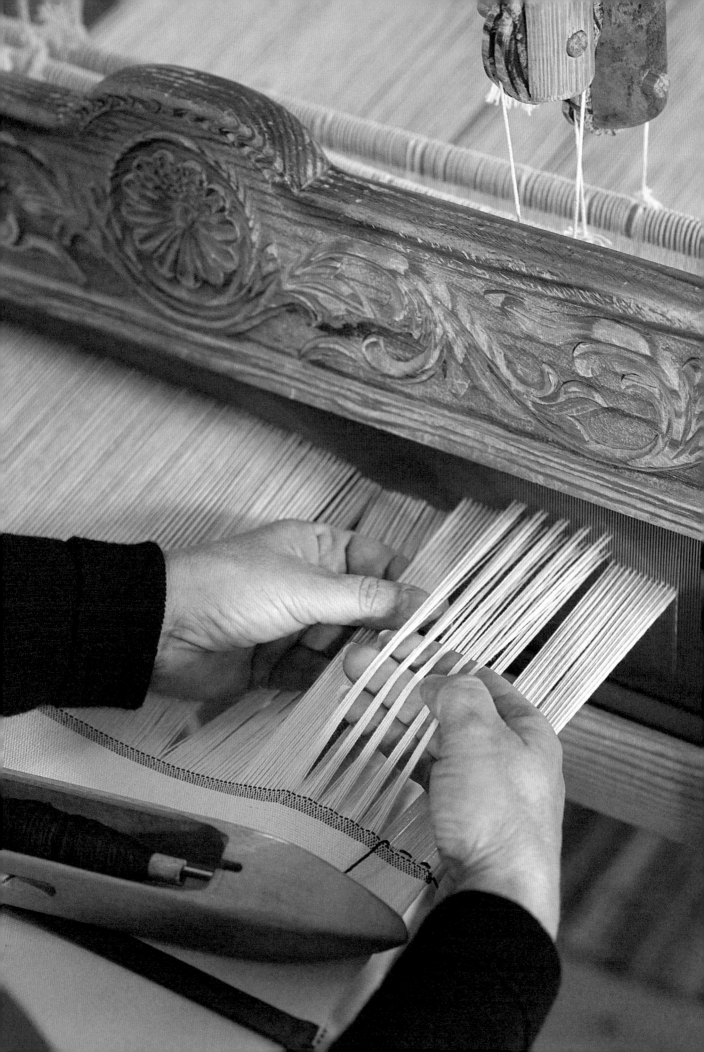

JULIA ASTREOU

NICOSIA, CYPRUS

Cyprus's unique culture and fascinating history is at the core of everything weaver Julia Astreou does, especially on her antique four-pedaled looms. To the cotton warp and weft, she adds local materials like raw wool, copper beads or wires, or seashells, for texture, weight, and color. Astreou is a master of traditional Cypriot weaving styles and designs, but she doesn't always stick to the traditional motifs. More often, she begins weaving without a particular plan, using the parts she likes as the basis for a finished piece. Most recently, Astreou has been creating designs inspired by science: "I find fascinating the balance of diagrams from physics and biology," she explains. "Their [composition] often follows the same rules of aesthetic balance as in design."

Astreou is one of only a dozen weavers on the island today who still practice the Cypriot weaving tradition. She works from her nineteenth-century home in the Kaïmakli quarter of Nicosia (Cyprus's largest city). She shares it with her illustrator daughter, Daphne, and it has been in the family for six generations—and always home to creative women. While Astreou's grandmother was a teacher, not a weaver, her aunts were experienced weavers. One hosted workshops from the home and took on apprentices. With some renovation, Astreou has adapted the space to better fit the oversized Cypriot weaving processes. Under the roofed veranda in her courtyard, she builds the large cotton warp (the lengthwise tension yarns on the loom, to which she will later add the horizontal

Textile, Astreou says, is a medium that allows as much expression as painting or sculpture. Using the traditional techniques allows her to convey meaning as an artist and keep alive the ancient Cypriot heritage.

Astreou hosts workshops and teaches traditional weaving from her studio, including *phyti*, the colorful, geometric style originating from a Cypriot village of the same name, and *asproploumia*, a textured, open-weave technique that more closely resembles ancient Greek designs. She plans to expand her offerings to other traditional Cypriot textile practices, including a local striped fabric, as well as embroidery, lace, and traditional costumes.

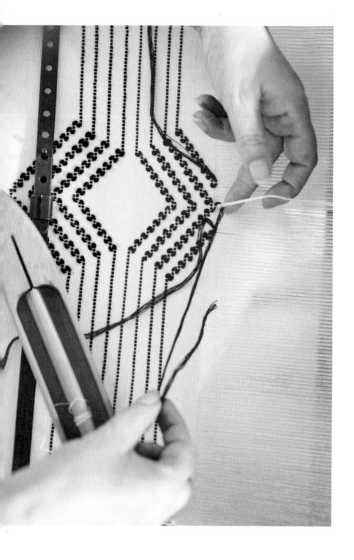

weft yarns). The warp needs to be about seventy-eight meters long per the Cypriot style. She then takes the prepared warp into her workshop, and joins the new warp to the old on one of her four enormous looms.

Each loom is from a different part of the island, Astreou says. The foremost Cypriot loom style is similar to eastern Mediterranean styles, but those from western Cyprus are smaller and more similar to traditional European looms.. The island's unique proximity to diverse civilizations from multiple continents over thousands of years, she says, resulted in the truly distinctive Cypriot culture and weaving tradition.

Cyprus sits in the bright blue waters of the eastern Mediterranean, with Greece to the northwest, Turkey directly to the north, and Israel to the southeast, and Syria and Lebanon close by. To the south lie Egypt and the expanse of the African continent stretching beyond. Beautiful beaches frame the island's rocky interior, which is dotted with wine regions, interspersed by archaeological sites relating to the island's famous cult of Aphrodite, the remains of grand dwellings, and impressive medieval cathedrals and structures. Long-inhabited coastal cities perch above sparkling lagoons or, like Nicosia, sprawl in the drier inland.

The whole weaving process starts with building the *syrma*, or warp (the vertical threads on the loom). In the courtyard of her home, Astreou sets up forty *kannia* (spools) on the pegs of a bent frame on the tiled floor, and then gathers the ends of each thread into her hands. The kannia spin as she pulls back the threads several feet, and as the length grows, she begins looping the threads around the pegs mounted to the adjacent wall, using a switch-backing pattern that stretches the gathered threads between the pegs. Finally, she carefully removes the threads from the

pegs, wraps them into a ball (this is the finished syrma), and takes them into the studio.

After the warp is made, Astreou joins it to the old warp, already on the loom, and pulls it through the heddles, the upright pieces that separate the warp threads on the loom, allowing room for the weft threads to be woven in between. In the Cypriot style, the heddles are thicker threads that have been dipped in a traditional flour solution called *psyshiasma* to stiffen them.

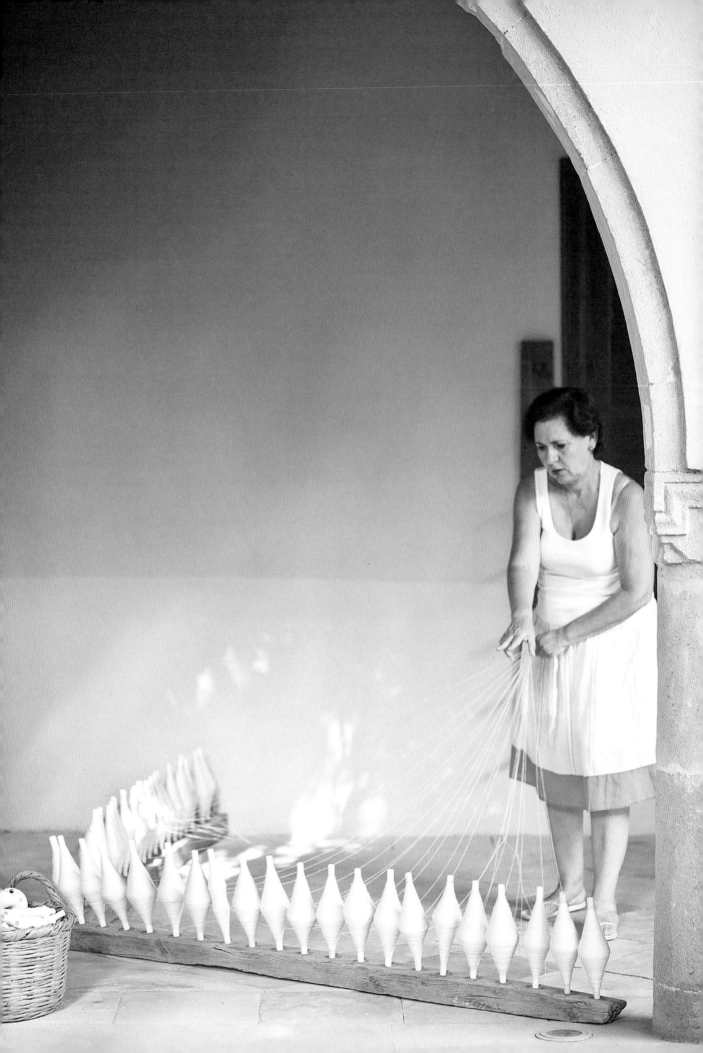

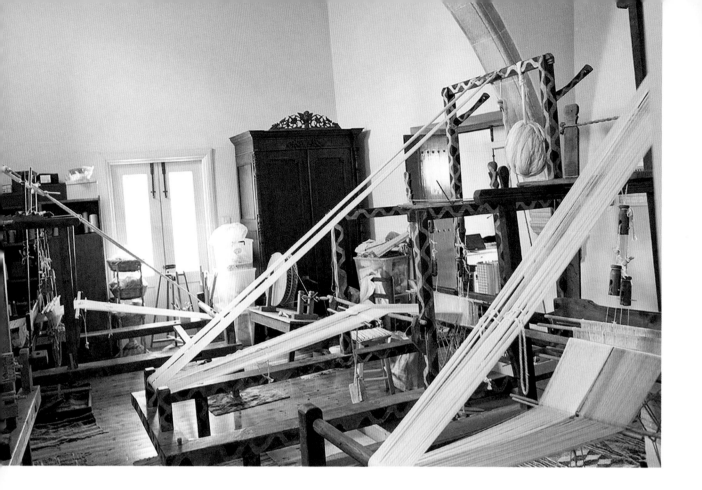

Astreou's workshop has seen at least six generations of women in her own family, and her looms also come with their own histories. There is much joy and pride in Astreou's work, and while she references tradition, her designs and style are utterly contemporary. Her unique aesthetic has resonated with people all over the world.

For centuries, weaving and textiles formed a key industry on the island. In addition to being a traditional weaver, Astreou is also a historian of how Cypriot weaving fits into the global weaving tradition. "It is difficult to distinguish when the weaving tradition emerged exactly," she says, "but it is known that weaving started [in] Neolithic times." Artifacts like bone needles and early spindles in Cyprus show that weaving and sewing were well-established practices even nine thousand years ago.

Growing up in a family of weavers, embroiderers, and women involved with other traditional textile practices, Astreou always had special skill in the visual arts. She studied textile design in England after completing secondary school, and it felt natural for her to specialize in weaving and knitting. "Our destiny," she explains, "is made by the talents gifted to us. It is up

to us to discover those talents and then apply them, and live them." Returning home, she spent the next two decades in the Cyprus Handicraft Service of the Ministry of Commerce Industry and Tourism, where she oversaw the Embroidery and Weaving sectors. It was here that she learned and mastered the traditional methods. She became an advocate for keeping the knowledge alive and she left the position in 2001 to work as a weaver and artist full time. Since then, she has devoted much of her time to teaching classes and hosting workshops from her studio. "There are no written instructions for learning the process of traditional Cypriot weaving," she says, so for now, the practice continues to be passed from experienced weavers like Astreou to the next generation directly.

"Traditional weaving is made from the knowledge and wisdom of many generations," she says. "It is modified by history and its study is important as it offers information about our culture and identity."

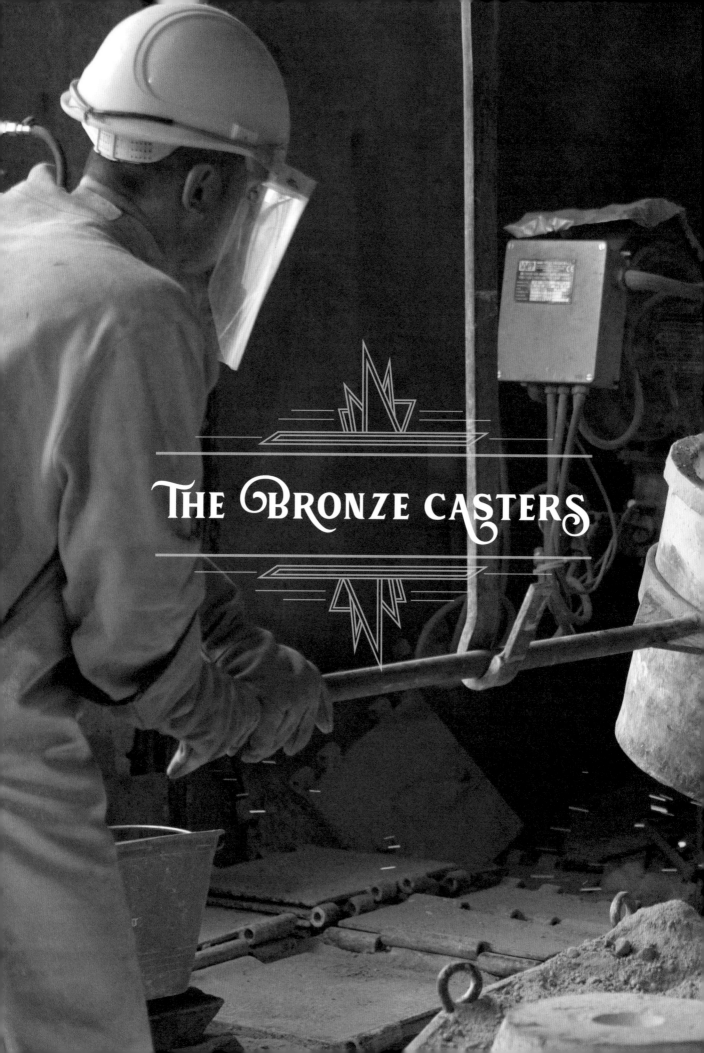

THE BRONZE CASTERS

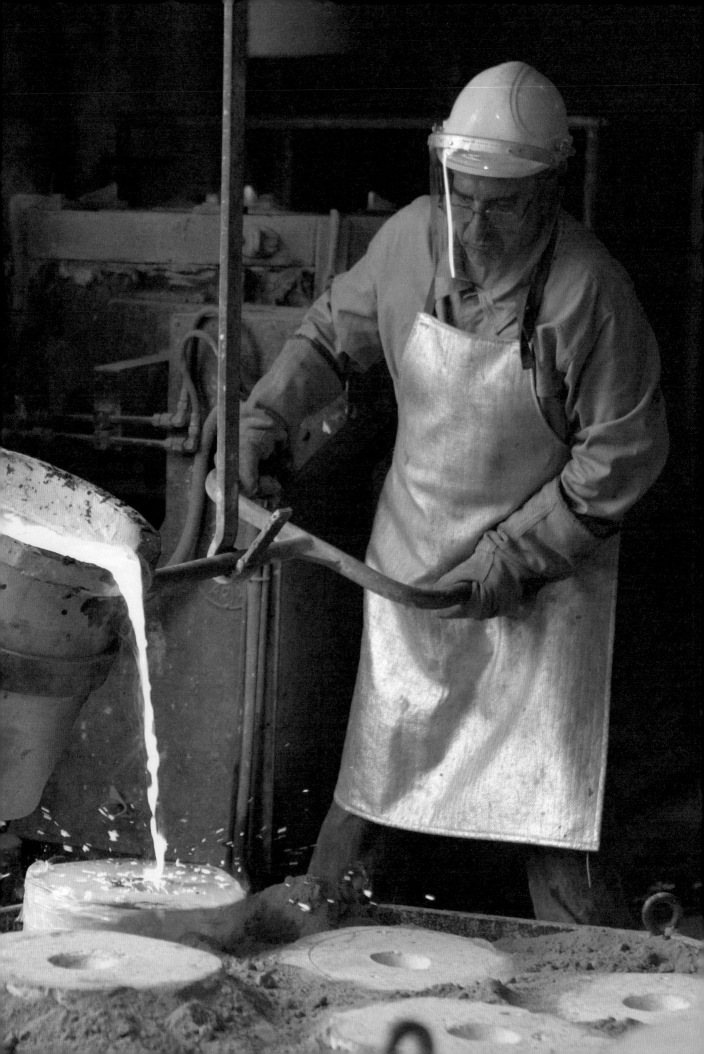

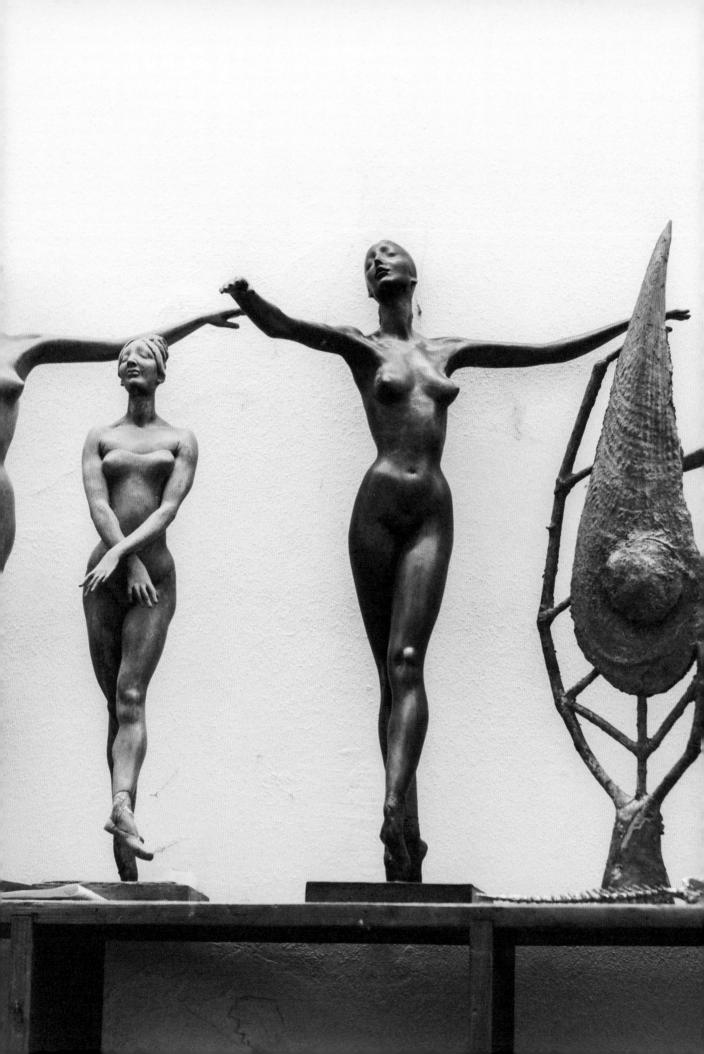

CAMILLA BONZANIGO,
FONDERIA ARTISTICA BATTAGLIA
MILAN, ITALY

Heated to thousands of degrees, molten bronze glows a vivid, primordial orange. Careful workers pour and coax it from a large crucible into molds. Soon the bronze will cool into the forms hidden inside the casting molds, and those figures and shapes will be cleaned and refined by skillful artisans, treated with chemicals for the desired patina, and thoroughly inspected before they receive the artist's final blessing.

This is the Fonderia Artistica Battaglia Milano (the Battaglia Fine Art Foundry of Milan), the oldest bronze foundry in Italy. It was established in 1913 by partners Ercole Battaglia, Giulio Pogliani, and Riccardo Frigerio. In the years after World War I, and shortly after World War II, the foundry was a powerhouse for huge, impressive monuments and war memorials—picture eagles the size of SUVs, huge horses with windswept manes, and towering papal and military figures. By the 1960s, it had become a haven for modern Italian artists, as the foundry moved away from its industrial beginnings toward a fine-art focus. Today, the foundry collaborates with major contemporary artists and design studios from around the world, including Marino Marini, Kengiro Azuma, and Peter Wächtler.

The foundry specializes in the lost-wax casting method, a process with ancient origins. "There is no real difference from the technique used in the Renaissance and even before

The Fonderia Artistica Battaglia Milano specializes in the lost-wax method. The first known traces of this process are in ancient Pakistan and Israel and date from as early as 3700 B.C.E. It was used by the Egyptians and Greeks throughout antiquity, spreading across southeast Asia, into Africa, and across Europe. On the opposite side of the world, the Aztecs and other cultures in South America developed a lost-wax method independently of the Western tradition around the tenth century C.E.

Around the Old World, says Bonzanigo, regional differences developed as foundries adjusted to local resources, meaning that the Fonderia Artistica Battaglia carries on the special legacy of the Italian bronze tradition.

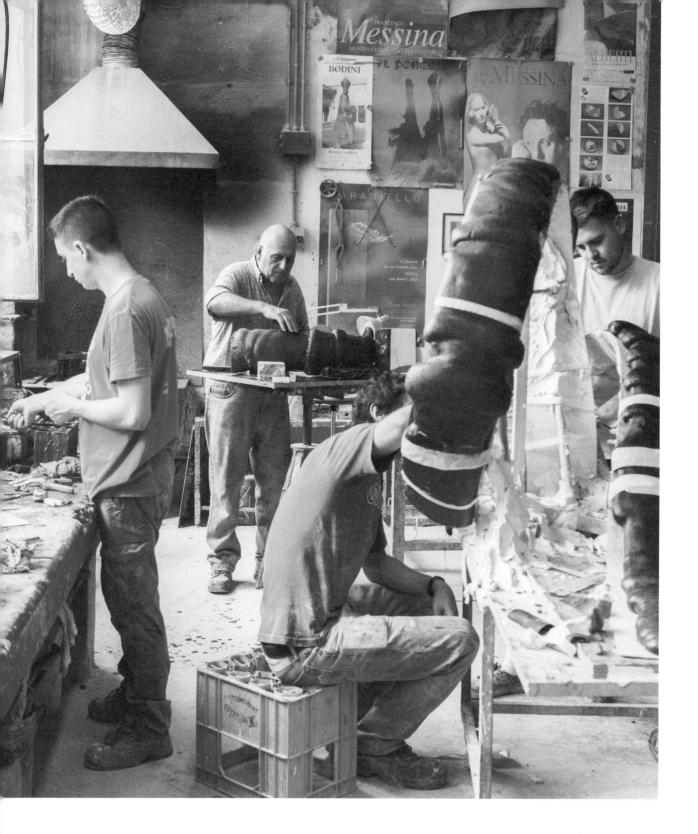

The ancient lost-wax technique, says Bonzanigo, is a process of negative and positive. "There's a transformative magic to that transference." First creation, then the loss (or the creation of the anti-form), before the form is rediscovered and reborn in brilliant bronze.

five thousand years ago," says Camilla Bonzanigo, the Head of Culture and Development for the foundry. "We use the same materials and methods of the past, and all handmade, to make sure to cast a unique piece every time."

This is a key difference between the foundry and others across Europe: Where other foundries updated or modernized over the years, this foundry has weathered years of technological change and economic tumult and remained dedicated to keeping alive this ancient technique. It recognizes not only the inherent cultural value of preserving an Old-World technique, but also the aesthetic quality of lost wax casting, which Bonzanigo says is not seen in other methods.

The lost-wax casting process involves close collaboration between the artist or designer and the foundry's artisans and craftspeople. Every step of the time-consuming process raises technical questions about what will result in the best finished product and achieve the artist's vision. First, the initial design for a new work is cast in plaster and silicon, and the resulting mold is the first negative created in the process. Melted wax is then poured into the plaster or silicon mold, and once it cools and hardens, it forms a new positive in wax. Sometimes wax pieces are created separately, then heated and attached, and once imperfections are retouched by the artisans, the wax copy looks like the final sculpture.

In the next phase, called "spruing," a series of rods are built into a treelike structure around the piece, which will provide channels for the molten casting material. The whole sprued piece is then dipped into a plaster mixture to form the new mold, called the refractory cylinder. This second negative is then heated in a kiln to 1202 degrees Fahrenheit to remove any residual water and to burn up the wax (hence "lost wax").

With the refractory cylinder ready, molten bronze is poured into the cavity left by the wax. Once cool, the cylinder is ground up and recycled, and the bronze is

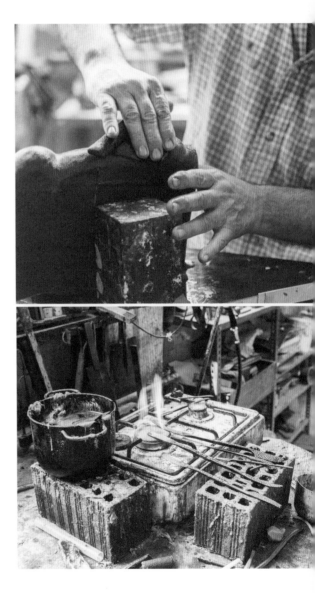

extracted for cleaning. A craftsman carefully chisels away any flaws in the bronze, and then prepares the surface for its patina—a series of chemical washes that react with the metal to achieve different effects and colors.

As Bonzanigo says, the majority of the work is done "by hand and fire"—the only real modernization to the foundry's process has been the switch to an electric branding oven (used for adding signatures and makers' marks to the approved works).

Bonzanigo credits the foundry's unwavering quality to the generations of highly skilled artisans, who transfer their unique knowledge to apprentices. It takes years of dedication to achieve what the foundry refers to as the "intelligence of the fingertips." Young artisans must devote time and patience, participate in the foundry's diverse projects, and work with different artists and designers to refine and strengthen that master craftsman's ability. With fewer young artisans willing to devote themselves to mastery of one task, Bonzanigo does foresee a challenge in maintaining the art.

But the foundry looks with hope toward the future, and they are embracing their important role in promoting cultural heritage and arts. "We have a quite vast archive of images and documents since 1913," says Bonzanigo, "and we work every day in creating the contemporary one. It is accessible for academics, artists, and [to researchers for] restoration." To support the next generation of artists, they have also established the Battaglia Fonderia Sculpture Prize, which funds and celebrates young artists working around the world in bronze and the lost-wax method.

The final touch for any completed bronze at the foundry is the patina, or the particular look of the surface. The foundry has a range of chemicals and formulas that, when applied, react with the metal to lend specific hues, textures, or patterns to the surface, and achieve the perfect look that the artist envisions.

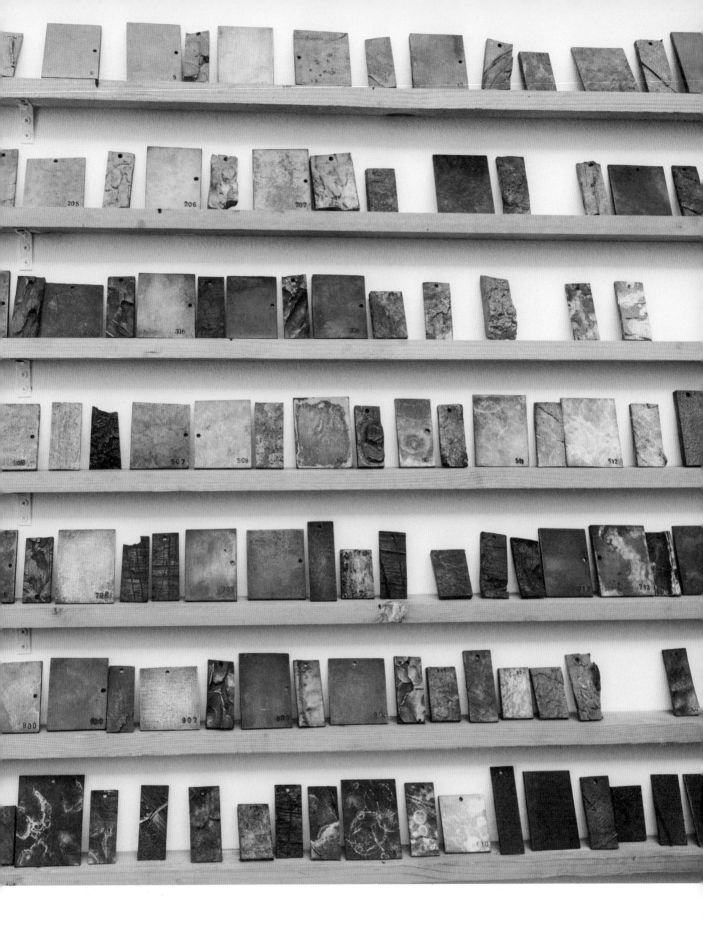

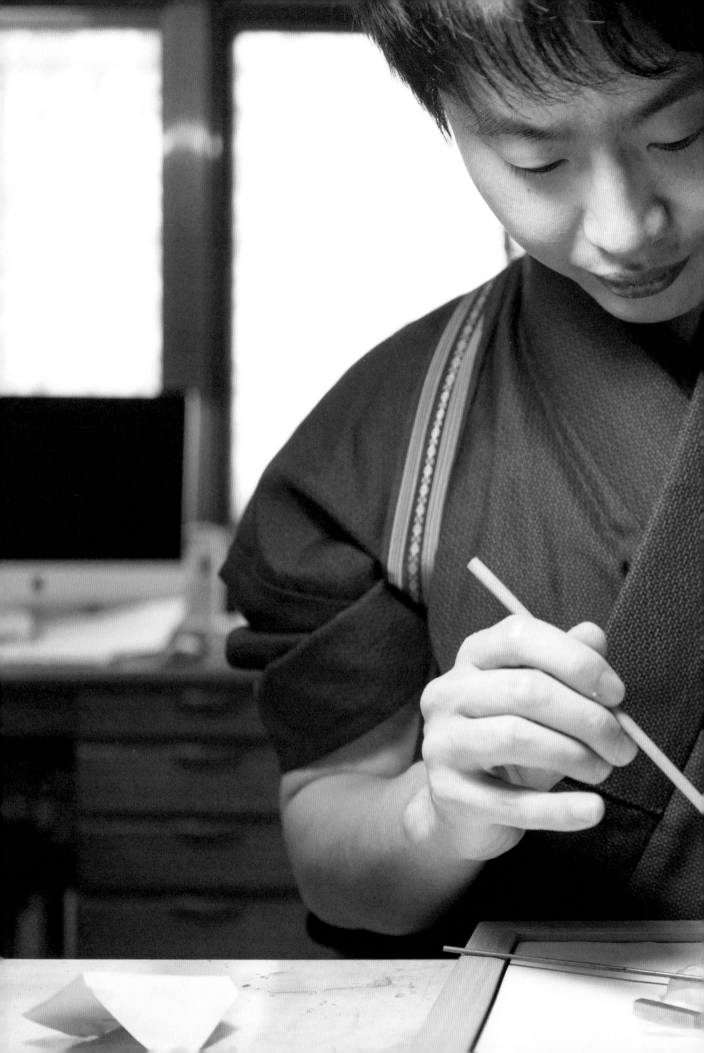

THE KINTSUGI-SHI

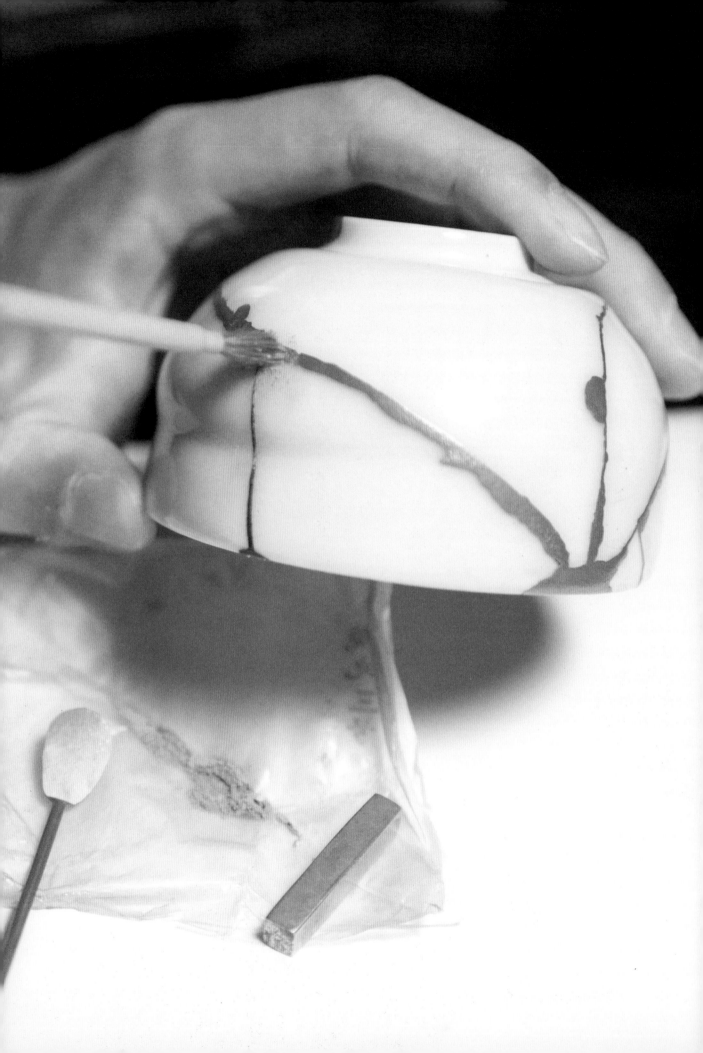

MUNEAKI SHIMODE,
STUDIO BAISEN
KYOTO, JAPAN

The Zen Buddhist philosophy of *wabi-sabi*, says lacquer artist Muneaki Shimode, is "finding the beauty in broken or old things." This concept is at the heart of *Kintsugi* (meaning golden joinery, or golden repair), the Japanese art of mending broken ceramics with *urushi* lacquer topped with fine gold powder. The result is a newly whole bowl, vase, or plate threaded with lines of bright gold—often much more beautiful than before it was broken.

The Kintsugi origin story is traceable to the fifteenth century. The story goes that shogun Ashikaga Yoshimasa sent a broken vessel (often described as a *chawan*, or tea bowl) to China for repair, but was displeased by the look of the metal staples that were used. His craftsmen, inspired to produce a more beautiful method of repair, introduced Kintsugi.

In the centuries since, three different methods of Kintsugi emerged, each with different results. The basic process is the crack-repair method, which yields a vein of gold where the crack was. But sometimes shards are missing from the original piece, so one of the two other techniques are used. In the piece method, resin is built up to fill in the space, and the area is covered in a layer of gold. In the joint-call method, pieces from other broken vessels are used in those gaps, which can add a patchwork playfulness to the finished piece.

Preserving traditional arts like Kintsugi, says Shimode, is important to maintaining identity in an increasingly globalized Japan. "Makie and Kintsugi will be a reminder for future Japanese to tell them who they are."

Shimode hosts workshops on the lacquer arts and teaches Kintsugi, hopeful of the growing interest in the practice. But a lot of today's practitioners, he says, see Kintsugi as a hobby, eschewing the careful dedication and painstaking patience required to meet the criteria of a master. Fewer and fewer artisans are certified each year. Of the handful of artisans working in Kyoto today, Shimode is the youngest at thirty-one.

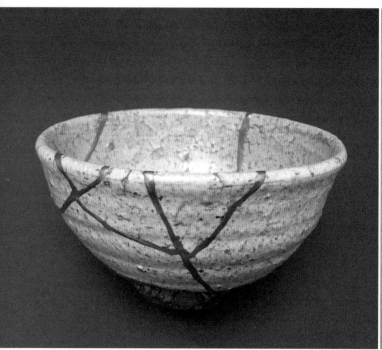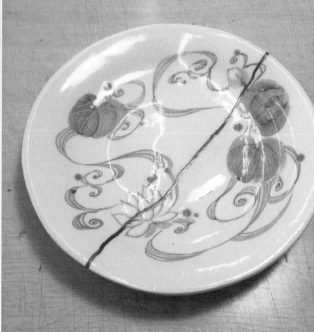

Shimode begins the basic Kintsugi process by arranging the broken pieces to find the original form. He sands down the rough edges of the pieces until they are smooth, but also so that when the crack is repaired, there is artful variation in the thickness and thinness of the line of gold. Next, he applies urushi lacquer (a mixture of rice, lacquer, and clay) to the edges to bind the pieces back together. After at least a week of drying, he will add layers of lacquer to smooth the filled cracks, before adding gold powder carefully over the urushi layer, and sealing the gold with another layer of transparent lacquer. Finally, he'll polish the lacquered cracks with fish tooth or deer antler powder and add additional layers of transparent lacquer and polishing as needed, until the piece is complete.

Kintsugi is an art form under the broader umbrella of *makie*, the Japanese lacquer arts, which mainly refers to the beautiful designs and illustrative scenes painted in gold and silver on a dark lacquer surface. Shimode was born into a family legacy of *makie-shi*, or lacquer men, under the craftsman name of Baisen. "My great-grandfather came to Kyoto with the skill, which he learned from masters in different district[s] in northern Japan," he says. His grandfather and then his father followed the family path, and Shimode felt it was the most natural thing for him as well. "My father had his studio in our house,

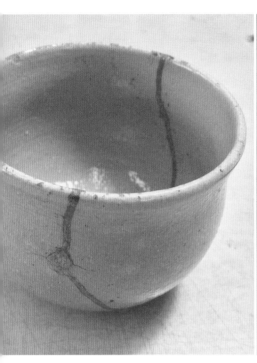
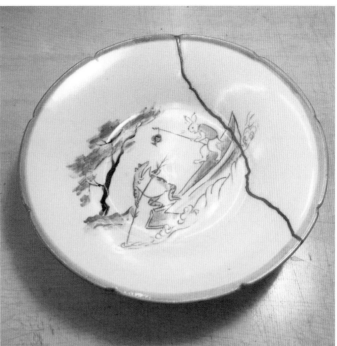

"When we talk about Kintsugi, we're talking about *shogyo-mujo*," says Shimode. *Shogyo-mujo* means the awareness of mortality in everything. Kintsugi's shimmering gold literally highlights the cracks in a once-broken vessel and shows the viewer that there is beauty in that space. This idea, along with the concept of *wabi-sabi* (seeing the beauty in the broken, imperfect, or aging) is at the core of the art, preserving an important perspective of traditional Japanese culture.

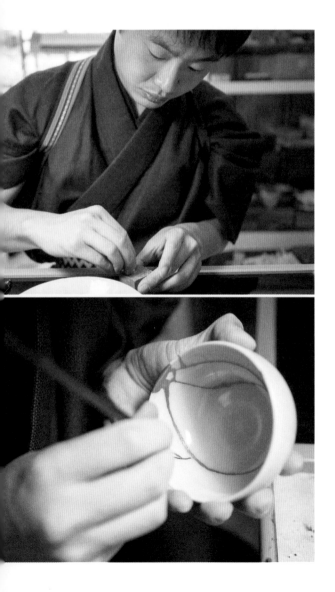

so I had more than enough time to feel and get used to the skills and materials." After graduating university, he learned the lacquer arts under other masters for two years (per the tradition of "eating from other houses' rice jars," in which sons succeeding a family trade learn from other artisans). He returned to his father's studio as a novice seven years ago. It takes ten years in the traditional path to officially become a master, he says, which is when you can be granted a national license for professional craftsmanship in the traditional arts.

"There will always be new and better materials and technologies which can replace what we do," Shimode says. But the inherent value of Kintsugi, makie masters believe, is that the beauty from the urushi lacquer, the gold dust, and the careful polishing by hand, yields a result that could never be replaced or modernized. While the process could be mimicked commercially, the outcome would never compare to the handiwork of Kintsugi makie-shi.

Shimode explains that the importance of Kintsugi isn't as a repair technique—it certainly is not the most "reasonable" or even the strongest way to repair ceramics. But this is precisely what drives him to continue the practice, and why he finds it meaningful and human. "I believe that [the] beauty of life isn't necessarily in 'the best way.' . . . But because it is unreasonable, I find it more beautiful and valuable for our spirit."

At Studio Baisen in Kyoto, Shimode and his
father, the lacquer artist Yasuhiro Shimode,
mainly create and mend the ceremonial objects
for Buddhist and Shinto altars.

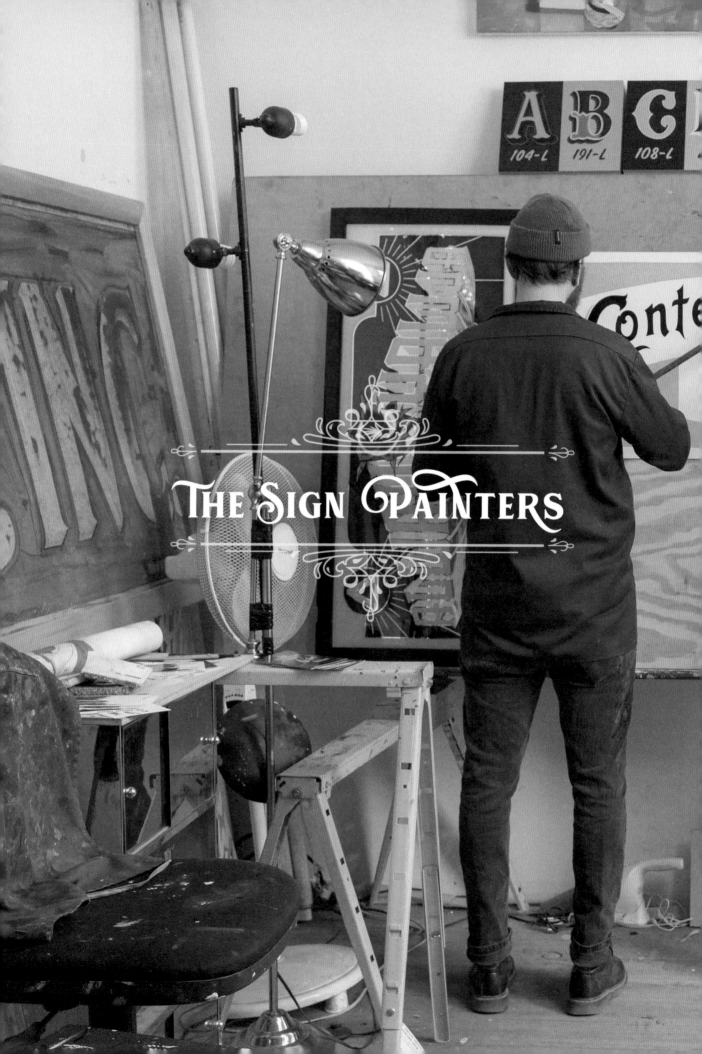

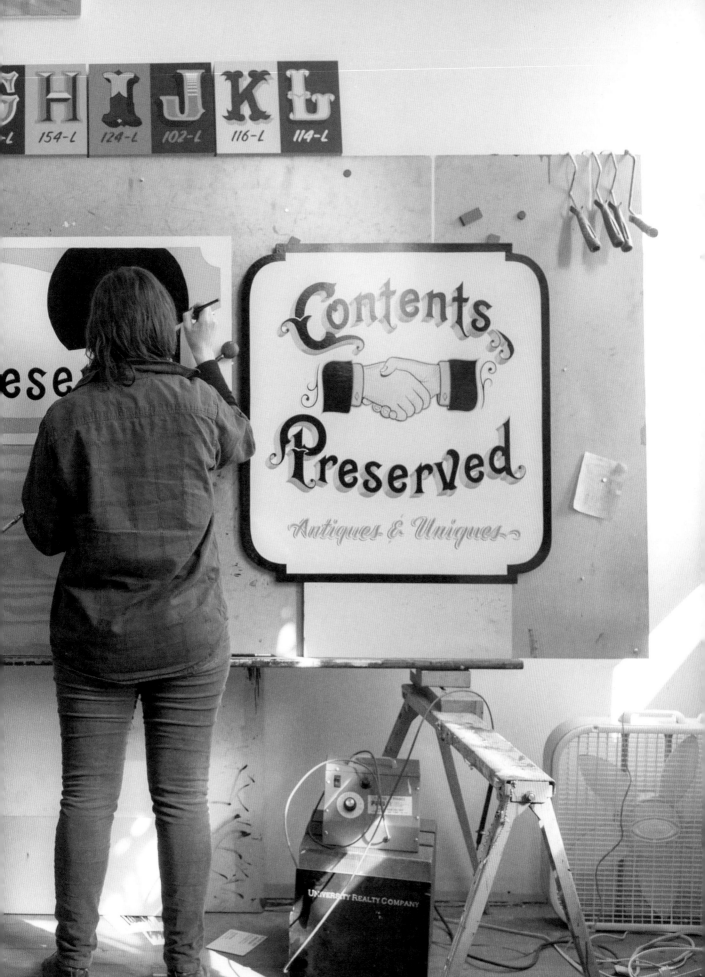

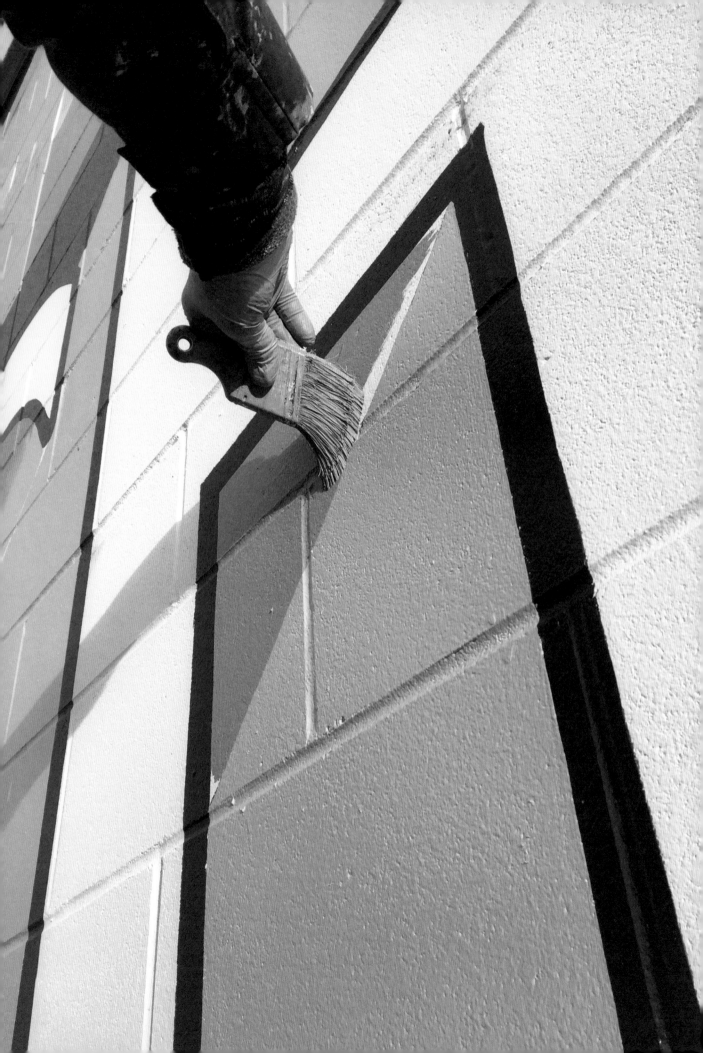

JOSH LUKE AND MEREDITH KASABIAN,
BEST DRESSED SIGNS
BOSTON, MASSACHUSETTS, USA

DEREK McDONALD,
GOLDEN WEST SIGN ARTS
OAKLAND, CALIFORNIA, USA

W hen she was a child, Meredith Kasabian's dad would point out the signs that her grandfather, a sign painter by trade, had made in their hometown. Her family is sure it's his original Bingo signs that still stand outside a local church. "Sign painting was always there," she says, "but it wasn't a part of my life in a major way. Sort of like knowing a song, but not the lyrics."

Kasabian's husband, and her business partner at Best Dressed Signs, is the sign painter Josh Luke. Luke also recalls the first hand-painted sign that made a big impression on him. It was while he was working at an art supply store in San Francisco. The then art student watched as workers across the street scraped away the dull beige paint that had covered the whole façade of a building. Paint fell away in chips and curls, gradually revealing the gold leaf and maroon lettering of a vintage cigar advertisement. "It was incredible," he recalls, "at least eight feet wide and four feet tall, painted on the inside of the store window." Not long after that experience, Luke got his start at San Francisco's New Bohemia Signs, the longest-running all-by-hand sign shop in the city, which today still exclusively hand paints its signs. The shop counts among its alumni not only Luke, but also the artist and painter Tauba Auerbach, who brought Luke in to work there.

Kasabian and Luke's *Made in Dorchester* mural is located at South Bay Center in Boston's Dorchester neighborhood, on the side of a new movie theater. It's also right around the corner from Best Dressed Signs' studio. In addition to taking on gradually larger and more complex mural projects, Best Dressed loves taking projects for store-window and shop signs. In 2017, they designed two new front windows for Provincetown's famous Cabot's Candy Factory, which has operated from the same historic location in Cape Cod since 1927.

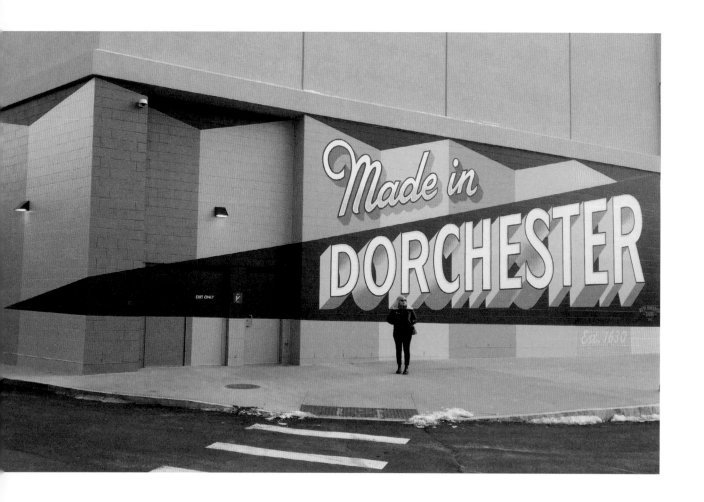

For Derek McDonald of Golden West Sign Arts, the inspiration was the ornate
signage on an old tattoo parlor. When he learned it had been hand-painted by one of the
Bay Area's legendary sign painters, known as Jimmy the Saint, he remembers thinking,
"There are actually people who still do this!" After that realization, he tried his own hand
at the style, with some guidance from "old timers" like Jimmy. "I'm actually not an art-
ist at all," he says, "but I'm a creative-minded person." McDonald sought a way to trans-
late his nostalgic aesthetic in an authentic way: Whereas many surviving sign companies
made the switch to vinyl printing, McDonald is true to traditional draftsmanship and the
brush, and the process looks much the same today as it did fifty years ago. He designs and
sketches all by hand and hand paints the finished sign on glass, wall, or board with his
go-to enamel paint brand, One Shot, or in shimmering gold leaf.

Kasabian and Luke strive for a similar sense of authenticity at Best Dressed. They
founded a loose collective of sign painters (as well as "sign enthusiasts and advocates")

called the Pre-Vinylite Society, inspired by the Pre-Raphaelite Brotherhood in the nineteenth century. The Pre-Raphaelites rebelled against the strict approach toward fine-art painting that had been passed down from Raphael—they looked further into the past, and to the environment around them, for truth. In the same way, says Kasabian, the artists in the Pre-Vinylite Society celebrate the art of the brush before vinyl's big takeover in the 1970s and '80s. But more than anything, she says, "It's about the future as informed by the past."

In addition to being a business-owner and curator, Kasabian is a historian of sign-making and the semiotics of signs in their historical and cultural contexts. "We live in a world that's governed by signs," she said at a 2013 talk at the Institute of Contemporary Art in Boston. "They tell us that we're not walking into the men's room by mistake; they tell us what we're eating when we go to a buffet; and they tell us how to get where we're going." Signs can be complicated, she says: They can create boundaries, and they have shaped our familiar spaces, for better or worse, throughout history.

By the nineteenth century, signs were part of everyday life, and sign painters were needed to create and maintain them. Georges Braque, co-founder of Cubism, grew up in his father's decorative arts business, which included sign painting, and Braque brought those techniques into his work. Later artists like James Rosenquist and Ed Ruscha also worked as sign painters before transitioning to the fine art world. Luke acknowledges how that story is "flipped" today: "Before, you started as a sign

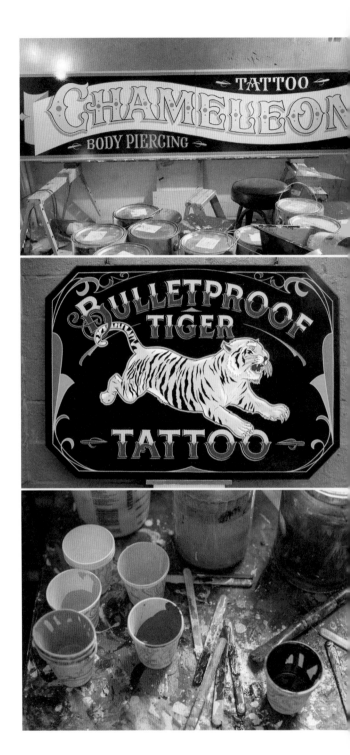

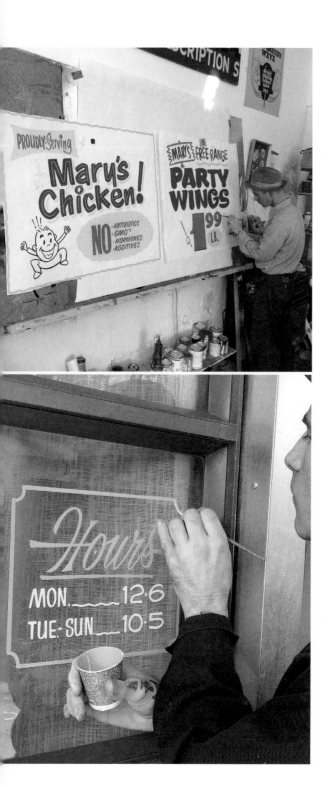

painter or a tradesperson, and now it's the opposite—artists and creatives are rediscovering and reviving and really pushing what can be done."

Golden West, Best Dressed, and their counterparts in the still-small (but growing) revival of sign painting all embrace their art consciously. They have great care for the technique, the history, and the content they're communicating. "Shops are the places where we do most of our business," Luke says. "Our signs represent the store, but what's important is what it makes you think about the shop." For McDonald, sign painting is a functional art, and he gets immense satisfaction out of distilling messages in new projects—balancing the most creative way to portray them visually with what is legible for the viewer. "Signs have a job," he says, "and at the end of my workday, the signs are still working—they never sleep!"

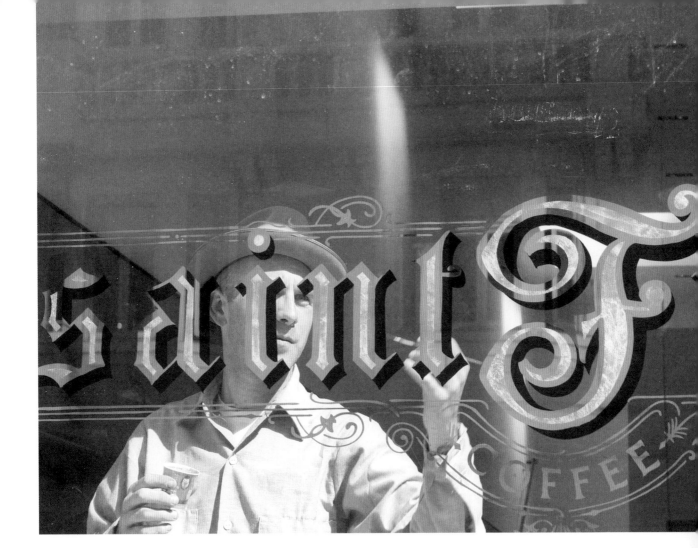

The staples of McDonald's client base are tattoo parlors and barber shops, but he says the desire for a hand-painted sign is spreading to restaurants, boutiques, and more. McDonald's truly analog practice starts with drafting a design on paper, usually iterating two or three concepts before determining the direction he likes best. Other than scanning his finished sketch to be reviewed and approved by the client over email, there is no digital component to McDonald's process. With the sketch approved to move forward, McDonald translates the sketch to a life-size drawing, carefully measuring and using a ruler and straightedge to get the letters just right. He then perforates the lines of the design so that the image becomes a stencil. He lines up the pattern, checking that the image is level, and tapes it into place on the

surface to be painted—a wooden or mason-board sign, a plywood sandwich sign, or the glass of a window. With the stencil in place, he "pounces"—that is, uses a tamping-like technique with a brush or pouf—to dust powdered charcoal or chalk into the perforated lines. With the faint outline transferred, he carefully removes the paper.

Using the dust guideline, McDonald begins by painting outlines of the letters, or maybe drop-shadows if they're part of the design, and gradually adds more color and builds on the detail in layers. Clients love effects like gold leaf, multi-toned drop-shadows, or even inlaid abalone to add beauty and complexity to the design, all of which require more time and careful patience. But when clients leave it up to him, McDonald prefers to keep his designs simpler.

One of Kasabian and Luke's favorite projects of 2017 was *Always Advance*, a mural at the Syracuse University School of Design in Syracuse, New York. Several years of planning and anticipation went into this massive public art commission, and the duo spent three weeks in the city painting the 102-foot-long by 20-foot-high mural. Both the text and the circular shapes around the letters in "Advance" are references to typewriter keys, an homage to the history of typewriter manufacturing in Syracuse. The technology had far-reaching effects—especially for women typists in the twentieth century, explains Kasabian, "eventually leading to the acceptance and advancement of women in many male-dominated fields, including design."

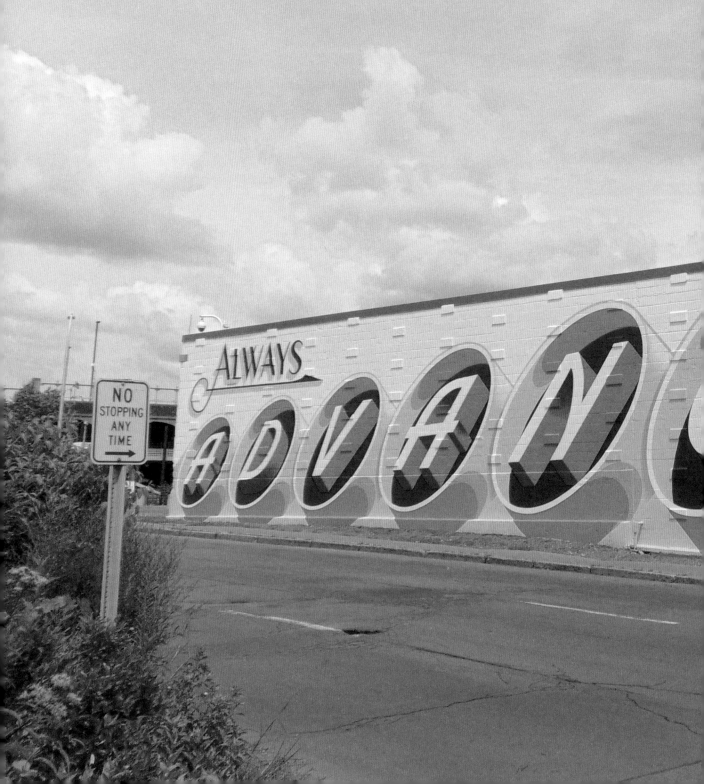

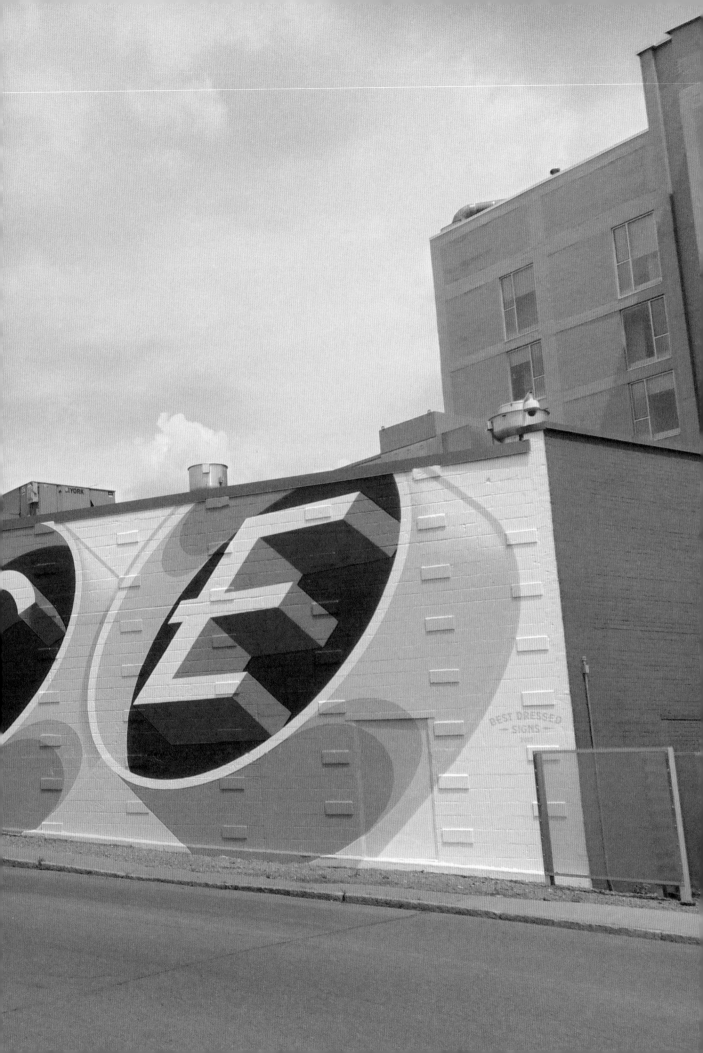

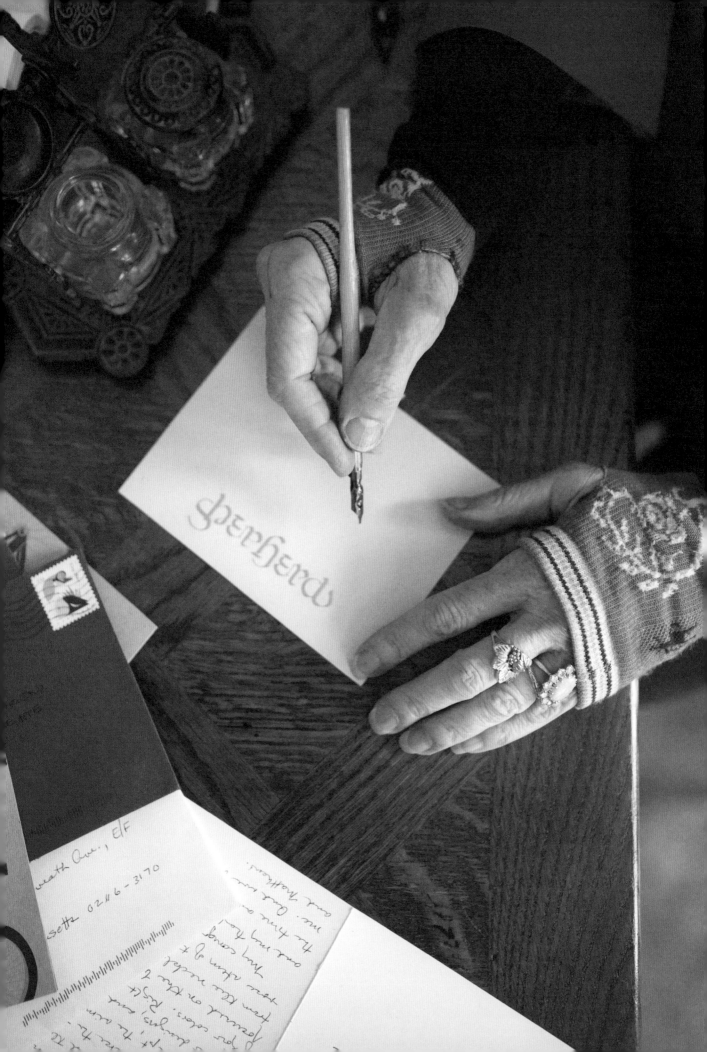

Ink Warms MY SOUL

by Margaret Shepherd, calligrapher and author of
The Art of the Handwritten Note

I'm a calligrapher by profession and by passion. I've been practicing calligraphy and writing things by hand for decades, and I never get tired of it. It fits into my life in so many ways: copying my favorite quotes, or lettering diplomas, or designing a book cover, or addressing invitations, or writing handwritten thank-you notes. I enjoy teaching calligraphy to beginners, as well, because I can watch hundreds of people's faces light up when they find that they, too, can look good on paper. What other craft lets you make even the most ordinary words look beautiful while you soothe your soul?

Watching the ink come out of the pen point makes me calmer, happier, and more self expressive. I don't agree with the many cynics who are quick to tell me that "it's a lost art." A skill that nearly everyone used to master shouldn't have to fall into disuse just because it's not absolutely necessary now for some of daily life. One bonus of practicing a "lost art" is that, because it's so rare, every time people encounter it, they really take notice.

Lost arts have a way of coming back stronger and more precious than before. We have so many choices now in our lives, and yet when we want a really special meal together, many of us don't begrudge the time and effort it takes to cook from scratch, to light candles, to iron the linen napkins, polish the silver, and get together in person for some leisurely hours with our friends and family. (After such a dinner, wouldn't *you* want to send a handwritten thank-you, too!?) Writing by hand is like gift-wrapping your words, to make them not only beautiful but unique.

I don't avoid the keyboard when I need to make a document or send an email, but I don't fool myself that a fancy font will impress someone the way my own handwriting or calligraphy does. Humans are exquisitely talented at judging how much effort things take; that's why it still matters to write some words by hand. Writing by hand, whether in elegant calligraphy or just slightly improved handwriting, lets me show people that I took extra trouble with the words I wrote for them.

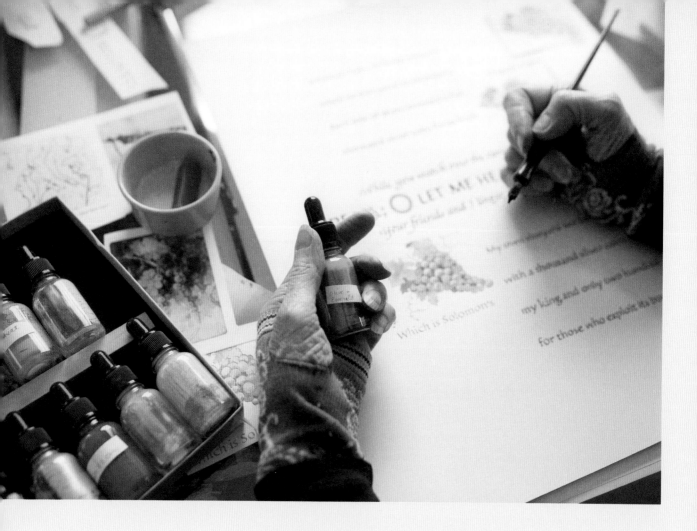

If people need convincing, I can give them some scientific, provable talking points:

Americans prefer making art to looking at it. We are the proud descendants of Ben Franklin, a printer himself, who admired people who worked with their hands.

Children report that they think differently when they write by hand. They especially like the way it seems to give them permission to slow down and calm down and curl up. It adds to their self-confidence if they feel they can present themselves nicely on paper.

Stroking seems kinder to your words than pounding. And in fact, different areas of your brain light up when you write with a pen than when you type with a keyboard.

You actually choose better words, partly because of slower speed, linear unspooling, and permanence.

But people seldom need to be convinced. They love the way calligraphy looks. They just need to break away from the pessimism that is in the air. I always assure them that if I could learn calligraphy, *anyone* can. I

had flunked cursive handwriting in third grade and given up on the whole effort by 7th grade; I scribbled all-caps, fast, or pecked things out on a typewriter. Even then, all it took was a nudge—an encouraging friend, a small booklet, and a calligraphy fountain pen—to inspire me to try hand lettering. Now I get fidgety if a day goes by without putting a little ink on paper. I enjoy equally every chance to write, from grocery lists to fine art for the wall.

It's easy to assume that we don't *need* handwriting and calligraphy because we have keyboards and printers. People have worried this way about other arts that seemed in danger of getting lost. But photography did not kill painting; movies did not kill stage acting; and radio and recordings did not kill live performance. Pen and ink, on paper, is such a vibrant way to connect, that it will surely find new roles in the future.

The only drawback to my love of letters is that when a friend, or a relative, or even a perfect stranger writes to me, I know I will *never* be able to throw that note away. It's a piece of art, adding so much to the moment and marking a whole era and way of thinking. I have shoeboxes full of these treasures, and I revisit them every few years to bring their writers back for a moment.

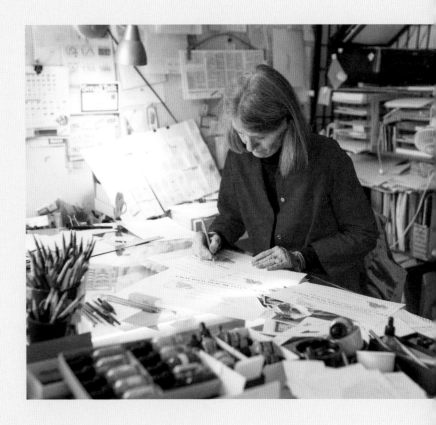

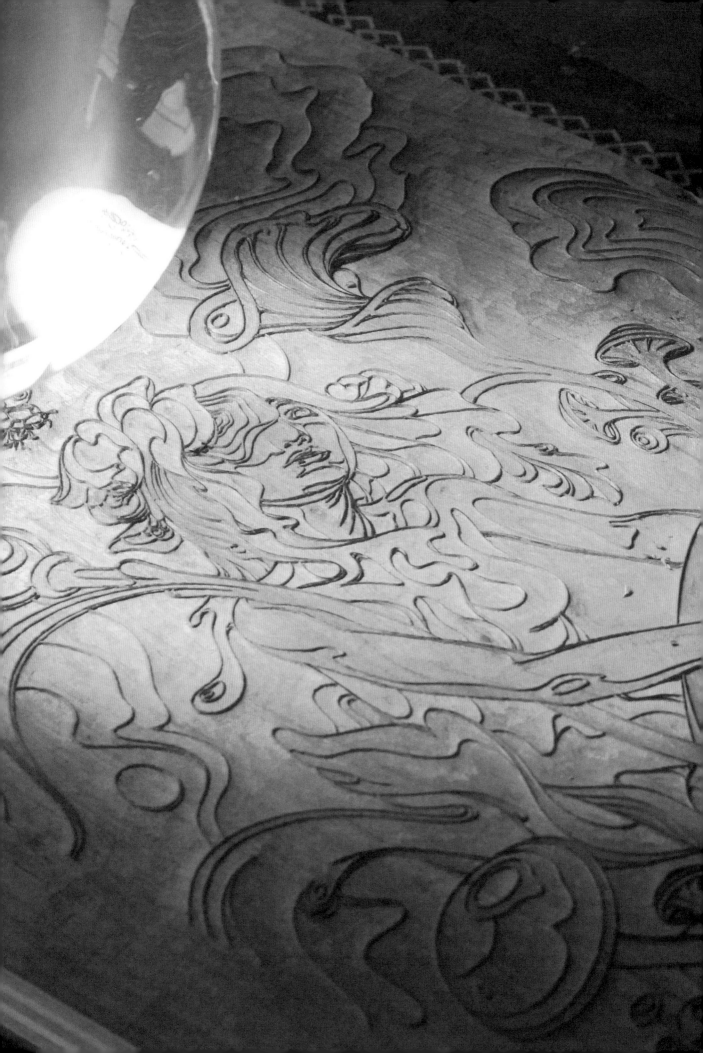

THE WOODCUT PRINTERS

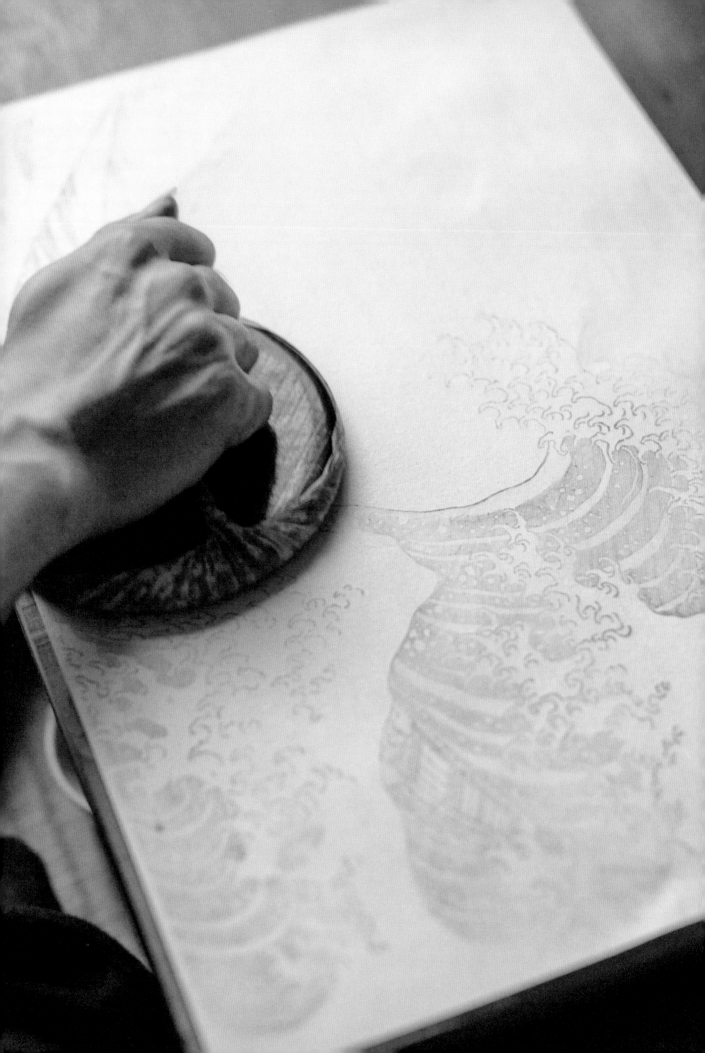

MEGURI NAKAYAMA,
THE ADACHI INSTITUTE OF WOODCUT PRINTS
TOKYO, JAPAN

The Adachi Institute of Woodcut Prints preserves and passes on to the world what it views as the "pride of Japan": the Ukiyo-e print. *Ukiyo-e* was a popular style of Japanese art, consisting mainly of woodcut prints, that flourished starting in the late eighteenth century. As a form of commercial printing, Ukiyo-e were made to be efficiently produced, but also beautiful. This resulted in the uniquely delicate lines, vibrant colors, distinctive composition, and minimalist aesthetic of the Ukiyo-e image. Impressionist painters in the west like Claude Monet, Edgar Degas, and Mary Cassatt, as well as architect Frank Lloyd Wright, were all highly influenced by Ukiyo-e, and today, the images continue to be highly acclaimed around the world.

Founded in 1928 as a woodcut print production company, the Adachi Institute did not much alter the methods originally cultivated in the Edo Period, nor has the intervening near-century affected their printing processes. Japanese-sourced materials like wild mountain cherry woodblocks, water-based pigments, and handcrafted washi paper are used to reproduce classic Ukiyo-e images, but also to create thoroughly new works through

Ukiyo-e means "pictures of the floating world." Starting in the late-eighteenth century, after advances in woodcut printing technology improved the ability to print color, artists created detailed, engaging scenes reflecting the hedonistic lifestyle of the era, including women's activities, cavorting kabuki actors, and other famous figures. The name "floating world" came from the style's unique bird's-eye view of buildings and rooms whose roofs and walls were cut away to show scenes inside.

These images of the everyday set the stage for print masters like Katsushika Hokusai and Utagawa Hiroshige to produce their iconic works celebrating nature in the 1830s, like *The Great Wave of Kanagawa* and the series *The Eight Views of Ōmi*. Far to the west, Ukiyo-e played an enormous role in European art at the end of the nineteenth century. Impressionist painters embraced Japanese aesthetics, or *Japonisme*, in composition and color palette, as well as facial expressions, gestures, and more.

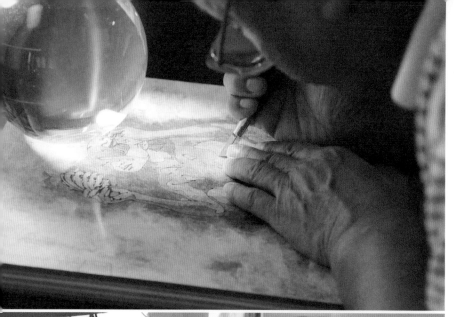

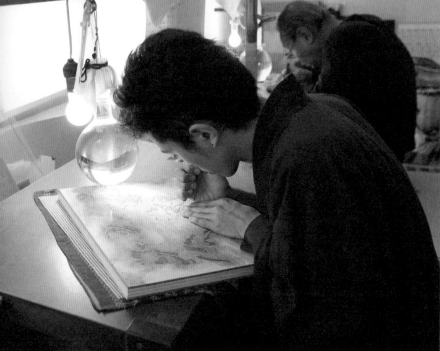

Hardwoods like cherry are preferred for the woodblocks, and the painstaking process of carving is truly the work of masters in Adachi's atelier. The carvers first transfer the image to be carved from washi paper onto the woodblock using a traditional rice paste as an emulsion layer. Then they use fine cuts to outline the image and chisel out larger areas to set certain portions of the image into relief. The craft is so well-developed that there are specific words for carving certain types of imagery. For example, *kewari* refers to the process of "separating out hair," which can mean carving individual strands less than a millimeter wide. Carvers and printers train for five to seven years to reach the minimum level of skill required of artisans, and it takes more years of "concentration, patience, and strong passion," says Nakayama, before they are considered masters.

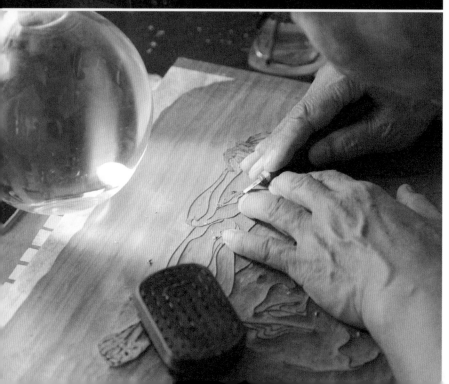

artist collaborations. According to director Meguri Nakayama, the Adachi Institute of Woodcut Prints is the only workshop where carvers, printers, and publishers still work in the same studio, also following the Edo-period precedent.

But over the years, cheaper and less time-consuming printing technologies like screen printing and lithography, and especially digital printing in more recent years, have all decreased the demand for woodcut. Today, there are fewer than fifty artisans of traditional woodcut printing techniques. The Adachi Institute continues to weather the effects of woodcut falling from favor, especially the hardship of fewer artisans learning the trades. "We are facing a critical situation," says Nakayama. "There is fear that it could be lost."

In 1994, as a response to this crisis, the Adachi Foundation for the Preservation of Woodcut Printing was established, with the objective of promoting and preserving traditional woodcut printing techniques through research and education, supporting and cultivating artisans, and maintaining a strong connection to the community. "Our foundation is committed to the cultivation of successors so that we can help preserve the unique printing culture that Japan boasts to the world and pass it down to future generations," says Nakayama. Part of that commitment has been to work with contemporary artists like Yayoi Kusama, James Jean, and Akira Yamaguchi. "Rather than simply preserving tradition, we hope to explore new possibilities for expression so that traditional woodcut printing will continue to develop as an attractive method of expression."

When starting a new collaboration, Adachi's masters meet with the artist and advise on the best images to reproduce in woodcut, setting up a plan for the process before they begin. They need to analyze the image's layers of color and its composition, since the image will be separated into separate woodblocks, each dedicated to printing a different layer of color. Templates are made from the artist's chosen painting or drawing, and the carver carefully, painstakingly carves the image. The master printer then uses the finished woodblocks to create test prints and, under the artist's direction, adjusts the printing process and colors to achieve the right look. After the final proofs are approved, the printer creates the number

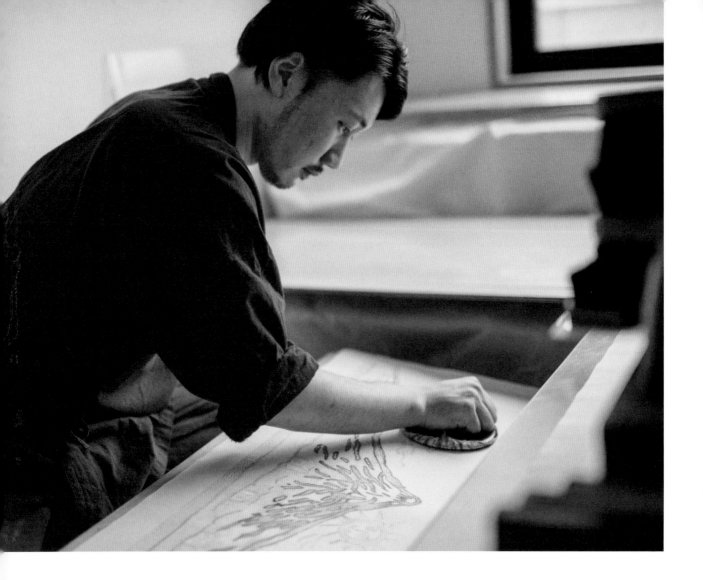

As impressive as the household names of the artists Hiroshige and Hokusai are today, it's important to understand that woodcut printing is the result of a team of experienced artisans and skillful experts who work closely with the artists to realize their image in print. The Adachi Institute retains the traditional woodcut print artisans: the designer, the carver, the printer, and the publisher. Contemporary artist James Jean's 2016 print edition, *Pomegranate* (right), is one stunning example of how artists today are embracing the tradition.

of editions needed for the run, perhaps one hundred twenty per colorway as in Kusama's series *Mt. Fuji in Seven Colours*. Other times a work is kept as an open edition, as with most of Adachi's mainstay classic reproductions.

Contemporary Adachi prints have a warmth of texture and vibrancy of color that echo the captivating look of the Ukiyo-e prints all those centuries ago. "There is something missing," says Nakayama of other printing techniques. "There is a gentle mood that only the traditional woodcut printing techniques can give."

THE MAPMAKER

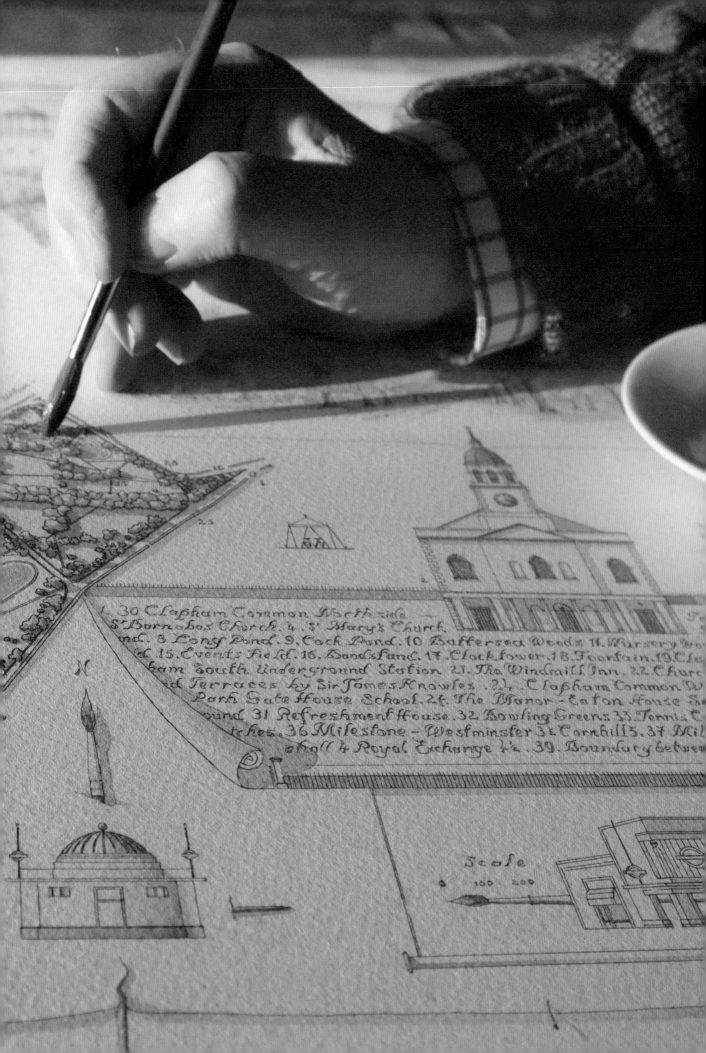

1. 30 Clapham Common North side —
St Barnabas Church. 4. St Mary's Church.
...nd. 8 Long Pond. 9. Cock Pond. 10 Battersea Woods 11. Nursery ...
... 15. Events Field. 16. Bands Land. 17. Clock Tower. 18. Fountain. 19. Cla...
...ham South Underground Station 21. The Windmill Inn. 22. Chur...
...d Terraces by Sir James Knowles. 2?. Clapham Common W...
...Park Gate House School. 24. The Manor - Eaton House S...
...und 31 Refreshment House. 32 Bowling Greens 33. Tennis C...
...tches. 36 Milestone - Westminster 3¼ Cornhill 5. 37 Mil...
...hall 4 Royal Exchange 4¼. 39. Boundary betwee...

N

Scale
0 100 200

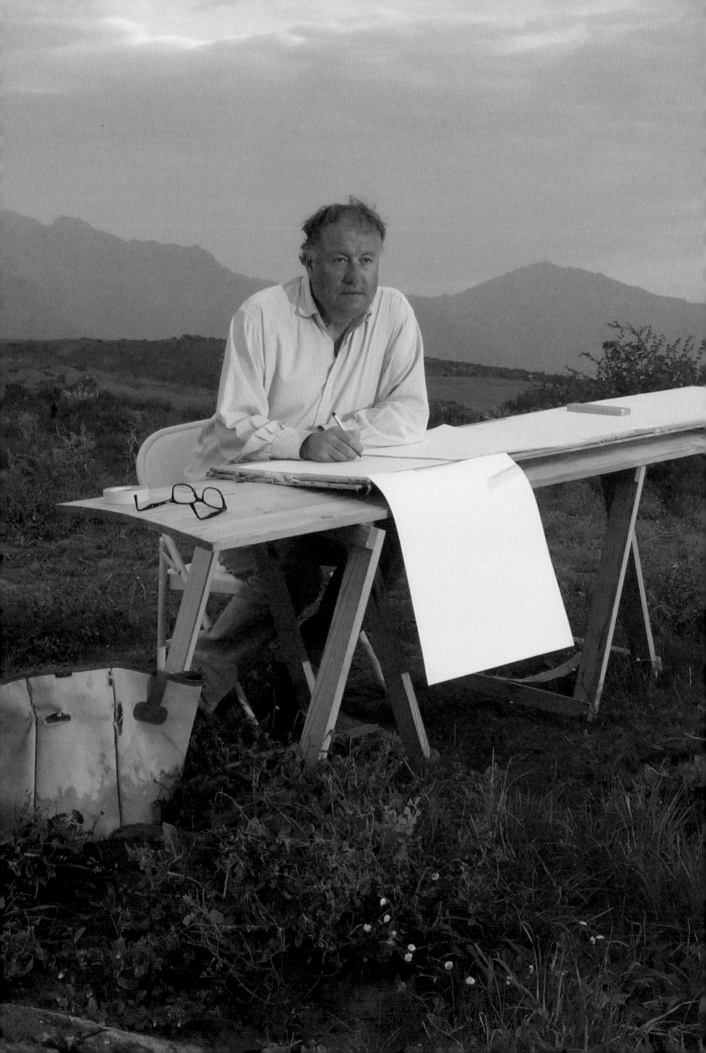

Simon Vernon,
WORLD'S END MAPMAKING COMPANY
WELSH MARCHES, UNITED KINGDOM

Before he was a mapmaker, Simon Vernon was a teenager training as a rural surveyor for agricultural land management. His first project took him far north of the United Kingdom and one hundred miles inside the Arctic Circle to survey the Kårsa Glacier for the Royal Academy of Sciences in Stockholm. "We were checking recession of the glacier in the face of what we now call global warming," says Vernon. He says those early experiences and the techniques he learned, as well as his training in architectural drawing, play into his current work as a mapmaker, and instilled in him an appreciation of working in the outdoors and gaining firsthand knowledge of places that he maps.

"Less than point one of one percent of people are still making maps the way I do," Vernon estimates. Through his studio, the World's End Mapmaking Company, Vernon creates his maps entirely by hand, employing surveying and observational skills used by mapmakers for centuries. "It's not very economically sound, but it's the way I love to work; almost all mapmaking is done on the computer, but onsite I feel like I'm claiming something by sitting down and observing and sketching." Vernon prefers to walk through the property he's meant to map, often for many days, to observe and make sketches. "In a way, it's to absorb the atmosphere of the place."

Vernon is one of the few people in the world still making maps like cartographers did three hundred years ago—work that falls more squarely in the realm of fine art today.

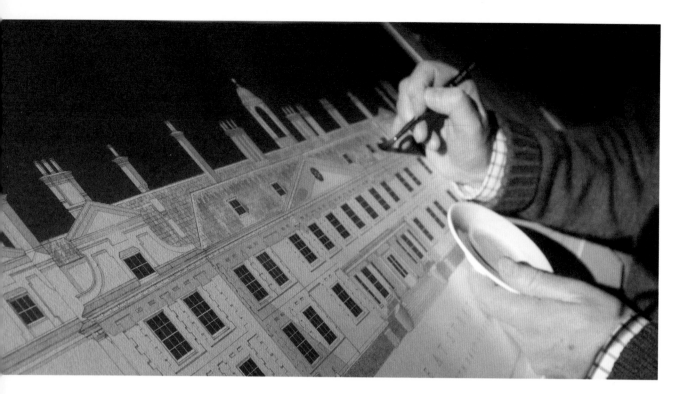

The earliest maps we know of were routes recorded in pictographs (wall paintings) in ancient Egypt and Anatolia. Later, the Greeks' passion for discerning the world around them led to the first maps of the known world, and Romans used the technique as a tool for their military and governance. Mapping methods and accuracy of measurement were refined throughout the Middle Ages thanks to advances from Muslim scholars and mapmakers across Europe.

By the sixteenth century, exploration and colonization, combined with innovations in commercial printing processes and improved mapping methods, led to a sharp rise in cartographers under the world's powerful nations. Intaglio was a key development and remained a popular printing method through the Industrial Revolution. Forms of intaglio are still used in printing currency, passports, and other official paper documents.

Today much of Vernon's work is for centuries-old estates around England and Wales, often for the original families. Brampton Bryan in Herefordshire, owned by the same family since 1309, and Benthal Hall in Shropshire, occupied by the same family since the sixteenth century, are two of his clients. Toting his drawing board, an umbrella for protection against the sun, and his drawing kit to these locations, Vernon creates a series of en plein air maps that incorporate aerial views and topographic features, capturing different aspects of the land, individual trees, architecture, and more.

Back in his studio, he artfully brings the map sketches together into a single composition, replete with meticulous detail captured on site, including smaller illustrations of specific places from different viewpoints. The goal, says Vernon, is not so much a precise accuracy but an evocative depiction of place meant to delight the onlooker: "I want an emotional reaction from the observer." The map drawing is completed with Vernon's exquisite calligraphy for place names and titles, as well as the legend (the key to the symbols used in the map).

Like the sixteenth-century mapmakers, Vernon does not consider this drawing the final map. In an etching studio in London, the finished drawing is printed in intaglio—the traditional process of copper-plate printing that goes back at least as far as the 1500s. Vernon's chosen studio has modernized some aspects of the process by projecting the map image (in reverse) onto a copper plate prepared with a layer of resistant wax, then etching into the coating. The plate is then treated in an acid bath that eats away any metal exposed by the etching, and the remaining wax is cleared away, leaving the negative image for printing. The plate is covered in archival ink, and the excess wiped from the surface. Finally, the prepared plate is run through a printing press, which transfers the positive image to paper.

Vernon takes the prints back to his studio, where he applies muted washes of color that conjure the look and feel of historical maps and prints. At one point in his decades-long career, Vernon worked for an antiquarian map dealer, and this experience enriches the historical perspective in his approach and aesthetic. "Color can get in the way of the structure," he says. "It's not that it's meant to look old, it's about how the structure should be allowed to come through. The color shouldn't dominate."

The result is a romantic composition that is both accurate and intimate, historical and contemporary. The maps are framed and displayed in their patrons' homes, a new document of their land and lineage—Vernon hopes—for generations yet to come.

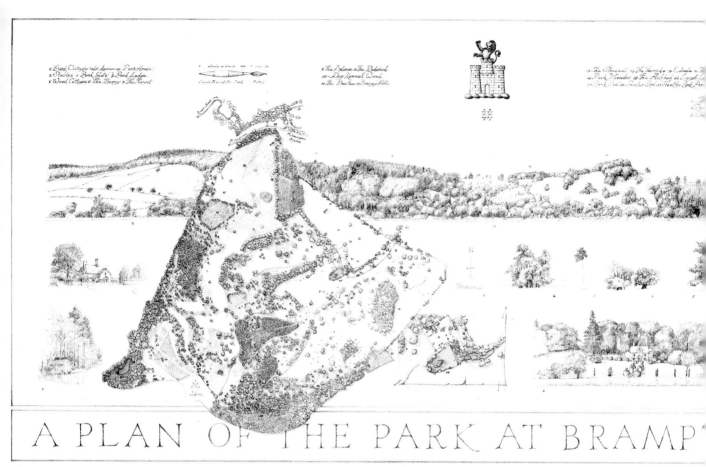

A PLAN OF THE PARK AT BRAMP

A PLAN OF BENTHALL HALL

BRYAN

One of Vernon's first estate commissions was mapping the park and buildings at Brampton Bryan.

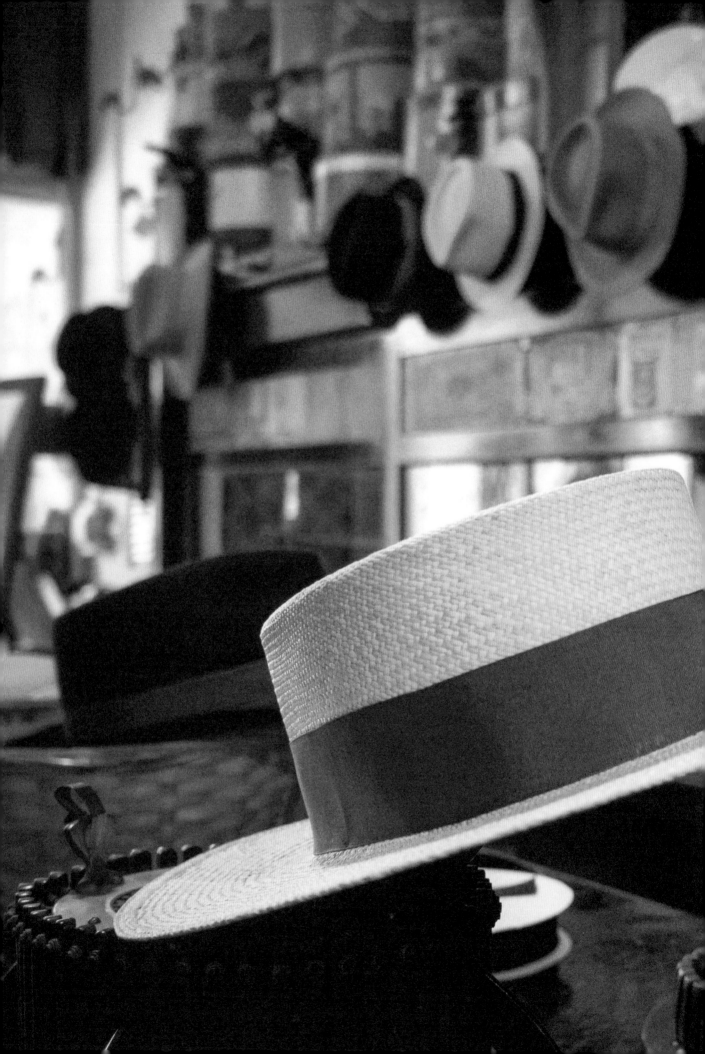

THE HATMAKERS

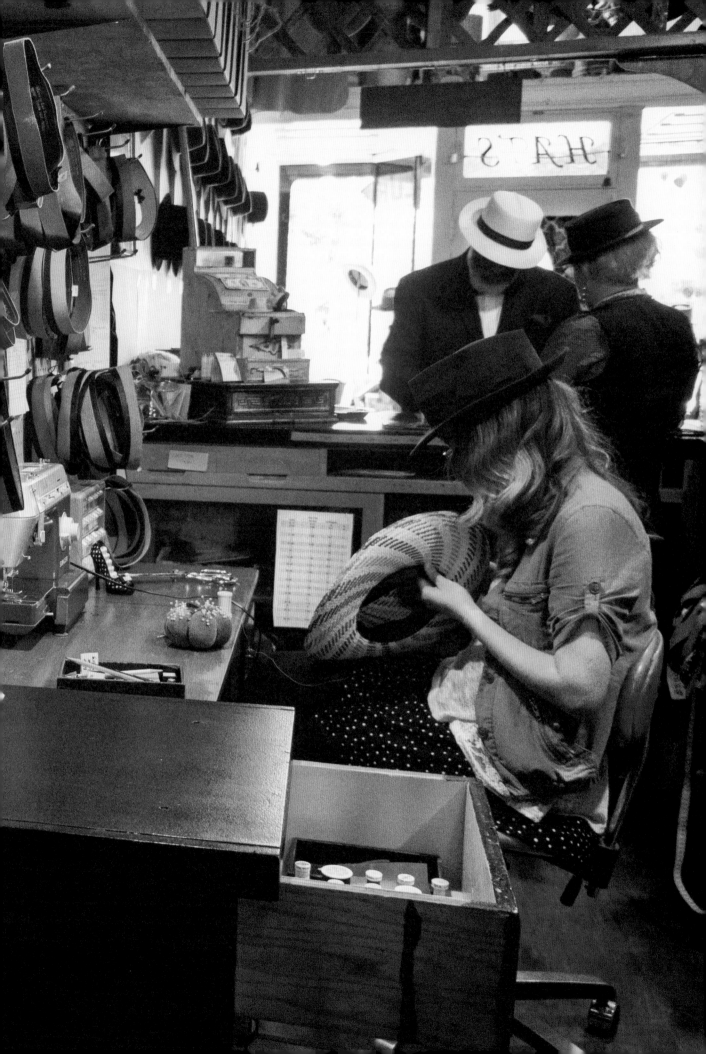

ABBIE DWELLE,
PAUL'S HAT WORKS
SAN FRANCISCO, CALIFORNIA, USA

"7 ⁵/₈ Teardrop, soft side dent, upsnap, natural, beaver fur felt, with distressed leather band," reads an Instagram post from Paul's Hat Works. "Just hit the floor, is it yours?" It might be a new hat, but the style recalls the mid-twentieth century (more than sixty years before Instagram), when the hat was a staple for American men (and, to a certain extent, women) in public spaces. Historic photos of urban crowds in the nineteenth and early twentieth century cities are a sea of hats, with hardly a bare head in sight. Fashion historians mark the inauguration of President John F. Kennedy, who notably eschewed the formal top hat during his inaugural address and was rarely seen wearing a hat through his presidency, as coinciding with a key shift in attitudes toward headware—when it became an option and no longer a requirement. Cars may also have had an impact, since it's not exactly easy to wear a hat in the car; and changing hairstyles that were no longer hat-friendly likely played a role. For these and many other reasons, the hat's popularity today is a ghost compared to previous centuries, and over the years, many dedicated hat-makers have slowly disappeared.

But in the Richmond District of San Francisco, the tradition has continued behind the same storefront at Paul's Hat Works since 1918. The shop was founded by Napoleon "Paul" Marquez and has changed hands as each Master Hatter taught the next generation of apprentices. But its future wasn't always safe, and almost a decade ago, the aging

The original Paul of Paul's Hat Works is long gone, but Dwelle and Hove keep his legacy alive a century later from the same storefront. They refer to themselves as "Pauls" and even sign the name on notes to customers or signs posted on the door if they need to step away from the shop.

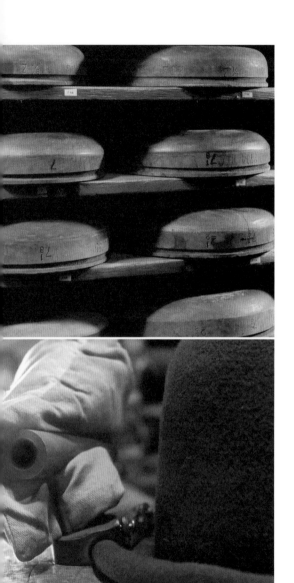

owner was struggling to find a buyer who would carry on the legacy of the shop. Then in 2009, current owners Abbie Dwelle and Kristen Hove, along with two other friends, fresh out of studying sewing and costume design, took a leap of faith and took over the store.

Over six months, Michael Harris (who had run the shop for at least thirty years) taught them everything he knew about hat making. This crash course was the culmination of the expertise of three previous generations of Master Hatters, and an opportunity not easily replicated, since programs for learning men's hat making are rare today. When the shop officially changed hands, it came with all the tools and materials—carved wooden molds and other specific hat-making tools are no longer made, and finding them can be a struggle. Since 2014, Dwelle and Hove have worked together to run the vintage shop and serve a base of devoted hat-loving customers.

The hat-making process, Dwelle explains, is a personal one. People come in for various reasons—to prepare for an event (maybe a wedding), to address a health issue, or just to add that special finishing touch to their look that only a custom hat could achieve. "The first step when a customer comes in," she says, "is getting to know the person and where they need a hat to accompany them, for both fashion and function, and then translating that character into a hat." She'll encourage the customer to try on a number of styles that she thinks might suit them. She talks them through the fit and shape of the crown, the "snap" (the downturn or upturn of the brim), the width of the brim, and the general sass or "rake" of the style.

Paul's Hat Works carries a broad selection of hat styles off the rack—fedora, porkpie, optimo, top hat, bowler, and more. But if a custom hat is in order, Dwelle will work with the client to finalize the color and the felt, and will take measurements for

Commercially made hats at your go-to department store may not, at first glance, look too different from a hat made at Paul's Hat Works. But there is something that sets apart a hat made by hand: Life is infused into each hat under the hatter's artful and skillful hands. "There's the art of the touch," says Dwelle, "and listening to the material in how you sculpt it." When creating a custom hat, she says, she can channel lines, colors, and textures into the hat in such a way that perfectly captures the personality of its intended wearer.

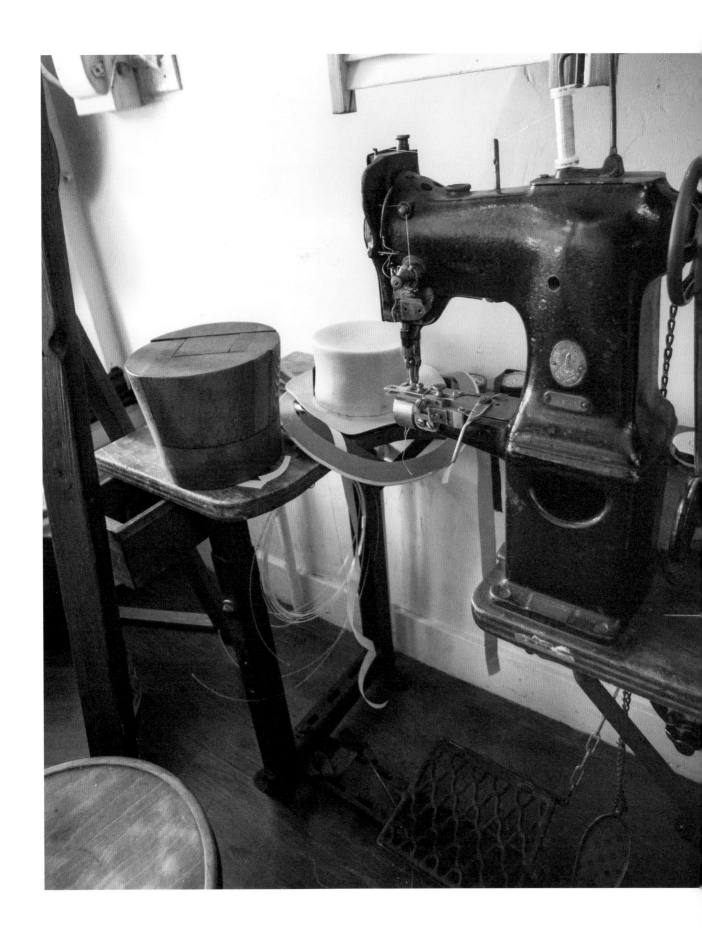

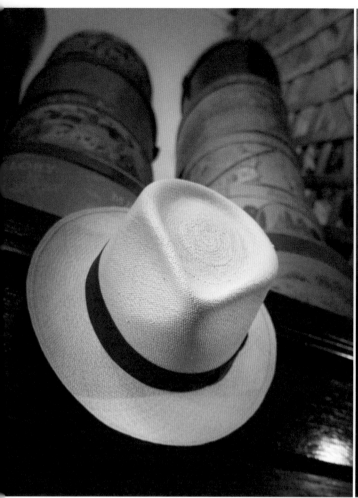
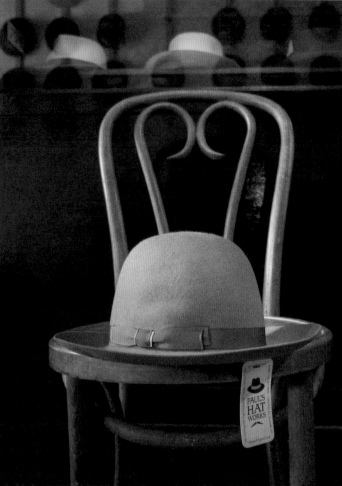

the perfect fit. She uses a conformiture, a strange metal top hat–like contraption covered with knobs and levers for adjustment, to precisely measure the head size and determine its shape. According to Dwelle, no person's head is exactly the same as another's, like fingerprints.

The body of the hat—that is, the basic blank hat form—is created by steaming felt around a wooden form, called a hat block. The hatters will then manually shape the pliable form to get just the right look. From there, they add a lining, sweat band, external decorative ribbon, and occasionally a brim binding. Finished hats are typically ready for pickup after two to four months, but sometimes the customer will also come back for fittings or to consult on style flourishes like the band ribbon, feathers, or other details.

Many customers return for two or three hats, and other devotees have as many as ten hats from the Hat Works. "Hat-wearers need options for every season, and for

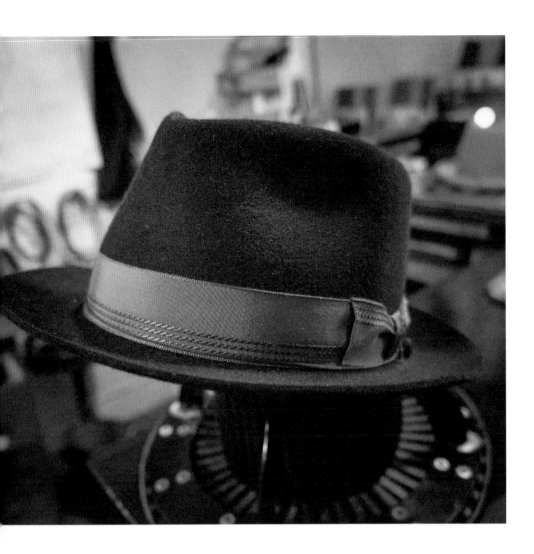

specials events," Dwelle explains. Developing a regular hat-habit might be hard to imagine given the price point (hats run from $450 to $5,000), but the hatters stand by their promise of eighty years to over a century of wearability—meaning that with the right care and maintenance, a hat from Paul's Hat Works could become a treasured family heirloom. And in the meantime? They guarantee: "You'll look good no matter what you're wearing or where you're going."

"I very much love that I'm making something that's going to last a long time and age well—it's not a disposable product. It's timeless," says Dwelle.

Acknowledgments

I'd like to thank each and every artist featured in this book, as well as some of the key people who support their work: Peter Bellerby and the globemakers, painters, and cartographers at Bellerby & Co.; Donald Vass and the King County Library System; Porfirio Gutiérrez and his talented, hardworking family; Leslie Mehren; Narayan Khandekar and the Strauss Center for Conservation and Technical Studies and the Forbes Pigment Collection; Daniel Arsham, Meghan Clohessy, and Ciena Leshley; Brittany Nicole Cox at Memoria Technica; Eric Dell Schwortz; Ray Bidegain; Ashley Jennings of Alchemy Tintype; Giles Clement and Kendra Kilkuskie; Jim Moran and the dedicated folks at the Hamilton Wood Type Museum; Steve Stepp, Robert Coverston, and the cassette-makers of the National Audio Company; Natasha Kennedy; Jeff Friedman, his designers, glass benders, and engineers at Let There Be Neon; James and Karla Murray; Matt Loughrey of My Colorful Past; Grace Rawson and Greg Wood of Exit Films; Lee Eun Bum and Gallery Huue; *Coyota in the Kitchen* author Anita Rodríguez, Joanna Keane Lopez, and Zippy Guerin; Stephanie Hare of SHare Studios; Jenny Rebecca McNutlty; Julia and Daphne Astreou; Camilla Bonzanigo and the incredible artisans of the Fonderia Artistica Battaglia; Muneaki Shimode of Studio Baisen, with thanks to Tim Toomey and Iku Nishikawa; Derek McDonald at Golden West Sign Arts; Meredith Kasabian and Josh Luke of Best Dressed Signs; Margaret Shepherd and Colleen Mohyde; Meguri Nakayama and the dedicated advocates, carvers, printers, publishers, and artists of the Adachi Institute; Simon Vernon of World's End Mapmaking; and last but certainly not least, Abbie Dwelle and team at Paul's Hat Works.

To Chronicle: Enormous thank yous to Bridget Watson Payne for another amazing project, to the intrepid Mirabelle Korn for guiding it from idea to shelf, and to Kayla Ferriera for the amazing design.

To my husband, Tyler: Your support means the world, and your quest for clarity brings me back to earth when I most need it.

Thank you to my parents, parents-in-law, sisters, and brothers. To my dad, Jamie: Thank you for teaching us to make paper in the driveway, to bind our own books, carve our own stamps, and build ceramics (that pale next to your own).

And this is for Doree: The light of your creativity still illuminates our world.

About the Authors

Emily Freidenrich is the author (as Emily Zach) of *The Art of Beatrix Potter* for Chronicle Books, and works as an image researcher in the publishing industry. She has a background in art history and archaeology and a deep interest in modern and contemporary art, as well as illustration, design, and pop culture. She lives in Seattle with her husband, Tyler, and corgi, Pancake.

Narayan Khandekar is the director of the Straus Center for Conservation and Technical Studies and director of the Center for the Technical Study of Modern Art at the Harvard Art Museums. He received a first class honors degree and PhD in organic chemistry from the University of Melbourne, followed by a postgraduate diploma in the Conservation of Easel Paintings from the Courtauld Institute of Art. He has worked at the Hamilton Kerr Institute of the Fitzwilliam Museum, Cambridge University; Melbourne University Gallery; and the Museum Research Laboratory of the Getty Conservation Institute. He has a long-standing interest in the materials and techniques of artists and is an author on over sixty publications.

Margaret Shepherd was born in Ames, Iowa. She studied brush painting in prewar Saigon before graduating from Sarah Lawrence College in 1969. Today, she lives in Boston with her husband, David Friend, and has not only authored but also hand-lettered fourteen books about calligraphy; her basic book *Learn Calligraphy* is now a classic in the field. She has participated in many exhibitions and lectured about topics related to her field. She takes special interest in encouraging beginners and nonartists to try calligraphy and learn about its history. She has taught workshops in Vietnam, Uzbekistan, and Finland. Building on the revival of interest in pen and ink, Margaret Shepherd has also written three books about communication in general. *The Art of the Handwritten Note* continues to inspire people today, more than fifteen years after she was told "that's a dying art."

Sources

THE GLOBEMAKERS

Bellerby, Peter. "A Brief History of…… Globe-Making," Peter Bellerby & Co. Globemakers Blog, July 27, 2015, http://blog.bellerbyandco.com/random/brief-history-of-globe-making/.

Boooooooom Staff, "The Painstaking Process of Hand-crafted Artisan Globes," Boooooooom, August 26, 2015. http://www.boooooooom.com/2015/08/26/the-painstaking-process-of-making-handmade-globes/.

British Pathé. "Globe Making (1949)," British Pathé, video, April 13, 2014, https://www.britishpathe.com/video/globe-making/query/globe+making.

History of Science Museum, "Renaissance Project: Make a model globe" Accessed June 12, 2017, https://hsm.ox.ac.uk/renaissance-project-make-a-model-globe.

THE BOOKMENDER

Boudreau, Joan. "The book boom: Early bookbinding inventions," O Say Can You See? Stories from the National Museum of American History, October 1, 2015, http://americanhistory.si.edu/blog/book-boom-early-bookbinding-inventions.

Garner, Julie. "How the UW Libraries brings damaged, rare books back to life," Columns, November 8, 2017, https://magazine.washington.edu/feature/uw-libraries-conservation-center/.

Johnson, Kirk. "He Fixes the Cracked Spines of Books, Without an Understudy," *The New York Times*, January 6, 2017, https://www.nytimes.com/2017/01/06/us/donald-vass-book-repair-seattle-library.html?_r=0.

KCLS, "Bookbinder: Moving at the Speed of Craft," KCLS, video, October 14, 2016, https://www.youtube.com/watch?v=q05HiQaIAHg.

THE ZAPOTEC DYERS AND WEAVERS

Goode, Erica. "In Mexico, Weavers Embrace Natural Alternatives to Toxic Dyes," *The New York Times*, September 18, 2017, https://www.nytimes.com/2017/09/18/science/mexico-textiles-natural-dyes.html.

Index—, "A Colorful Tradition," Index—, January 17, 2018, https://www.harvardartmuseums.org/article/a-colorful-tradition.

Porfirio Gutiérrez y Familia Studio. "The Process," Accessed January 21, 2017, http://www.porfirio-gutierrez.com/index.html.

THE CASTER

52 Insights, "Daniel Arsham: The Time Traveler," 52 Insights, March 1st, 2018, https://www.52-insights.com/daniel-arsham-time-traveller-art-interview/.

Arsham, Daniel. "About," Accessed February 15, 2018, https://www.danielarsham.com/about/.

Kei, Pei-Ru. "Eye openers: corrective lenses have lent colour to artist Daniel Arsham's monochromatic output," *Wallpaper*, September 14, 2016, https://www.wallpaper.com/art/corrective-lenses-have-lent-colour-to-artist-daniel-arsham-of-snarkitectures-monochromatic-output#4d8UqsQTXUUyRDOS.99.

Frane, James T. *Craftsman's Illustrated Dictionary of Construction Terms*, 1994. Craftsman Book Company, pp. 126.

Ferro, Shaunacy. "Why Designer Daniel Arsham Won't Work for Anyone But Himself," *Fast Company*, March 20, 2015, https://www.fastcompany.com/3044031/why-designer-daniel-arsham-wont-work-for-anyone-but-himself.

THE ANTIQUARIAN HOROLOGIST

Great Big Story, "A Craft of Future Past: Mastering Antiquarian Horology," Great Big Story, video, March 21, 2017, https://www.youtube.com/watch?v=irdTng8MbIE.

Holmes, Tao Tao. "How an Antiquarian Horologist Brings Tiny Machines Back to Life," Atlas Obscura, February 6, 2017, https://www.atlasobscura.com/articles/how-an-antiquarian-horologist-brings-tiny-machines-back-to-life.

Spitzer, Gabriel. "Seattle Horologist Masters Clock-work to Make Time Travel and Stand Still," KNKX, August 28, 2015, http://www.knkx.org/post/seattle-horologist-masters-clockwork-make-time-travel-and-stand-still.

THE WET PLATE PHOTOGRAPHERS

Clement, Giles. "I Shot the World's First Drone Tintype," Peta Pixel, June 12, 2017, https://petapixel .com/2017/06/12/shot-worlds-first-drone-tintype/.

Department of Photographs, The Metropolitan Museum of Art, "Photography and the Civil War, 1861–65," The Met: Heilbrunn Timeline of Art History, October 2004, https://www.metmuseum .org/toah/hd/phcw/hd_phcw.htm.

McNamara, Robert. "Wet Plate Collodion Photography," ThoughtCo., April 4, 2017, https://www .thoughtco.com/wet-plate-collodion-photography-1773356.

Nikitas, Theano. "The rebirth of tintype: an old photographic medium is revitalized," Popular Photogaphy, March 5, 2017, https://www.popphoto.com/ rebirth-tintype-an-old-photographic-medium-is-revitalized.

THE WOOD TYPE PRINTERS

Hamilton Laboratory Solutions, "Company History," Hamilton Laboratory Solutions, Accessed April 25, 2017, http://hamiltonlab.com/about-us/company-history/.

Hamilton Wood Type & Printing Museum, "History," Hamilton Wood Type & Printing Museum, Accessed April 21, 2017, https://woodtype.org/pages/history.

Heller, Steven. "When Wood Trumped Metal: An Interview with Bill Moran," AIGA, April 14, 2009, https://www.aiga.org/when-wood-trumped-metal-an-interview-with-bill-moran.

THE CASSETTE TAPE MANUFACTURERS

Great Big Story, "Throwback on a Comeback: The Last Cassette Tape Factory," Great Big Story, video, June 2, 2016, https://www.greatbigstory .com/stories/the-last-cassette-tape-factory.

Holman, Gregory J. "The world was running out of cassette tape. Now it's being made in Springfield," Springfield News-Leader, January 7, 2018, https://www.news-leader.com/story/news/local/ ozarks/2018/01/07/world-running-out-cassette-tape-now-its-being-made-springfield/852739001/.

Hunt, Michael. "Why the Cassette Tape is Still Not Dead," Rolling Stone, April 18, 2016, https://www .rollingstone.com/music/music-news/why-the-cassette-tape-is-still-not-dead-48276/.

Pettitt, Jeniece. "This Company Is Still Making Audio Cassettes and Sales Are Better Than Ever," Bloomberg, September 1, 2015, https://www .bloomberg.com/news/articles/2015-09-01/this-company-is-still-making-audio-cassettes-and-sales-are-better-than-ever.

THE NEON SIGN MAKERS

Jow, Tiffany. "The Workshop Where Famous Artists Get Their Neons Made," Artsy, June 28, 2017, https://www.artsy.net/article/artsy-editorial-new-york-workshop-famous-artists-neons-made.

Schulz, Dana. "Where I Work: Inside Let There Be Neon, the 46-year-old Tribeca workshop that revived neon arts," 6sqft, December 6, 2017, https://www.6sqft.com/where-i-work-inside-let-there-be-neon-the-46-year-old-tribeca-workshop-that-revived-neon-arts/.

Stern, Rudi. "History of Neon," Let There Be Neon, Accessed September 16, 2017, https://www .lettherebeneon.com/?page_id=13.

Vankin, Deborah. "L.A. helps Havana's vintage neon signs glow again: 'It marks a new era, a return of the light, of hope,'" Los Angeles Times, June 16, 2016, http://www.latimes.com/entertainment/arts/ la-et-cm-havana-light-20160613-snap-story.html.

THE IMAGE COLORISTS

Boyle, Darren. "Ellis Island in colour: Artist brings archive of earliest immigrants pictures to life - including a portrait of the first person ever to pass through," Daily Mail Online, February 21, 2017, http://www.dailymail.co.uk/news/article-4245210/ Amazing-images-New-York-s-Ellis-Island.html.

Loading Docs, "The Colourist," Loading Docs, video, 2016, http://loadingdocs.net/thecolourist/.

Strochlic, Nina. "Vintage NASA Pictures Get New Life in Vibrant Color," National Geographic, February 17, 2017, https://news.nationalgeographic .com/2017/02/nasa-colorized-photography-astronauts-space-race-science/.

THE GORYEO CELADON POTTER

Huue Craft, "Lee Eun Bum," Huue Craft, June 17, 2016, http://huuecraft.com/lee-eun-bum-3/.

Lee, Soyoung. "Goryeo Celadon," The Met: Heilbrunn Timeline of Art History, October 2003, https://www.metmuseum.org/toah/hd/cela/hd_cela.htm.

Pak, Youngsook and Roderick Whitfield, *Earthenware and Celadon*. London: Laurence King, 002.

THE ENJARRADORA AND ADOBE-BUILDERS

Humans of New Mexico, "Anita's Magical Taos," Humans of New Mexico, Accessed June 2, 2017, https://humansofnewmexico.com/2017/06/02/anitas-magical-taos/.

Parezo, Nancy J., Kelley A. Hays, and Barbara F. Slivac. "The Mind's Road: Southwestern Women's Art." *The Desert is No Lady: Southwestern Landscapes in Women's Writings and Art*. New Haven and London: Yale University Press (1987).

Romero, Orlando. *Adobe: Building and Living with Earth*. New York: Houghlin Mifflin Co., 1994.

Rodriguez, Anita and Katherine Pettus. "The Importance of Vernacular Traditions." Association for Preservation Technology International (APT) Bulletin, 22:3 (1990), 2-4.

THE PAPERMAKER

Britt, Kenneth W. "Papermaking," *Encyclopaedia Britannica*, Accessed November 20, 2017, https://www.britannica.com/technology/papermaking/Introduction.

Hubbe, Martin A. and Cindy Bowden, "Handmade Paper: A Review of Its History, Craft, and Science," BioResources, 4:4 (2009), http://ojs.cnr.ncsu.edu/index.php/BioRes/article/view/BioREs_04_4_1736_Hubbe_Bowden_Handmade_Paper_Review/482.

Levine, Mark. "Can a Papermaker Help to Save Civilization?" The *New York Times*, February 17, 2012, https://www.nytimes.com/2012/02/19/magazine/timothy-barrett-papermaker.html.

THE CYPRIOT WEAVER

Konyalian, Claudia. "Weaving the Tales of Time," *Cyprus Heritage*, pp. 88–92.

Lonely Planet, "History of Cyprus," Accessed January 7, 2018, https://www.lonelyplanet.com/cyprus/history.

Spirou, Kiriakos. "Textile Artist Julia Astreou is Keeping Cypriot Weaving Tradition Alive," Yatzer, May 24, 2017, https://www.yatzer.com/julia-astreou.

THE BRONZE CASTERS

The Editors of Encyclopaedia Britannica, "Lost-wax Process: Metal Casting," *Encyclopaedia Britannica*, Accessed September 8, 2017, https://www.britannica.com/technology/lost-wax-process.

Fonderia Artistica Battaglia, "Sculpture," Fonderia Artistica Battaglia, Accessed February 12, 2018, https://www.fonderiabattaglia.com/index.php?node=scultura&lang=en.

Ker, Anna Dorothea. "A Visit to the World's Oldest Bronze Casting Foundry," iGnant, July 18, 2016, https://www.ignant.com/2016/07/18/a-visit-to-the-worlds-oldest-bronze-casting-foundry/.

THE KINTSUGI-SHI

Jobson, Christopher. "Kintsugi: The Art of Broken Pieces," Colossal, May 8, 2014, https://www.thisiscolossal.com/2014/05/kintsugi-the-art-of-broken-pieces/.

McFadden, Christopher. "Kintsugi: The Japanese Art of Fixing Broken Pieces of Pottery With Gold," Interesting Engineering, July 3, 2017, https://interestingengineering.com/kintsugi-japanese-art-fixing-broken-pieces-pottery-with-gold.

My Modern Met Team, "Kintsugi: The Centuries-Old Art of Repairing Broken Pottery with Gold," My Modern Met, April 25, 2017, https://mymodernmet.com/kintsugi-kintsukuroi/.

THE SIGN PAINTERS

Allen, Justin. "Not Yet Lost: Golden West and the Craft of Sign Painting," *Creosote Journal*, August 15, 2012, http://creosotejournal.com/2012/08/not-yet-lost-sign-painting/.

Kasabian, Meredith. "A History of Signs and how we and Barry McGee make Space into Place," Best Dressed Signs (adapted from a talk given at the ICA Philadelphia, June 15, 2013), June 18, 2013, http://bestdressedsigns.tumblr.com/post/53313052525/a-history-of-signs-and-how-we-and-barry-mcgee-make.

The Pre-Vinylite Society, "The Pre-Vinylite Society Manifesto," The Pre-Vinylite Society, Accessed February 20, 2018, http://www.previnylitesociety.com/the-pre-vinylite-society-manifesto.

The Sign Painter documentary, *Sign Painters: The Film*, 2014, http://www.signpaintersfilm.com/#watch.

THE WOODCUT PRINTERS

Department of Asian Art, Metropolitan Museum, "Woodblock Prints in the Ukiyo-e Style," The Met: Heilbrunn Timeline of Art History, October 2003, https://www.metmuseum.org/toah/hd/ukiy/hd_ukiy.htm.

Merritt, Helen. *Modern Japanese Woodblock Prints: The Early Years*. Honolulu: University of Hawaii Press, 1990.

Tachibana, Tamaki. "Artist strives to revive ukiyo-e glory," *The Japan Times*, June 5, 2014, http://www.japantimes.co.jp/news/2014/06/05/national/artist-strives-revive-ukiyo-e-glory/#.WMYnDY7avUp.

THE MAPMAKER

Crichton-Miller, Emma. "The art of hand drawn map-making," *Financial Times*, April 6, 2016, https://www.ft.com/content/a246774a-f690-11e5-96db-fc683b5e52db.

The Editors of Encyclopaedia Britannica, "Intaglio," *Encyclopaedia Britannica*, Accessed February 19, 2018, https://www.britannica.com/topic/intaglio-printing.

Vernon, Simon. "A Brief History and Some Earlier Maps," Simon Vernon Mapmaker, Accessed February 20, 2018, http://www.simonvernon.com/a_brief_history_and_some_earlier_maps.html.

THE HATMAKERS

Fine Arts Museums of San Francisco, "Paul's Hat Works," Fine Arts Museums of San Francisco via YouTube, video, July 21, 2017, https://www.youtube.com/watch?v=ExeA3GCJoCQ.

Hintz-Zambrano, Katie. "New Award-Winning Documentary Looks at The Ladies Behind Paul's Hat Works," May 25, 2011, https://www.refinery29.com/new-award-winning-documentary-looks-at-the-ladies-behind-paul-s-hat-works.

Nolte, Carl. "4 women breathe new life into classic hat store," SF Gate, September 13, 2009, https://www.sfgate.com/news/article/4-women-breathe-new-life-into-classic-hat-store-3287106.php.

Image Credits

THE GLOBEMAKERS

pp. 12–13, 17 (bottom): Photos by Tom Bunning, courtesy of Bellerby & Co.

pp. 14, 16, 19: Photos by Alun Callender, courtesy of Bellerby & Co.

p. 17 (top, center), 18: Photos by Ana Santi, courtesy of Bellerby & Co.

pp. 20–21: Courtesy of Bellerby & Co.

THE BOOKMENDER

pp. 22–29: Ruth Fremson/*The New York Times*/Redux

THE ZAPOTEC DYERS AND WEAVERS

pp. 30–39: Adriana Zehbrauskas/*The New York Times*/Redux

A TOUR OF HARVARD'S FORBES PIGMENT COLLECTION

pp. 40–45: Photography by Tony Luong, www.tonyluong.com/@itsmetonyluong, originally for Artsy.

THE CASTER

pp. 46–47, 50–52: Young-Ah Kim for IDEAT Magazine, @ideat_magazine.

p. 48: Jesse Frohman/Figarophoto/Contour by Getty Images

THE ANTIQUARIAN HOROLOGIST

pp. 54–61: Photography 2018 by Eric Dell Schwortz.

THE WET PLATE PHOTOGRAPHERS

pp. 62–63, 69: Photography by Giles Clement.

pp. 64–67: Photography by Ashley Jennings.

THE WOOD TYPE PRINTERS

pp. 70–78: Photos by Jeff Dawson, courtesy of the Hamilton Wood Type Museum

THE CASSETTE TAPE MANUFACTURERS

pp. 80–89: Photography by Natasha Kennedy.

THE NEON SIGN MAKERS

pp. 90–99: Photos by James & Karla Murray, @jamesandkarla

THE IMAGE COLORISTS

pp. 100–101, 106–108: Photos by Greg Wood/Loading Docs.

pp. 102–105: Colorized photo by Matt Loughrey/ My Colorful Past.

THE GORYEO CELADON POTTER

pp. 110–117: Courtesy of the artist and Gallery Huue.

THE ENJARRADORA AND ADOBE-BUILDERS

pp. 120–121: Cpw2017 via Wikimedia Commons / CC 4.0

pp. 122–124, 126 (right): Photography by Zippy Guerin.

p. 125: Courtesy of Anita Rodriguez.

p. 126, 127 (left): Courtesy of Joanna Keanne Lopez.

THE PAPERMAKER

pp. 128–130, 133 (bottom right), 136, 137: Photography by Jenny Rebecca McNulty, www.wyldephoto .com, @wyldephoto.

pp. 132–132, 133 (top, center, bottom left), 134–136: Courtesy of Stephanie Hare/SHare Studio.

THE CYPRIOT WEAVER

pp. 138–140: Photography by Dinah Kaprou.

pp. 142–145: Photography by Panagotis Mina, courtesy of Julia Astreou.

THE BRONZE CASTERS

pp. 154–161: Photography by Jessica Pepper-Peterson, www.jppfoto.com, @jppfoto.

THE KINTSUGI-SHI

pp. 154–161: Courtesy of Muneaki Shimode.

THE SIGN PAINTERS

pp. 162–167, 170–171: Courtesy of Best Dressed Signs.

pp. 168 –169: Courtesy of Golden West Sign Arts.

INK WARMS MY SOUL

pp. 172–175: Photography by Ashley McDowell.

THE WOODCUT PRINTERS

pp. 176–183: Courtesy of the Adachi Institute of Woodcut Prints, Tokyo.

THE MAPMAKER

pp. 184–190: Courtesy of Simon Vernon.

THE HATMAKERS

pp. 192–199: Photography by Yon Sim Kim, Courtesy of Paul's Hat Works.

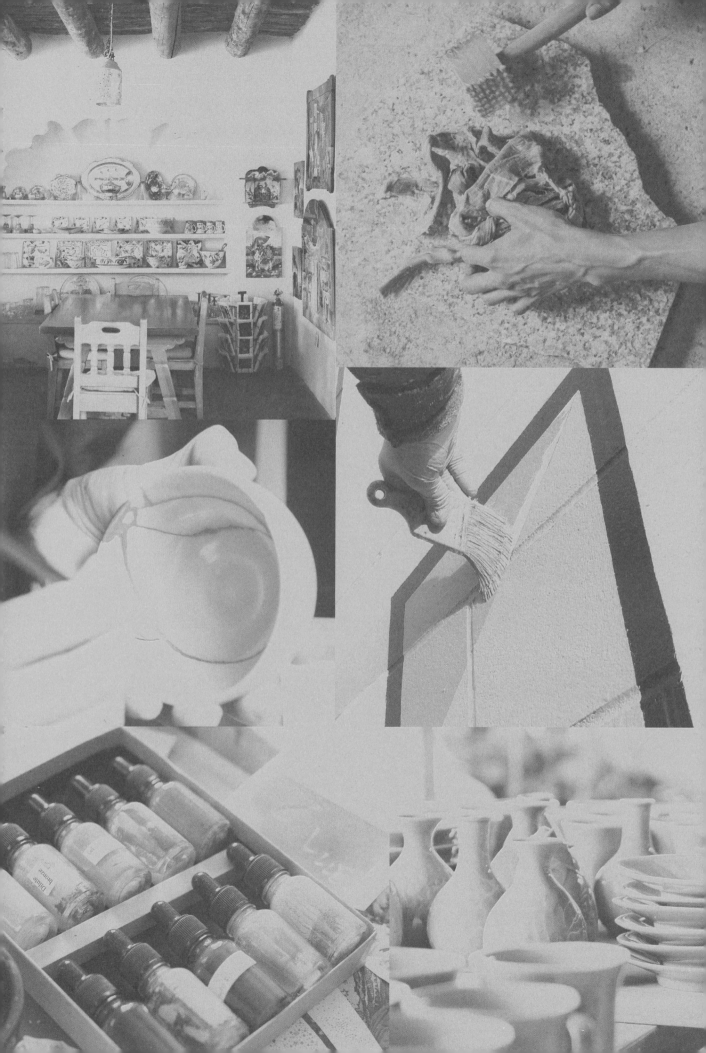